The CREATIVE
MONOCHROME IMAGE

The CREATIVE MONOCHROME IMAGE

HOW TO EXCEL AT BLACK & WHITE PHOTOGRAPHY

David Chamberlain ARPS

BLANDFORD

Series editor: Jonathan Grimwood

This paperback edition 1989
First published in the UK 1986 by **Blandford Press**,
An imprint of Cassell
Artillery House, Artillery Row,
London, SW1P 1RT

Frontispiece: see page 51 for details.

Distributed in the United States by
Sterling Publishing Co, Inc,
2 Park Avenue, New York, NY 10016

Distributed in Australia by
Capricorn Link (Australia) Pty Ltd,
PO Box 665, Lane Cove, NSW 2066

British Library Cataloguing in Publication Data
Chamberlain, David
 The creative monochrome image: how to excel
at black & white photography.
 1. Photography
 I. Title
 770'.28 TR146

ISBN 0 7137 2126X

Typeset by Asco Trade Typesetting Ltd,
Hong Kong
Printed and bound in Great Britain by
BAS Printers Ltd, Hampshire

CONTENTS

Folio Section

Conclusion

Index

INTRODUCTION -
why <u>creative</u> ?

The word 'create' is probably one of the most misused and over used words in the English language when applied to any of the arts, and in particular when applied to photography. Creativity in photography is extremely subjective, in that while one viewer may think a particular photograph creative another may totally disagree, and dismiss it as 'gimicky' or banal. However, I personally feel that recent trends in colour photography have a great deal to answer for, in that the over use of 'effect' filters, prisms and other 'creative' gadgets have greatly devalued the meaning of creativity in photography.

The average dictionary would define the word *create* thus 'bring into being or existence/originate'. I think a fair interpretation of this definition in photographic terms would be 'to produce original images/to produce pictures exhibiting a different or unusual approach.'

This does not imply that any picture brought about by the use of special techniques, filters, or materials is automatically creative. If this was the case, we would all be instant masters of creative photography ... No, there is much more to creative photography than mere equipment.

An artist uses brushes or a palette knife to apply paints to a canvas, but these items are merely tools and materials which are necessary to the craft, for without them an artist could not produce paintings. The artist still needs skill and dexterity to actually produce the picture required. The tools and materials are not capable of applying themselves to the canvas, and a sound knowledge of the techniques is required by the artist to produce a good

likeness on canvas of the scene or subject.

Although a sound knowledge of technique combined with the right materials and adequate ability will enable the artist to produce a good painting, these attributes alone will not necessarily make a 'creative' artist. In much the same way, a photographer who owns a comprehensive outfit of top quality equipment and has, perhaps, a thorough knowledge of photographic technique, will be more than adequate but will not necessarily be a creative photographer. Creativity is more than just equipment or technique. Although both are an aid to the creative photographer neither provides instant creativity.

Creativity is an elusive quality that resides in the mind. Although brilliant technique is not necessary to creativity, imagination is! Moreover, creativity can add so much to technique, and so too can technique to creativity. Good technique will enable the creative photographer to be even better, while imagination and creativity will greatly enrich the work of the good technical worker. Take, for example, two technically-equal, talented musicians. Both may have the same ability to play any written composition, yet only one may have the creative ability actually to compose and write original music. This musician will obtain the greatest amount of pleasure from the art.

Now, I believe that it is this extra pleasure that makes creative monochrome photography so rewarding. The satisfaction of having produced and, indeed, being able to produce regularly, creative and original images is unsurpassed. Although it has been said to me that it takes two people to make

a successful picture – the photographer and the viewer – I do not agree. If you analyse your reasons for starting up in this hobby of photography, I am sure you will find, like myself, that your initial intentions were to produce pictures for yourself, not for others!

Intense use of your mind and imagination to produce photographs can only add to this enjoyment of your own pictures, and creativity will develop quickly in the pictures you produce for yourself. As soon as you start trying to produce photographs for others, you will find that everything you do becomes a compromise to some extent. If other people do admire your personal work, then treat this as no more than a bonus but don't give way to the criticism that you will inevitably receive from those that do not like or understand your pictures. And don't try to produce photographs simply to please the critics, as this is certain to cause your work to stagnate. In any event, the likelihood of ever producing a picture that will please everybody who views it is non-existent. There will always be people who think a picture is good and those who think a picture is poor. There will also, of course, be those who just 'don't know'. So, when it comes down to it, there is little point in setting out to produce 'creative' pictures to please anyone other than yourself.

Creativity is within most of us, even if we do not realise this or understand how to exploit it. The problem is that although many people do indeed appreciate creative and imaginative photography, it is very difficult just to start producing this sort of work yourself. What is usually required is some form of initiative – almost a jolt – to spark off an interest that can then be harnessed and further developed and cultivated. It is rather unfortunate that until a few short years ago there existed a general attitude that unless a picture adhered to certain 'rules' of composition, it was doomed to failure as a photograph. Sadly, this attitude still affects some of today's photographers, thereby killing stone dead their chance of achieving true creativity.

I have heard it said more than once by many so-called creative photographers that these rules are rubbish and should now be forgotten. I feel that this too is a rather thoughtless attitude. It is no good – and certainly not intelligent – simply to dismiss something without ever really thinking about *why*? I believe that in the beginning the rules were never set out as such; more that through observation certain photographers quickly realised that pictures laid out in certain compositional fashions did, in fact, seem to be generally pleasing, and these observations are still very true today. However, the observations, which should loosely be taken as guidelines were, over the years, turned into the very rules which stifled the creativity of the very same people that used them. Pictures do not *have* to follow any rules whatsoever. If a picture looks right, it is right. Once you have mastered the ability to forget these rules of composition – and after you have spent some time producing creative pictures with a free mind – you will probably note that a high percentage of your pictures still conform, to some extent, to these compositional phenomena, thereby proving that the original observations were sound!

The initiation or jolt into creative photography can be brought about by several things, not least by looking at the work of other photographers. However, never make the mistake of copying another person's work, for you will not learn anything by doing this. By all means use the work of others to seek out a particular style or treatment, or any other aspect that may strike you, and then use this as a basis for expansion and experimentation but, above all, be prepared to go your own way in creative photography, always striving to be original in how you 'think' or 'see' things.

This is by no means an easy route, and you must be prepared to receive criticism as you progress along the path towards producing rewarding and original pictures. Learn not to press the shutter release button until you have a clear idea in your mind of how the finished print will look. Creative work rarely comes about by accident. The more thought and pre-planning that you put into each picture, the more successful it is sure to be. With my studio pictures it is common for me to make notes and sometimes sketches of how the shot should be carried out, and how it will look when

completed. More often than not, when working on one particular idea, or sometimes after having completed a picture, other ideas for further pictures will develop; and so it progresses, the more pictures you produce, the easier it becomes to produce further photographs.

When dealing with 'found' subjects, or subjects that you just happen upon while out with your camera, I have found the best approach is to stop and think before you ever put a camera to your eye. Consider exactly what it was that attracted your eye to the subject. Was it shape, form, texture or lighting? Try to analyse the scene before you to decide what is its strongest or most striking aspect, and only once this is clear in your mind should you use your camera to exploit and emphasise this aspect. Try to take everything possible into consideration, including any potential darkroom work you may be able to carry out to emphasise the most striking aspect. Expose your film for the effect you wish to achieve, not just for that which your exposure meter would indicate generally. For example, a darkish scene with perhaps a dominant highlight area might well benefit from some underexposure to further darken the scene and place further emphasis on the highlight area. Or a predominantly light scene, with maybe one important area of black or dark tone, might be emphasised by some degree of overexposure which could turn the scene almost pure white, thereby isolating the dark tone in a sea of light tones. In much the same way, if there is an important element of perspective or shape then this can be exploited by the use of different lenses: most obviously by a wide-angle lens to expand or a telephoto lens to compress the apparent perspective. All these possibilities should be considered fully, but the difficulties should not be underestimated. It will take practice and perseverance before you can expect regularly to produce original and creative pictures.

A trap to watch out for – one which many photographers fall into, who may otherwise already be well on their way to producing good creative work – is to become hooked on one particular theme or technique. This can be quite disastrous, in that you can find you have no way to turn without leaving behind a style you are now dependent on. Once you have exhausted a particular style or technique you may feel that you now have to start afresh on something completely new, and you can easily become reluctant to do this. But do it you must! You will never progress if you stick with the same theme.

More often than not, you will find that a great deal of what you have already learned can be applied with good effect to other styles, and this can often be combined with the new work as a starting point to produce something entirely different. In this way, by applying and carrying on the stronger points of your style from one type of work to another, you will gradually build up your own personal style of work which will eventually make you stand out from the crowd, and make your work instantly recognisable as your own. Never be afraid to drop what you have been doing previously if you feel it is no longer right for you. It is better to have the courage to do this, and perhaps move in a completely new direction, than to remain stuck.

It is hoped that the ensuing text and photographs in this book will prove an initiation or provide a jolt to help you on your road to the creative monochrome image. All the pictures are accompanied by information explaining my own personal feelings and aesthetic reasons for producing each of the photographs, along with all the technical details of the equipment and techniques used to create them. I hope that you will analyse your own pictures in much the same way, preferably prior to taking them, as I believe that these considerations are the very essence of 'creative' photography.

DAVID CHAMBERLAIN, ARPS

1
NECESSARY EQUIPMENT

It should not be necessary to dwell for too long on the subject of photographic equipment as the last quarter of a century has seen such vast strides forward in the technology and quality of cameras, lenses and accessories that there is now really very little to choose between any of the better known, equally priced cameras on the market. Even many of the cheaper cameras available today are capable of producing results that would have been the envy of any photographer only 10 or 15 years ago. With this in mind, it would be pointless to recommend any particular model and therefore the final choice and selection of a new camera must finally be based on personal taste and feature preferences.

Although there are many different types of camera still available today to the serious photographer, including single lens reflex (SLR), rangefinder, and compact models in the 35mm field, it

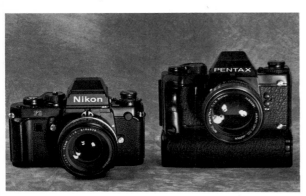

The 35mm SLR camera is an ideal choice for the creative monochrome photographer. Most of the top SLR models provide a host of useful features, including fully interchangeable viewfinders, focusing screens and winders or motordrives, in addition to their extremely comprehensive range of lenses.

is also worth considering the rapidly expanding range of medium-format cameras – those that use roll film. Many of these are every bit as technically advanced, and even automated, as their 35mm counterparts. Many are also as versatile, with their interchangeable viewfinders, lenses, backs or magazines, and focusing screens. If you require the utmost in image quality, and don't mind the extra weight and bulk to carry around, then one of these could well be the answer for you.

Whichever format you decide to work with, without a doubt the most versatile of these cameras is the single lens reflex. With its total freedom from the problems of parallax and the vast range of lenses and other accessories available for most models, this has to be the choice for the serious creative photographer.

When purchasing a new camera, it is always worth buying the best quality instrument that you can afford. This is not to say that lower priced cameras will not produce such good results; they can and sometimes do. But what you do get with the more expensive models is built-in reliability and, in most cases, the nucleus of a very comprehensive system, affording you the ultimate access to a vast range of different focal length and special purpose lenses. In this way your potential creativity will never be restrained by inadequate equipment. Moreover, some of the better cameras include more of the useful features such as mirror lock, depth-of-field preview, winder and motordrive facility, interchangeable viewfinders and focusing screens: all of which can prove invaluable to the creative photographer.

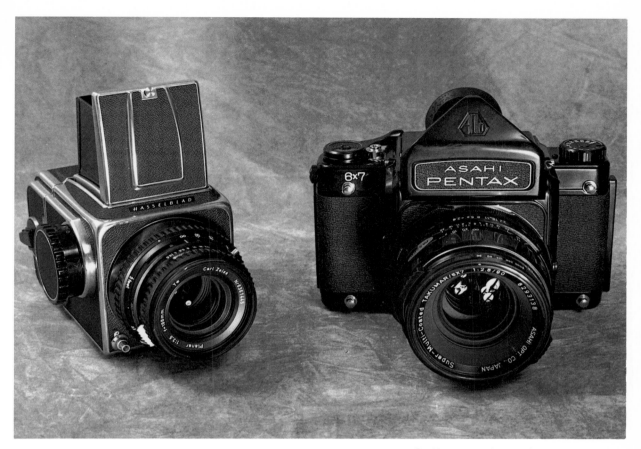

Medium-format (roll film) cameras offer some advantage to the monochrome worker who seeks that extra quality. Models are now available to suit every type of photographer's requirement, but you should be careful to select the right model for your own type of work. These cameras are, in general, more expensive than their 35mm counterparts and a mistake in your initial choice can prove costly if you then decide to change the model later. Illustrated are the Hasselblad 500CM 6 × 6cm format and the Pentax 6 × 7 which, as its name suggests, takes exposures of 6 × 7cm format. Unlike many medium-format cameras, the big Pentax features a focal plane shutter with speeds up to 1/1000th second which permits the camera to be designed like a scaled up 35mm SLR. Although this design provides very good handling for hand-held photography, it is not able to incorporate interchangeable film backs like many other models.

If you are contemplating going for medium format it is worth considering just what type of photographer you are, and what kind of work you are interested in. You should also stop to consider how your interests might develop in the future, before investing a great deal of money in a medium-format camera or outfit. Is most of your interest in taking photographs outside – landscape, etc? Or is the majority of your photography carried out in the studio? Perhaps you do some of each, but if this is the case, in what proportions? Some medium-format cameras are suitable for one particular type of work and may not be so suitable for others. For example; if you work mainly or solely in the studio, a camera such as the Mamiya RB/RZ67 or Rollie-flex 6006 may be the ideal instrument whereas – if your interests involve action photography, or landscape which could involve you carrying lots of equipment long distances on foot – a camera such as the Bronica ETR or Pentax 645 could be better, as it provides medium-format quality, combined with relatively light weight, portability and speed of use. For those that combine studio work with outside work, suitable cameras could be the Bronica 6 × 6 models, Hasselblad, or if a significantly larger format is preferred, the Bronica GS1

The Mamiya RB67 (or its electronic brother the RZ67) would be a perfect choice if you work mainly in the studio. Utilising the large 6×7cm format, this camera has many features which make it particularly suitable for such work. With interchangeable film backs – which rotate through 90 degrees, making it unnecessary to turn the camera on its side when changing from horizontal to vertical formats – fully interchangeable viewfinders, including a metering head for through-the-lens exposure metering, long bellows-type focusing which permits close-up photography without extras, and a good range of lenses from fish-eye to 500mm tele (all featuring leaf type shutters for full flash synchronisation), this camera is extremely versatile indeed. However, the RB67 is not so well suited to outside work, and hand-held use may be found to be rather cumbersome.

or Pentax 6×7 which has a focal plane shutter with speeds to 1000th second for action shots, handles like a 35mm reflex, but does not have a facility for interchangeable film backs.

The most useful lenses in the 35mm format range vary from the 20mm ultra-wide angle, which can be very useful for providing exaggerated perspective without any real distortion (whereas lenses much wider than this can tend to become a bit of an 'effect' in themselves), through 24mm, 28mm, 35mm wide angles, 50mm standard to 85 or 105mm short telephoto, 135 to 180mm medium telephoto, and 300mm telephoto which is about the longest lens that can be genuinely handheld. Zoom lenses, although very attractive to the colour worker, do not offer so much potential to the creative monochrome worker and do, in fact, have a number of drawbacks. Although enormous strides forward have been made in the technology involved in the manufacture of these lenses, and there is no doubt

that their performance is improving rapidly, there still remains a certain amount of doubt as to whether they can actually equal the performance of a top-quality lens of fixed focal length. Moreover, unless you are willing to part with a vast sum of money for a zoom lens, you will end up with a lens having a very much smaller maximum aperture-to-focal-length ratio than a comparative fixed focal length lens. At the other end of the scale, zoom lenses do not seem to perform very well when stopped right down for maximum depth-of-field. And besides this we, as monochrome workers, have an additional stage in the production of our finished photograph – the printing stage – and it is during this operation that we can duplicate the function of the zoom lens, by moving our enlarger head up or down the column, thus diminishing the greatest asset of the zoom lens.

Such a comprehensive range of lenses is neither so necessary nor desirable for a medium-format camera. The lenses are not so necessary because the camera offers a very much larger negative in the first place, from which we can crop to tighter and more selective compositions if required without losing too much quality, and they are not particularly desirable due to the added weight and bulk such a range of lenses adds to an outfit. A basic and yet still comprehensive outfit of medium-format lenses would be simply a wide-angle, standard, and short or medium telephoto lens. Nearly anything or any eventuality can be accommodated with such an outfit.

Whatever format of camera you choose to work with, you will find a waist level viewfinder to be an extremely useful accessory, and for any low level work (or when the camera has to placed on the ground) this accessory is invaluable. Although nearly all medium-format cameras feature the facility to fit a waist level finder, this is not true of many 35mm reflex models. However, if you can afford one of the top-of-the-line models with this feature it is well worth having. Cameras without this facility can be converted for low level work with the addition of a right-angle finder. This simply clips over the eyepiece to provide a means of looking down into the viewfinder when the camera is on the

ground. These can be very difficult to position for the eye, and subsequently quite slow in use.

Virtually all cameras with an interchangeable viewfinder facility (and even some without) have the ability to accept a range of interchangeable focusing screens. This can be a valuable asset, particularly when struggling to focus a wide-angle lens or when working with a long lens, perhaps with a small maximum aperture, when a split-image or microprism centre spot may black out. A quick change of screen can make life much easier.

Other camera features can also be invaluable when needed. Mirror lock-up facility when using a long exposure, or with a telephoto lens to avoid any possibility of vibration or shake. Depth-of-field preview, to determine precisely what is sharp and what isn't, at the particular aperture at which you are working. Winder facility to provide continuity with little loss of concentration during a portrait or modelling session. Motordrive for sports and action shots, and even the good old fashioned (albeit with flashing *LED*s nowadays) self timer, not just to put yourself in the picture, rather to use as a means of operating the camera without any physical contact should you have forgotten the cable release, or when the one you have decides to fall to bits in the middle of a session. All these features are useful but don't be blinded by the many trinkets which adorn cameras today. Just how inducive to creativity are multi-modes and flashing lights?

Filters play a small but important part in producing creative monochrome images and are mostly used for correction or to control contrast. The most commonly used filters are red, orange, yellow and green, with other useful filters being blue and polarising. The yellow filter, once used almost universally by landscape workers to slightly darken a blue sky, is not now used for this purpose to such an extent. It can still be very useful, however, to improve clarity on a slightly hazy day and produce a picture with a little more bite. The small amount that a yellow filter will darken a blue sky can, more often than not, be accomplished by slight burning-in during printing, as most modern films are capable of holding this much detail in the highlight areas.

For dramatic dark sky effects from a rich blue sky, the red filter comes into its own and when combined with a polarising filter a blue sky can be turned so black that a 'night for day' effect can be achieved. The same red filter can be used in portraiture and will turn Caucasian skin almost white, with some loss of detail. This can be used effectively to smooth a poor complexion.

A scene containing plenty of dark tone with some highlight areas can be turned into a very high contrast picture with the aid of a red filter. Simply expose to obtain detail in the highlights and let the shadows fill in. An orange filter can be used in much the same way as a red filter, but it is somewhat less dramatic in its effect. However, it can be used to great advantage to bring out the grain of timber and is particularly useful when photographing grained furniture, etc.

A green filter will also increase contrast quite considerably, and will lighten foliage whilst darkening red to almost black. This can be very effective when photographing red flowers against green foliage. The blue filter, although rarely used, can also be very useful to ensure that a blue sky records as absolutely white if this is required. It can also create a very mysterious effect when used in misty or hazy conditions.

Although a polarising filter can be used in monochrome photography to darken a blue sky in much the same way as it is used in colour work, this is rarely necessary as the coloured filters are available, and it is perhaps best reserved for eliminating reflections in water, glass or any other reflective surface. Useful as all of these filters undoubtedly are, don't use them unnecessarily. Take the time to consider if the use of a filter will enhance the subject matter further, and if it is necessary to produce the effect you wish to achieve.

An important piece of equipment that receives little consideration until you've already bought it, and after which you are committed to having to live with it, is a case or bag into which to put all your equipment. Don't underestimate this humble item of equipment. If you make the wrong decision at the time of purchase, you will regret it every time you have to lug equipment across country!

There is little doubt that a sturdy aluminium foam-filled or compartment case affords the ultimate in protection for your outfit, but you cannot possibly appreciate just how heavy and awkward

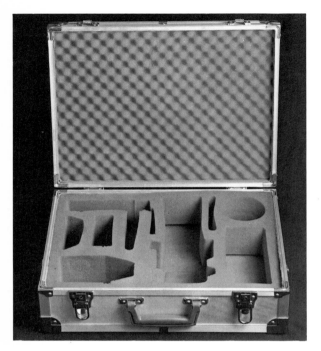

A foam filled aluminium case, such as this, provides the maximum protection for your equipment. These can, however, become rather heavy to carry for any distance.

Lightweight canvas or Cordura bags can offer good protection for equipment while being comfortable to carry. A further advantage is that most of these bags feature extra pockets which are useful for carrying all the small items of equipment and, of course, film!

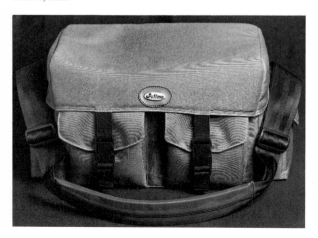

these can become on a long walk until you have experienced this; although they do have an advantage in that you have something on which to stand if you need to gain height to see over a wall, etc. You also have something sturdy on which to sit when you become weary from carrying the case!

Camera or outfit bags have come a long way in the last decade, and they are an item of equipment which, like cameras themselves, have benefited from vast strides forward in both technology and materials. The modern bag, probably made from Cordura, available around the world and featuring corrosion free and quick action zips and clasps, is both robust and comfortable to carry. The bag also affords pretty good protection for your valuable equipment. These modern bags are available in such a vast range of sizes and types that the only problem you are likely to encounter with them is in choosing the right one for your requirements in the

A sturdy tripod is an essential piece of equipment. However, an alternative to carrying a heavy tripod may be found by attaching a bag filled with stones or soil to the centre column of a medium-weight tripod, so achieving a lower centre of gravity and added stability. This may be done by forming a hook from metal. The hook can then be attached to the centre column with a hose-clip.

first place! This soft type of bag does, however, seem to offer nearly the best of everything. Except a seat!

Finally, another piece of equipment that is rarely given enough attention is the tripod. We all know that they are a nuisance to carry around, but a good sturdy, and preferably heavy tripod is a sound investment. If you are unable to persuade someone to carry it for you, buy a tripod bag or an outfit bag that features tripod straps. Another alternative to carrying the extra weight of a really robust tripod is to use one that is sturdy but not too heavy, and then adapt it so that you can hang a weighted bag from the base of the centre column. You should not find it difficult to glue or fasten a hook of some sort to the centre column, and you can then carry a lightweight bag with you, which can be filled with stones or soil, etc when necessary. This eliminates the problem of otherwise quite steady tripods which vibrate or even move in strong winds.

FILTERS

The chart below lists various filters and their applications in creative monochrome photography.

Filter and Factor	Effects and Applications	Exposure Increase
Yellow ×2	Will lighten yellow and orange while darkening blue to provide contrast between clouds and sky to the level seen by the human eye.	1 stop
Orange ×4	Lightens orange, red and yellow, while darkening blue and green. Noticeably increases contrast, and considerably darkens blue sky. Good haze penetration. Brings out the grain of many timbers and will lighten old or stained masonry.	2 stops
Red ×8	Lightens red and orange. Darkens green, and blue almost to black. Provides extreme contrast and dramatic dark sky in landscapes with very good separation of clouds. Lightens Caucasian skin tones in portraits to almost white. Provides a high level of mist and haze penetration.	3 stops
Green ×3	Lightens green and slightly lightens yellow. Darkens red and blue. Slightly darkens orange. Provides better detail in green foliage. Will make tanned skin tones slightly darker.	1½ stops
Dark Green ×6	Will considerably lighten green while darkening red and orange. Useful for photography in forest areas where it will lighten foliage, while turning some tree barks darker. Will turn tanned skin very dark.	2½ stops
Blue ×6	Lightens all shades of blue or violet. Dramatic darkening of red and orange. Slightly darkens yellow and some greens. If used in misty or hazy conditions can produce 'mysterious' effects with its emphasis of mist. Turns red lipstick almost black.	2½ stops
Polariser no fixed factor	Can be used to darken a blue sky providing the sun is at a suitable angle. Extremely dramatic black skies can be obtained when combined with a red filter. Very useful for eliminating reflection from glass, water and other reflective surfaces.	various

EXPOSURE-METERS AND USER TECHNIQUE

Although the current state of technology in the design of exposure-metering systems now incorporated into many modern cameras makes it possible to obtain satisfactory results almost every time, there is still much more to obtaining 'correct' exposure than merely pointing a camera at the subject and accepting the camera's reading as being right. Any exposure meter, no matter how sophisticated and accurate it may be, is still only a mindless instrument, and will require intelligent use by the photographer to obtain optimum results.

Types of Meter

An understanding of the different systems which are available, how they work, what they do and how to use them, is essential if you are to acquire the ability to achieve full control over exposure problems, and subsequently to improve your ability to obtain greater creative control over your photography.

All exposure meters consist of a light sensitive cell or cells which measures the amount of light falling on the photo-electric cell and transfers this measurement either directly into shutter speeds and apertures or, sometimes, into a reading on a scale, which is then converted into suitable shutter speeds and apertures according to the speed, or sensitivity, of the film in use. There are four different types of light-sensitive cell in common use;

these are the *Selenium cell*, which requires no batteries to operate it and functions from a small electric current generated by the light falling on the cell. This current is measured by a sensitive galvanometer, and the measurement is then displayed as a reading of light intensity on a scale by a moving needle. Although this type of meter has, in the past, been built-in to some cameras, it is far too large, and not anywhere near sensitive enough to be used for through-the-lens metering systems. Nowadays, this kind of cell is used only in some separate hand-held exposure meters. However, due to its poor response to low light levels, the Selenium cell has all but given way to other, more sensitive types of photo-electric cell.

The *CdS*, or *cadmium sulphide cell* is very much more sensitive, and its small size has made it possible to fit this easily into cameras. The first of the through-the-lens metering cameras utilised this type of cell, and it is still in general use today. Although it relies on a battery to make it work, it makes up for this in its very high sensitivity with readings being possible even by reflected moonlight. However, it does have some disadvantages, in that it is rather slow to respond to changes in light intensity. This means you must allow a little time for the needle to settle down to a correct reading, particularly when measuring low light levels immediately after bright sunshine, etc. The CdS cell is also somewhat over sensitive to the colour red, which can cause false readings of red-coloured subjects or when photographing a subject illuminated by this colour light.

The *silicon photo diode* (*SPD*) is one of the most modern types of cell available. It is highly sensitive and extremely quick, and adjusts to large changes in brightness with no 'lag.' With its high accuracy and extremely small size, it is now used almost universally for cameras featuring through-the-lens

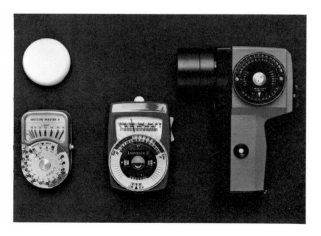

Three types of hand-held exposure meter: from left to right *Selenium meter* with separate invercone attachment, *CdS meter* with built-in invercone, which either slides into position over the light sensitive cell to provide incident light readings or to one side of the cell to provide reflected readings, *Hand-held spot meter* featuring reflex viewing and a (one degree) angle of measurement.

metering systems. The SPD cell, as it has become known, does not suffer from the colour bias problems associated with the older CdS type cell, and so it is suitable for use under almost any condition.

Finally, the only other type of photo-electric cell in common use is one of the latest. The *gallium photo diode*, or *GPD*, although not used in very many of the production cameras, does offer much the same virtues as the silicon cell but with even quicker responses.

TTL Systems

Through-the-lens metering, which is featured on most SLR cameras in current production, uses the actual light which passes through the camera lens to assess exposure. There are, however, in use today several different ways or methods in which this light is read. These are the average reading system, in which all the light which passes through the camera lens is read. This is achieved by (usually) two cells situated in the prism housing, which measure the brightness of the entire focusing screen. This measurement is then 'averaged' to produce a suitable exposure. However, as this method does not take into account the position or proportions of light or dark areas in the scene, unsatisfactory results often occur with this type of system. The problem is that not many subjects or scenes have their light and dark areas distributed evenly throughout the picture area. It is often necessary to move in close to the subject in order to obtain a useable exposure meter reading with this system, thereby using the camera's meter almost as a separate hand-held meter.

Centre-weighted systems are a better alternative, in that it is not always necessary to move quite so close to the subject matter to obtain selective meter readings. In many cases, quite satisfactory point and shoot results may be obtained with this type of system. The photo-electric cells in such systems are situated so that, whilst they do read – in most cases – the entire focusing screen, prominence is given to a central area which, in camera manufacturers' theory, is where the subject is most likely to be positioned: in practice, for the creative photo-

grapher at least, this is rarely the case, and it is still often necessary to take very much more selective readings than those afforded by point and shoot techniques.

Of all the built-in through-the-lens metering systems spot-reading systems probably offer the ultimate in creative control over exposure, although they are not quite as suitable for automatic, or point and shoot situations.

This kind of metering system takes its reading only from a central circular area of the focusing screen, and this is usually indicated by an engraved circle in the middle of the viewfinder. The remainder of the field of view has no effect whatsoever on the meter readings obtained from this central portion, so very selective readings can be taken by this method. However, a good knowledge of exposure metering technique is required to obtain accurate

Comparative areas 'read' by different SLR through-the-lens metering systems.
A) Integrated or averaged method, which takes a reading from the entire area of the camera's focusing screen.
B) Centre weighted systems still measure light across the whole screen, but take a higher proportion of their reading from a fairly large central area. This central area is often positioned slightly low in the format to compensate for bright areas of sky, etc.
C) Spot reading systems use only an area from the centre of the focusing screen to provide a reading, and this is usually marked by an engraved circle.
D) For comparison, this is the view through a hand-held spot meter. Readings are taken only from the very small engraved circle in the centre of the screen. This usually represents only a 1° angle of acceptance, providing highly selective readings.

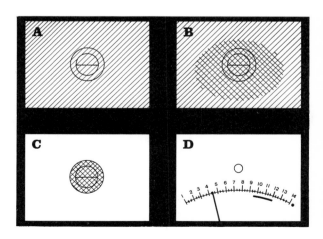

and consistent results with this type of system.

Although this system is called *spot metering* this is not quite true. The engraved circle of meter sensitivity in the viewfinder is really quite large; particularly so, when the subject matter is some way from the camera or when a wide-angle lens is fitted to the camera. A true spot meter, which is a separate hand-held device, reads a very much smaller area than this, and a more accurate description of a built-in type 'spot-metering' system would perhaps be a selective-metering system.

A very recent development of this type of system is multi-spot metering. In this type of system several very tiny spot readings are taken from different areas of the focusing screen and a 'mini computer' then calculates the optimum exposure for that particular range of readings. This would, however, appear to be just another – albeit superior – form of averaged reading.

Advantages of a Separate Meter

Many advanced photographers make use of a separate hand-held meter which, if used intelligently, can provide the ultimate in control over exposure. There are several different makes and models available around the world of this type of meter. Some still use the older selenium cell, which has an advantage in that it does not require a battery and so is very unlikely ever to let you down. It will also keep on working properly in temperatures or conditions where other meters either fail completely or else operate less efficiently. Other meters make use of the CdS, or cadmium sulphide cell, which does require a battery, but is far more sensitive, or the latest silicon cells which are both extremely accurate and quick to respond.

Almost all separate hand-held exposure meters offer you the choice of either reflected or incident (measurement of light actually falling on subject) light reading methods, and some even accept special accessories, such as spot reading, enlarging meter, copying and probe attachments.

Without doubt, however, one of the most accurate tools for creative monochrome work is the separate hand-held spot meter. This type of meter usually employs a highly sensitive and accurate silicon cell, and operates through an optical reflex viewfinder system, providing a viewfinder display similar to that found on most SLR cameras.

A very small central circle is engraved on the screen, from which the meter readings are taken, and as this usually takes in an angle of only one degree extremely accurate readings can be obtained from very small areas of the subject or scene. The reading is displayed as a value, on a scale by a moving needle, which is then transferred to a dial which will indicate a range of shutter speeds and aperture combinations. Some such meters, however, read directly to f-stops, having first been programmed with film speed and required shutter speed information.

Although these types of meter *do* provide the ultimate in precision metering, they tend to be rather slow in use and are therefore not particularly suitable for moving subjects.

Using Meters Successfully

In order to obtain the optimum results from any exposure meter, whether of the through-the-lens

Exposure meters are calibrated to translate any tone or light intensity received into a reading which will produce a negative density that, in turn, will reproduce in a final print as an 18 percent mid-grey. Whether a reading is taken from a white tone or a black tone, the meter will simply indicate less or more exposure to bring this tone to the 18 percent mid-grey.

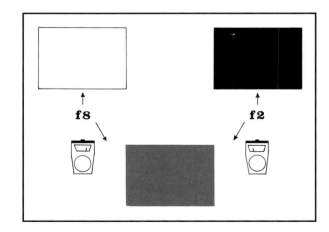

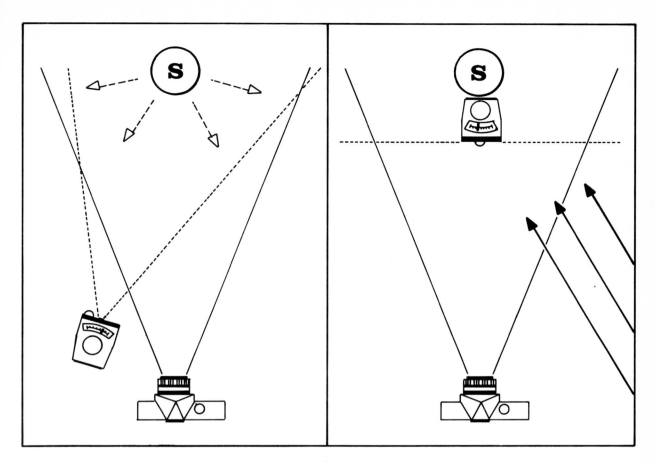

type or any of the separate hand-held types, it is first necessary to have a clear understanding of what an exposure meter does, why and how it translates the light intensity it reads.

Whenever a meter is used to take a reading of a scene or subject – whether that scene contains a full range of tones from bright highlights to deep shadows, or only one single tone – the meter will measure the intensity of light reflected and record a value, or f-stop/shutter speed combination which will, in theory, produce a negative density that will print to an 18 percent mid-grey. This applies whether the reading is taken from a very dark tone or black, or a white or very light tone: the meter simply indicates more or less exposure accordingly. Consequently, if the indicated meter readings are followed without any modification, black and white will both reproduce as grey from respective readings taken from these tones. In order to obtain correct renderings from these tones

Illustrated on the left is the normal method of taking a reflected-light exposure meter reading. Note that the invercone dome is positioned to the side of the light sensitive cell so that the cell directly receives light reflected from S, the subject.

On the right is the normal method for taking an incident light reading. In this case the invercone is placed over the light sensitive cell and the meter is positioned close to the subject, pointing back towards the camera, which means that the light the meter receives through the invercone is the same as that falling on the subject.

it would be necessary to give less exposure to that indicated for the black or dark tone, and more for that indicated for the white or light tone. With this in mind, close up or selective readings should be taken from a subject tone which you wish to record in your print as an 18 percent mid-grey and this, in effect, is the first choice open to the creative monochrome photographer – the ability to select a tone, knowing how it will reproduce on the final print.

An 18 percent mid-grey card can be purchased

This picture illustrates the effect of exposing to obtain full detail in the shadow areas. This produces a result similar to that 'as seen' by the eye.

Simply by decreasing exposure, or exposing for the highlights, a very much 'thinner' negative is obtained, producing a much darker, more dramatic effect.

from most photographic shops, and it can be used to obtain accurate exposure for subjects containing many tones, where it might otherwise be difficult in actually deciding precisely what tone to take the exposure meter reading from. A reflected light reading taken from the mid-grey card, when placed in a corresponding position and similar lighting conditions to the actual subject, will provide a very good general exposure and will reproduce those tones present in the subject almost 'as seen' in the final print.

A very good and accurate alternative to this, and one which will ensure correct exposure for the highlights, is to use the incident light reading method. For this you will need a separate hand-held meter with an invercone attachment – a white translucent dome which covers the cell. This method measures the light actually falling on the subject, rather than that reflected from it. For this type of reading it is necessary to take the reading from the subject position, with the meter cell

covered by the invercone and pointing towards the camera position. If used correctly, this type of metering method will provide very accurate general exposure readings under difficult situations.

These more general methods of measuring light intensity do not, however, provide much potential for creative control of exposure, and for this reason it is an advantage to have at least an understanding of the *Zone System* which was developed by that great American photographer, Ansel Adams.

Ansel Adams applied the principles of sensitometry to everyday photography and developed a system in which the tones recorded by a photographic film were divided into ten distinct and separate zones, each zone corresponding to one f-stop difference in exposure between the preceding or succeeding tone. These zones range from Zone 0 which is pure black with no detail, to Zone 9 which is pure paper-base white and once again has no detail. In between these two extremes are a further eight zones. You will see from the zone system chart (opposite) that Zone 5 represents the same tone as the 18 percent mid-grey card mentioned earlier, and it is this zone to which your exposure meter, whatever its kind, will translate a reading of any particular tone that you make. Simply put: it matters not whether your meter reading is taken from black, white or any tone between, your meter will indicate a suitable exposure to place that tone on Zone 5.

Now, the control that you, the photographer, have is an ability to determine how you wish the tones of your subject to record in your final print. Achieving this is really quite simple, if you remember that the tone or part of your subject from which you have taken your exposure reading will (if unmodified) always print to Zone 5; knowing this, you can move this tone either up or down the scale, to lighten or darken it, in precise steps.

So, if you close the diaphragm of your lens to one f-stop smaller – say f16 instead of an indicated f11 – you will darken this tone or part of your subject by one zone. The same effect can be achieved by selecting one shutter speed faster than that indicated, say 1/500th second instead of 1/250th. In the same way, it is possible to lighten this tone by

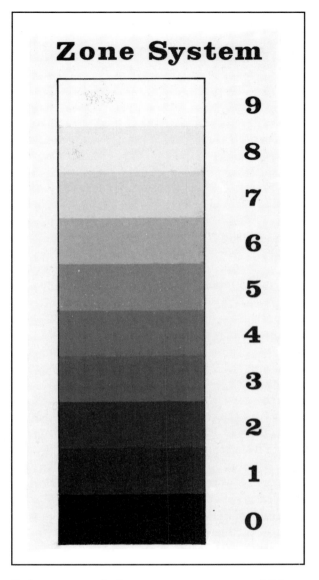

Each separate zone in the zone system represents one full f-stop increase or decrease in exposure. Zone 5 represents the 18 percent mid-grey that exposure meters are calibrated to produce and, bearing this in mind, it is quite a simple matter to place a selected tone of your subject on a specific zone by adjusting the indicated reading of your exposure meter.

O solid black. *1* almost black, just noticeably lighter than zone O. *2* very slight texture but nothing recognisable. *3* dark shadows, showing the first signs of recognisable shadow detail. *4* average shadow tone on Caucasian skin. *5* mid-grey 18 percent reflectance. *6* light grey with full detail, normal value for Caucasian skin tones. *7* bright areas with detail, fair skin. *8* lightest tone with any detail. *9* detail-less white, almost the same as unexposed printing paper.

selecting a larger aperture – f8 instead of f11 – or by using a slower shutter speed – 1/125th instead of 1/250th. Each f-stop of increased or decreased exposure from the one originally indicated by the meter will move that tone, one zone at a time, up or down the scale. The same will apply to each increase or decrease in shutter speed duration.

For example, suppose you were to take an exposure meter reading from a dark area in which you wished to retain some detail in your final print. You will see from the zone system chart that Zone 3 might be the correct choice of tone for this result. Your meter, however, will have indicated an exposure which will print this as Zone 5 which is too light for the effect required. You will see that to obtain the 'correct' exposure (to enable this tone to print to the required Zone 3) you will have to give two stops less exposure, thereby moving the tone down the scale by two zones. So, if your indicated exposure was 1/125th second at f4, you would now expose for 1/125th second at f8. Alternatively, you could alter the shutter speed instead and expose for 1/500th second at the original aperture of f4. Both of these actions, or indeed, a combination of altering both the shutter speed and aperture settings, will have the desired effect, and you will obtain a negative density which will print that tone to Zone 3.

Of course, it is important to remember that these modifications will change the entire range of tones present in the picture, so it is imperative that you do at least consider what will happen to the other tones before committing yourself to an exposure which, although providing the correct tone for the particular part of the subject or scene you have metered for might cause problems elsewhere; resulting, perhaps, in either burnt-out highlights or blocked-in shadows.

Another example, if you meter for a particular part of your subject and decide that it should record on Zone 6, this will obviously require you to give one f-stop more exposure than that indicated by the meter. Now, suppose you have an important highlight detail which will ideally print to Zone 8, then the action of increasing exposure by one f-stop to move your prime subject tone into Zone 6 will now result in the important highlight detail being shifted up the scale into Zone 9, which is pure paper-base white, with no detail whatsoever. Fortunately, a satisfactory method for controlling this can be found by making use of the different grades of printing paper available.

We probably all appreciate that a harder grade of paper is used for printing from a soft negative, and a soft grade of paper for a contrasty (hard) negative, but these different grades of paper can also be used to compress or expand the tonal range of the negative. Although you will have to carry out some experiments with your own particular make of printing paper, in general, it can be said that a one grade harder than normal paper will give an expansion of approximately one zone, and a paper one grade softer will provide a similar amount of contraction. Although this system does not work so well as controlling contrast by individual negative development, unless you are using cut film and processing each piece of film separately then it is the only working alternative available. After all, it is not possible to develop a whole roll of film containing several exposures, perhaps of different subjects, and still give individual consideration to each of the exposures! However, the paper grade technique allows a fair degree of control.

To complement these techniques, the separate hand-held spot meter is the ideal creative tool. With its narrow, one degree angle of acceptance, it can be used to make highly selective exposure readings from various parts of the subject or scene, thereby enabling you to ascertain how the various elements of the scene will record in your final print, and precisely what will be the effect on the other tones when altering one particular key tone.

An understanding of the preceding techniques, even if you do not follow these through completely, will greatly improve your ability creatively to control your exposures. The most important thing that such a system can offer, and its real value, is the ability it will give you to pre-visualise the effect you wish to achieve. To be able to view a scene, and visualise in your mind how that scene will reproduce in your final print is an immense step forward in achieving controlled, or pre-planned creativity.

2
USING A STUDIO

The very essence of studio photography is total creative control over lighting, background, props and, ultimately, the finished photograph. Don't look on the studio – home, club or professional – as merely a means of being able to take pictures when the sun no longer shines, or a convenient place to take a few glamour shots or portraits. The studio is a tool for creativity, and as such is a means of extracting further pleasure and satisfaction from photography.

Many people imagine a studio as being of enormous proportions, with batteries of lighting equipment and vast amounts of other expensive kit. Well, perhaps one or two of the top professionals' studios are rather like this, but it is still quite astounding the creative results that can be achieved with a small, relatively inexpensive but well thought out set up.

It is not necessary to have lots of lighting equipment, as good creative results can easily be achieved with a single light. In fact, it can be an advantage to start with just one light and perhaps a reflector, learning how to use these to create good pictures, before spending lots of money on other equipment. In this way, experience can grow and you can add further lights to the studio as and when you have developed your ability enough to be able to make good use of them.

CHOOSING A SUITABLE ROOM

Almost any reasonably-sized room can become an improvised studio, and if you are fortunate enough to have a spare bedroom or whatever, then you may be able to commandeer this as a more permanent studio. A suitable room size is about 3×4 metres $(10 \times 13$ feet$)$ or larger. If you are forced to work in a studio much smaller than this you will have problems with full length shots of people, and your pictures may well suffer from harsh lighting, with the added problem of unwanted shadows on the background or walls due to the lights having to be positioned too near the subject or the subject not being positioned far enough away from the background. The room should also be long enough to allow you to use a short-to-medium focal length telephoto lens, as this gives a more pleasing perspective to portraits.

Although, for the creative monochrome worker, the colour of the room is not too important, if you *are* fortunate enough to have a spare room for your studio use then it can be an advantage to decorate this in as dark a colour as possible. Dark grey (or black) is probably the best choice. It is also an advantage to have some way of quickly blacking out the windows. Although some photographers prefer to work in a white studio, this tends to produce far too many reflective surfaces with subsequent loss of lighting control. It can be far better to start with a darkened studio, and then add light as and when required. In this way it is easier to build up your lighting effects. Don't worry if you have no choice but to use a room which is in general use, much creative work is carried out in just such surroundings and the room colour will have no real effect on monochrome materials. Simply by blacking out the windows, you will still have the potential to build

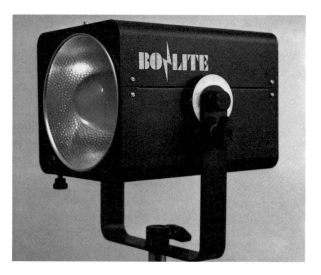

Studio flash unit. Not all studio flash is expensive, and models such as this Bowens Bolite provide a versatile, relatively inexpensive start to a comprehensive studio flash system. A good range of accessories are available, including barn-doors, honeycombs, brollies, diffuser screens, etc, and Bowens even produce an extremely accurate flashmeter, at relatively low cost, specially for the Bolite system.

This is a fairly typical control panel for a studio flash unit. This model includes flash on/off switch, modelling lamp on/off switch, full/half power settings with proportional modelling lamp, built-in slave cell for multiple flash, and provision for fitting a remote slave cell.

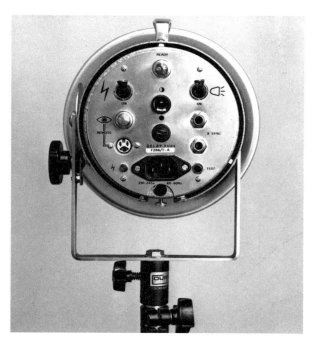

up your lighting. With the availability nowadays of black opaque plastic sheeting it should not prove difficult to make a black-out of this material stretched across a light timber frame, or even to make or purchase roller blinds made from a similar material.

It is – if at all possible – best to avoid rooms having 'deep pile' (shaggy) carpets, as this can lead to all sorts of problems: background paper will tear and split as soon as anyone walks on it, while lighting stands and other equipment may well be somewhat insecure or easily knocked over. The best type of floor covering is a smooth but non-slip vinyl, or corded carpet.

EFFECTIVE LIGHTING

Tungsten or flash? Although in the first instance tungsten may seem to be the cheaper and easier alternative it has a number of disadvantages. First and foremost, you must consider the state of the wiring in your home. It does not take that many tungsten lights to accumulate quickly the capacity of a fuse in a domestic plug and, in winter when you may well be using other appliances to heat the house, you could find that you require a separate 30 amp ring main. To ignore this would be very dangerous!

Furthermore, tungsten lighting usually requires comparatively long exposures, so most subjects will have to remain fairly still. Also, in a surprisingly short modelling session, tungsten lights will generate an enormous amount of heat, making the studio very uncomfortable for both the model and the photographer.

Studio flash does offer vast advantages over tungsten lighting. It is relatively safe, with the modelling lamps fitted to most units being of very low output. It is cool and pleasant to work with, emitting very little heat from the modelling lamps and, above all, the effective exposures with flash are extremely brief, eliminating the problems of subject or camera movement almost entirely.

Although studio flash equipment can at first seem very expensive, it requires very little main-

tenance once it has been purchased, and the running costs are comparatively low. The very expensive high output systems are not necessary for the amateur photographer, as small apertures can be obtained by using the latest technology film stock, which is incredibly fine grained for its speed. Extremely fine grain results can nowadays be achieved with ISO 400 films of the chromogenic type.

Studio flash does have some disadvantages, however, in that it is necessary to wait after each exposure for the flash unit or units to recharge. Fortunately, in practice this does not cause too many problems as most modern studio flash heads are capable of recharging within one to three seconds. The only time this may become a problem is when working with a winder or motor-drive unit fitted to the camera.

In real terms, the only serious disadvantage of studio flash is that it is only possible to control exposure by moving the flash heads nearer to or further away from the subject, although many of the units available today do have provision for cutting the power of the flash, some by only a half, others by half and three-quarters. This facility is a useful means of allowing the selection of larger apertures for differential focusing, etc.

Most modern studio flash units have modelling lamps fitted, so that the photographer can assess the lighting effect while setting up and prior to actual exposure. Although these are nowhere near as bright as photographic tungsten lamps, they are adequate for the purpose. Most units with a facility to cut down the power of the flash also feature proportional cut down of the modelling lamp, which allows you to preview the lighting effect more accurately.

One extra item of equipment that you will require if using studio flash is a flash meter. This is an exposure meter which is capable of reading the light from the short duration of a flash tube. There are many models available in different price ranges, and they all read light by the incident method – that of the light actually falling on the subject – and provide extremely accurate results. The flashmeter, which is usually connected to one of the flash units via a synch lead, is positioned in the sub-

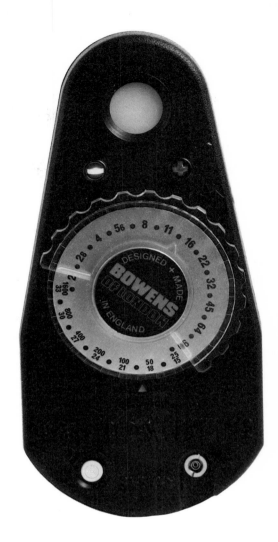

This is a typical flashmeter, which is essential for accurate exposure when using several flash units. It takes its readings by the incident light method but, unlike most normal exposure meters, is capable of measuring the very short duration of flash.

ject position facing the camera. The flash is then fired by means of a button on the flashmeter, and a reading is taken. Accurate results will be obtained even if several other flash units are fired at the same time with the aid of 'slave cells', which are sometimes built-in to flash heads or else can be purchased as an accessory. Many flashmeters have available (as an extra) a separate synch lead which can be used to fire small portable flashguns, as used on a camera, and these can be useful for supplementary lighting, for backgrounds, hair lights, etc.

Reflectors

Reflectors are used with both tungsten and studio flash, for without them the light from either a bulb or flash tube will radiate in all directions totally out of control. The prime function of any reflector then, is to direct light in a controlled manner, and as efficiently as possible, towards the subject. This will, of course, depend to a great extent on the subject requirements, in that a group of people will require a much wider spread of light than a single person or object. Consequently, a reflector which spreads the light over a 45 degree angle will provide a much higher level of brightness than one that covers an angle of 90 degrees providing, of course, that they are both used with an identical light source. They may both be considered equally efficient in that they are designed to do different jobs.

Types of reflector commonly used with tungsten or photoflood lamps. The smaller the reflector, the harder the light quality. The bigger reflectors produce softer light, and some of these larger reflectors feature a small conical dome suspended on wires in front of the lamp itself, so that no direct light reaches the subject from the lamp. This produces very soft lighting quality, similar to that produced by a brolly. The actual surface of a reflector influences the lighting quality. A highly polished type produces harsher lighting than a matt type.

Perfectly adequate reflectors can be constructed from a covering of fabric stretched tightly over a light timber frame. A simple free standing base can be made by adding two cross pieces of timber at the bottom. A fairly thick material having a matt white surface probably makes the most useful type of reflector, one which can be positioned at will to throw light back onto the subject to fill-in either unwanted shadows or else shadows which are otherwise too dark. It can also be very worthwhile to make one (preferably two) black reflectors. These can be made in exactly the same way as the other, but using a black fabric that absorbs light – black velvet being the ideal choice. These are very useful for 'taking away' light from where it is not required: in the case of light over-spill, for example, or perhaps if light is bouncing back, from a light coloured wall, onto the side of a subject where you do not require any light.

The Quality of Light

The actual quality of the light, the hardness or softness, can also be controlled by the choice of reflector. A reflector with a smooth and polished (or silvered surface) will produce hard lighting with

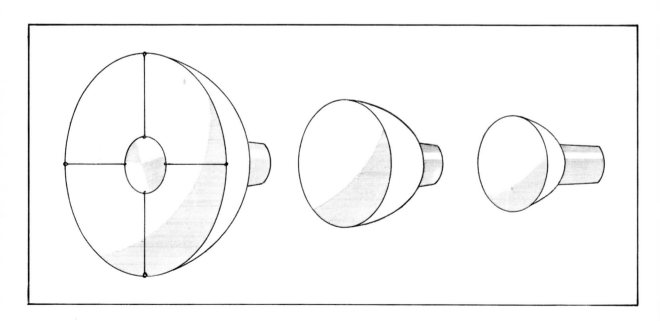

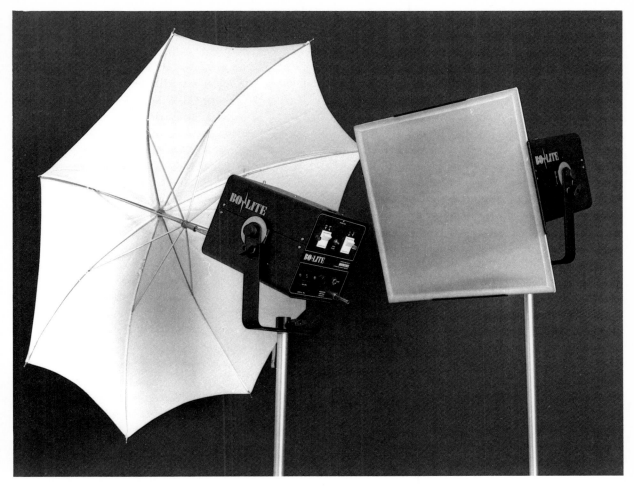

harsh, well-defined edges to the shadows and will reflect the maximum amount of light, while a reflector with a dimpled white enamel finish, or matt aluminium surface, will provide a much softer lighting with a greater level of dispersion. Although this will reduce the output of the light source, it has the advantage of providing very soft shadows with no hard edges. Further softening can be obtained by using a large shallow matt type reflector with a cap, or mini-reflector, positioned in front of the actual light source. In this way, no direct light whatsoever reaches the subject, and the lighting will be totally diffuse.

To create even softer results, an umbrella may be used in front of the lamp or flash tube. With the lamp facing away from the subject, the light is then reflected back from the umbrella onto the subject.

The quality or characteristics of the light from studio flash may be modified by fitting accessories to the flash heads. Illustrated are two commonly used accessories, a plain white umbrella (brolly) and a diffusion panel. Both will soften the quality of the light.

When a white umbrella is used, the lighting quality will be extremely soft and almost shadowless. An umbrella having a silver reflective surface will provide a slightly harder light, with a little more 'life' to it. Lighting quality is very dependent on the relationship in size between the light source or reflector and the subject. The larger the light source or reflector is in relation to the subject, the softer will be the light. However, this is more effective with a large diffused light source than with a reflector. A diffused source can easily be achieved by

27

positioning a large screen of diffusing material – tracing paper or frosted perspex – between the actual light source and the subject. In this way, the diffusion screen virtually becomes the light source, and the larger this screen the softer will become the light. Professional studios use purpose-made lighting units for this effect, known as soft boxes, fish fryers or window lights.

Extremely hard and directional light is provided by a spotlight. The professional versions of these are quite expensive as they often have a focusing optical system incorporated in their design which enables a very sharp and tightly controlled beam of light to be thrown onto the subject, thus providing very precisely defined shadows. A cheaper and fairly satisfactory substitute can be found in a conventional slide projector if you are working with tungsten lighting. Alternatively a black 'honeycomb' attachment can be purchased for many studio flash units which will provide a similar effect.

Inexpensive free-standing reflectors are very easy to build. Simply make a frame from timber batten, over which is stretched a fabric covering. This may be either black or white fabric. Two of each type will cover most of your studio requirements.

Some purpose made reflectors may be fitted to lighting stands to provide maximum versatility. These types of reflectors have the advantage that they may be adjusted for both height and angle.

Other Useful Accessories

Besides the black honeycomb, there are several other useful items of lighting equipment which can make your basic outfit more versatile. A silver honeycomb will provide highly directional but diffused lighting, while a barn door attachment can help you to keep the light from reaching or spreading onto parts of the scene which you don't require to be lit. Another useful item is a conical snoot, which is like a tapered tube. This fits over the light unit to provide a pool of light similar to that provided by a spot light. However, it is not possible to focus this pool of light, and in order to increase or decrease its size it is necessary to move the light nearer to, or further from the subject.

Lighting stands should be given special consideration. Never try to support heavy lighting units on an insubstantial stand as this can prove disastrous. Not only do you risk breaking a lighting unit, you could also easily end up seriously injuring a model, and possibly even being sued for damages. Stands should be thoroughly checked for security and, if possible, it is preferable to purchase the correct stands for the lighting units you use.

A boom arm is an extension of a lighting stand and allows a light to be positioned above the subject on a projecting arm. This permits the use of a 'top light' without the stand being evident in the final photograph.

Special stands can be purchased to support a roll of backgound paper. Although some such systems are large, complicated and highly expensive, there are also some relatively cheap, very compact and simple to use background support stands available. These smaller units also have an advantage to the occasional user that they are easily dismantled and stored when not in use. Stands and background rolls are available in sizes from about 1 – 4 meters (4 – 12 feet) wide.

THE STUDIO IN USE

Best results are obtained when a studio is used to create a pre-planned and well thought out picture or series of pictures. It is rarely rewarding to arrange a studio session with little or no idea of what you are going to do, or what pictures you want to produce, and this habit can often cause a certain amount of disappointment with studio work. The studio will not produce pictures by itself; it needs you, the photographer, to control it and manipulate it to help *you* produce the pictures. All the equipment and those accessories mentioned previously are only tools to adequately assist *you* in *your* work.

With this in mind, there is no point in me describing to you how you should actually take *your* photographs. It is, however, important to stress that you should have thought about the session before starting and have a clear idea of the picture or pictures that you would want to produce. Once you have this in your mind, use your lights and other equipment to build to the required result. It is simply not necessary to have dozens of lights blazing away and, in fact, this can confuse the issue. Virtually all lighting situations require the use of just one main light – the key light – and sometimes this may be the only light that is necessary. If it is, then leave it at that, and don't be tempted to

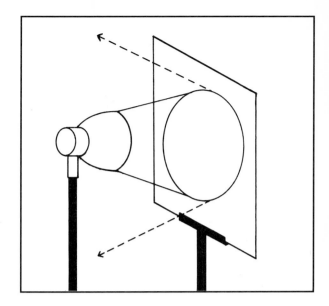

It is not really necessary to spend a fortune on special accessories in an effort to control the quality of light from either studio flash or tungsten lights. Any light bounced off a piece of white card will produce a soft lighting quality, and it is usually a simple matter to attach such a piece of card to a spare lighting stand.

In much the same way, it is a simple matter to make up a diffusion panel from a lightweight timber frame covered with tracing paper, which can then be mounted on a lighting stand. A light directed through this screen will be very soft, but somewhat more directional than that obtained from a reflector.

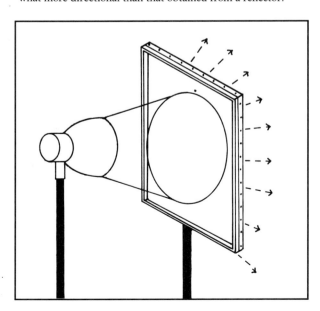

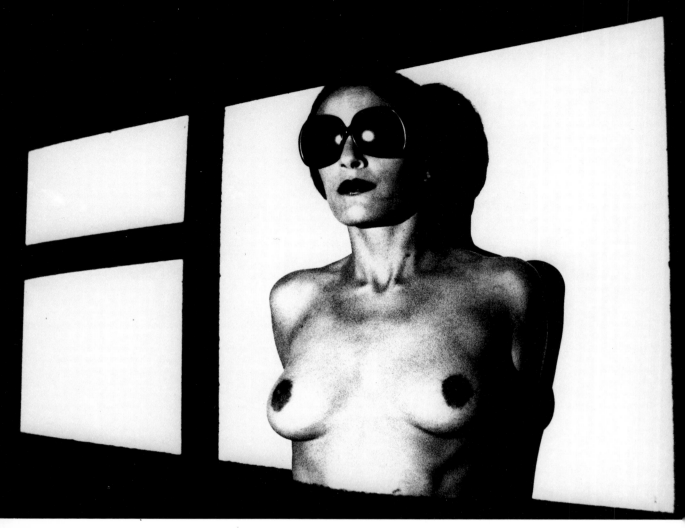

An ordinary slide projector can be used to provide a useful alternative to an expensive spot-light, and can be extremely useful for lighting small objects, or may be used with a slide 'mask' in the projection gate to throw interesting patterns onto a background.

This picture was produced by making a window shape out of black insulation tape affixed to the outside of a glass transparency mount. The model was positioned against a white wall, and this 'mask' was simply projected onto her.

add further lights just in case, or for the sake of it. If other lights are required, these will usually be fill-in or effect lights. Once again, use them carefully, and don't overdo it. Fill-in can often be provided by an additional reflector rather than a light and, more often than not, this will be preferable. It is, after all, far easier to achieve a balanced and natural lighting effect with a reflector, for this provides proportional fill-in, in relation to the bright-ness of the light source and the distance from the subject at which the reflector is placed.

Black reflectors, or light absorbers, are a very useful means of adding shadow depth to the unlit side of a subject. They can be used to provide a similar lighting effect to that seen in many news-paper 'glamour' photographs, where the model appears almost as if her outline has been drawn, with dark shadow outlining her form usually against a white background. All that is necessary to produce a similar effect is to evenly light a white back-ground, in front of which should be placed the model, who should be lit by soft light from an umbrella positioned directly in front of her. Black reflectors should be positioned on either side of the model, and quite close to her. This effect can be further emphasised by slightly over developing the

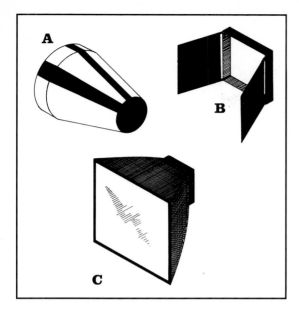

Some of the accessory attachments which are available for studio flash units. These are *A*) conical snoot, *B*) barn-doors, *C*) soft box.

A boom-arm is a very useful accessory, which permits a light to be positioned above and close to the subject, without the lighting stand encroaching into the picture. This is essential when a top light, or hair light is required.

A relatively inexpensive background system can be found either by purchasing a specially adapted lighting stand, or by making a suitable adaptor yourself. Plastic gutter is ideal for this purpose, and has the advantage of being extremely lightweight.

film, and printing on a harder than normal grade of printing paper.

When other lights are to be used for effect lighting, they are best kept to a minimum. They will most often be used to provide a hair light, which will give extra life to what could otherwise be dull hair, or for a rim lighting effect – when a light is placed immediately behind the subject to produce a halo or outline rim of light around the subject. An additional light can also be used to throw an interesting pattern onto a background. This can be achieved by placing a cardboard cut-out of the required pattern in front of a light, and projecting this onto the background. Quite often, a 35mm projector can be used for this purpose. Shapes or patterns may be cut from black self-adhesive vinyl, or insulation tape, and stuck to the glass of a transparency mount. This can then be projected – and focused or defocused as required – onto the background. You must be careful to make sure that your main lighting set up does not wash-out this effect.

Finally, never throw away any props or effects that you have used, as you will be surprised how useful these can prove for other pictures. It is often possible to produce entirely different results using many of the same props over again, or else you may wish to build up a set of pictures on a similar theme.

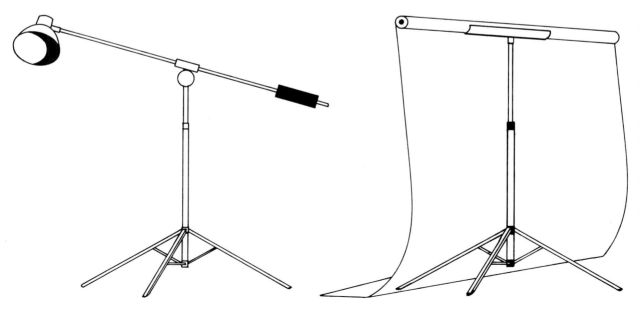

3
MASTERING
THE DARKROOM

In order to produce consistently creative mono-chrome images it is necessary to be in full control of the situation from beginning to end, and processing and printing are very important stages in the progress from initial conception of the idea for a picture to the final print. Indeed, since it is possible

This enlarging focusing device permits very accurate focusing of a dim negative image on the enlarger baseboard. A built-in, high power magnifying optical system magnifies the image to such an extent that it is possible to focus on the actual grain structure of the negative's emulsion.

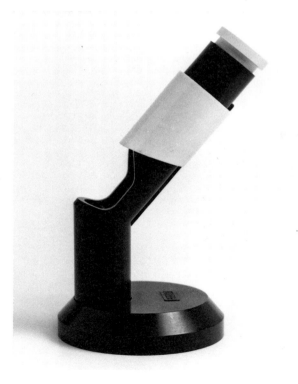

to exercise considerable control over the final image during this stage, it is every bit as important as the original taking of the picture. Developing and printing merely complete the repertoire of skills required to produce creative and imaginative images. It must, however, be stressed that darkroom tricks, no matter how clever they may be in themselves will never compensate for poor photography at the taking stage, and it is not advisable to try to make something of a poor picture by such methods. Good darkroom technique really comes into its own when it is used as a continuation in the process from taking a *good* picture to producing a *good* print, and the best work usually results from knowing how the finished picture will look before you take it, not after you print it!

If you learn the techniques well enough you will be able to apply your knowledge of darkroom work to your photographs, as you take them. In this way you will develop the ability to expose for a certain effect, use the correct film and develop it to enhance this effect, and finally you will have a negative that should be capable of producing the print you 'saw in your mind' when you took the picture.

YOUR DARKROOM AND ITS EQUIPMENT

A suitable darkroom can be set up almost anywhere. Obviously, the more room you have in which to move the better, but it is quite surprising just how little room is needed to set up a workable darkroom. If you are not fortunate enough to have

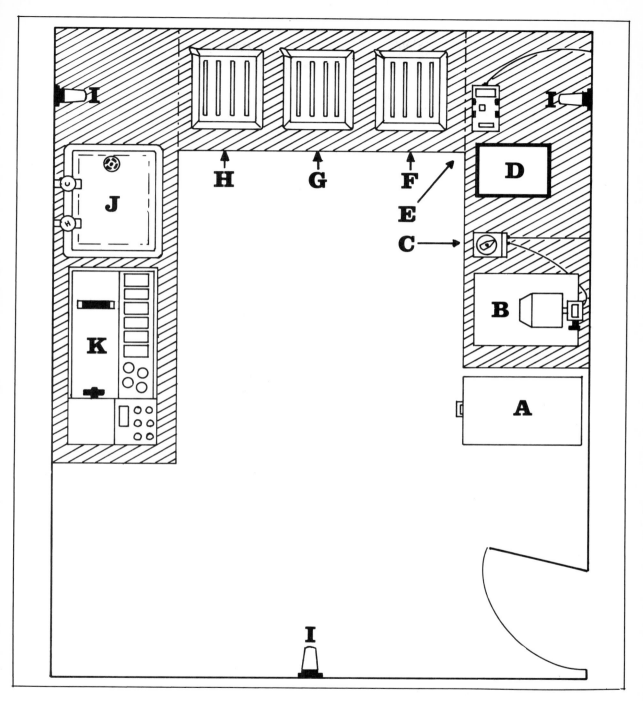

If you are lucky enough to have a spare room which can be devoted to darkroom use, then now is an ideal opportunity to obtain a good working layout. This diagram illustrates how I have set out my own darkroom:

A) Filing cabinet. *B*) Enlarger. *C*) Enlarger timer. *D*) Light-box. *E*) Process timer. *F*) Developer dish. *G*) Stop bath. *H*) Fixer. *I*) Safelights. *J*) Basin with hot & cold water. *K*) Rotary processor.

All worktops are chemical and stain resistant, with plenty of drawer and cupboard space provided by kitchen units which support the worktops.

a small spare room available then it is often possible to black out a bathroom, bedroom, kitchen or any other room which might be used. Although it is certainly preferable to have hot and cold running water present, it is not a real problem if this is not the case, as the only stage in the process that requires plenty of running water is during the washing of films or prints. It is always possible to transport these items to a bathroom once the fixing stage has been carried out. Films will be in a developing tank anyway so these are no problem, and prints can quite easily be placed in a spare developing dish after fixing, so that they can be carried to a suitable water supply without dripping fixer all over the floor. If you do have to utilise a bathroom, make certain that no electrical equipment is used anywhere near the water supply as this can be extremely dangerous. It is always best to try to arrange your darkroom so that you have a dry side, with all the printing equipment – enlarger, timer, etc – on one side of the room, and a wet side, where the print dishes and washing facilities should be situated.

Very little equipment is really needed to enable you to process and print your own work. There is certainly no reason why you should have to break the bank in setting up an outfit which will enable you to produce top quality work. The most important and probably the most expensive item you will require is, of course, an enlarger. It would be foolish to suggest any particular make or model as your choice will depend on several things. Certainly though, a condenser type of enlarger is preferable for monochrome work, as this will enable you to make the most use of the different grades of printing paper. A diffuser type will almost certainly lose you the use of at least one grade of paper, as this type of system tends to print about one paper grade softer than a condenser enlarger and although this can be compensated for during film processing, it is really not the best answer. Obviously, you will have to take into consideration in your choice of enlarger such things as the format or formats that you work in, the biggest size of enlargement that you are likely to require and, finally, the price. You should also consider such things as how steady it is when the

Many enlargers incorporate a facility to rotate the enlarger head through 90 degrees for wall projection, enabling large prints to be produced. If you already own an enlarger and it does not have this facility, you may be able to reverse the head on the column so that the image can be projected onto the floor over the edge of the table or worktop.

enlarger head is at the top of the column, how freely the head can be moved up and down the column, how securely will the head lock into position, and is it possible to reverse or turn the head to enable you to make extra-big enlargements if you should ever wish to? Above all, do not make the mistake of attempting to save money by purchasing a cheap enlarging lens, as this is a false economy. Spend as much money as you can possibly afford on this item, and try to buy a well-known make. You will never regret it! It does not make sense to use a top quality lens on you camera, and then produce your prints with an enlarging lens which only costs the price of a few beers – you will simply not get the benefits of all the design work and technology that went into your expensive camera lens.

To complete your enlarging equipment you will need a timer, and a masking frame or easel. These items are not expensive but you should make sure that the masking frame is capable of doing the job properly. Check that its blades lay flat and that they do not bend easily. Metal frames are far better than plastic ones, which are extremely light weight and, consequently, can easily be moved accidentally. Other useful little items to have handy during a printing session are some pieces of thin but opaque card, and some thin pieces of wire. These are useful for shading or burning-in during printing.

On the wet side, you will require a set of print dishes – if you have to transfer your fixed prints to another room, you will need four of these – and it is best to buy a set of dishes which are one size larger than the prints you intend to produce. This will make it far easier to remove the print from the dish when its time is up: it's also far more hygenic, to say nothing of safer if you purchase a pair of print tongs for this purpose, as photographic chemicals can be harmful to skin and eyes.

Also on the wet side, you will require the following for film processing, a film developing tank complete with film spirals to take the size of film you use (these are available in either plastic or stainless steel, and the choice will be based on personal preference), two or three measuring jugs (preferably to take 1 litre, 2 pints), some bottles in which to keep the various chemicals, and a good accurate 'certified' thermometer to ensure accurate temperature control. Although most monochrome processing is carried out at only 20 degrees Celsius (68F) – which is not difficult to maintain – it can be an advantage, especially during the winter months, to have some form of temperature-controlled water bath. A bowl of water and a fish tank immersion heater should suffice for this purpose. You will also require a suitable sink, bath or purpose made print washer to enable you to carry out efficient washing of your prints; a special device for washing films in their tanks can be purchased very cheaply. With the simple addition of one or more safelights (depending on the size of your room), and a simple timer or stop-watch to time the various stages of

processing, you will be suitably equipped to process and print your own work.

DEVELOPING THE FILM

Note: The films in this book are given in ASA and DIN. For example, 125 ASA/22DIN – this is often given on a film carton as an ISO number in this case, ISO 125/22

Although there are a vast range of monochrome films available, and an equally vast range of developers in which to process them, it is far better at first to standardise and confine the use of these materials to perhaps three different types of film and maybe only one or two types of developer. In this way you will have available a suitable film/ developer combination for almost any eventuality, and by using only these few materials you will quickly learn how to obtain the most from them, and how to exploit their own particular characteristics. Such a range might consist of Ilford Pan F – 25 to 64 ASA/15 – 19 DIN – with very fine grain, Ilford FP4 – 64 to 200 ASA/19–24 DIN – with fine grain, and Ilford HP5 – 200 to 3200 ASA/24–36 DIN – with medium to coarse grain. The only developers required to obtain these speed ratings with these films will be Ilford Perceptol and ID-11.

However, before you start manipulating film speed, etc it is first necessary to be able to process your film satisfactorily to obtain a perfect negative at normal speed ratings. Although details of processing times, etc are provided with most monochrome films and developers that you purchase, these are only a guide and although very acceptable results will certainly be obtained if you simply follow these instructions, the serious creative photographer will require greater precision in order to obtain the perfect sort of negative to suit his or her own taste and equipment. As there are inevitably small differences in such things as shutter or exposure meter accuracy from one camera to another, even with those of the same make and model, and as different enlargers with their various lenses and light sources may produce different print characteristics, it can be an advantage to produce your

own method of film development, tailored to suit your own equipment and requirements. Once this is accomplished, it is another step in the chain of events, from initial exposure in the camera to completed print, where you will be in total control, and knowledgeably working towards a pre-visualised image.

'INDIVIDUAL' DEVELOPING

Load your camera with the film which you use most frequently, and set your camera on a tripod. In front of this, place a Kodak 18 percent grey card, which, as its name might suggest, reflects 18 percent of all the light falling on it. Set the camera lens on its closest focusing distance, and position the grey card so that it entirely fills the viewfinder. It does not matter if the card is not in focus, as only the tone is to be recorded not the fabric of the card. Now set your camera, or separate exposure meter, to the manufacturer's recommended film speed and take a meter reading from this card. If you are using a separate hand-held meter, take a reflected reading from close up. The resulting shutter speed and aperture settings will provide a density on the film which will print to the same tone as the 18 percent grey card: the tone to which your exposure meter is calibrated. Now select an aperture four stops smaller than that indicated – whilst leaving the shutter speed unaltered – and make an exposure at this setting. Then, wind on the film and trip the shutter once more, only this time with the lens cap over the lens, so that you have a totally unexposed frame. Next, you should make another exposure with the lens stopped down a further half a stop, followed by another unexposed frame, and then another, with the lens stopped down a further half a stop (one stop underexposed compared to the first exposure) which should also be followed by another unexposed frame.

You should now make another exposure, this time with the lens opened up by half a stop more than that for the first exposure, followed by another unexposed frame and, finally, one more exposure with the lens opened up a further half a stop.

For example, if your original reading indicated an exposure of 1/60th second at f4, your first exposure should be made with an aperture four stops smaller than this – f16. The succeeding frames should be taken in the following sequence: Frame No. 1 – 1/60 at f16; No. 2 – blank; No. 3 – 1/60 at f16/f22; No.4 – blank; No. 5 – 1/60 at f22; No. 6 – blank; No. 7 – 1/60 at f11/f16; No. 8 – blank; No. 9 – 1/60 at f11. Do not make any further exposures on this film. Now develop your film using your choice of the most suitable developer, for the recommended time and at precisely the correct temperature. When dry, carefully examine the film to find the exposed frame which is only just 'clearly' defined from the unexposed frames. From this you will be able to tell at what speed you should rate this film to suit your own equipment.

For instance, if the film's nominal speed rating is 125 ASA/22 DIN, the equivalent speed ratings for the exposed frames on your film will be: Frame No. 1 – 125 ASA/22 DIN; No. 3 – 160 ASA/23 DIN; No. 5 – 250 ASA/25 DIN; No. 7 – 80 ASA/20 DIN; No. 9 – 64 ASA/19 DIN. Now whenever you use this particular film/developer combination you will be able to set this 'corrected' film speed on your exposure meter, with the knowledge that this will produce the fullest possible range of tones on your film. It will, of course, be necessary to repeat this procedure with any other film/developer combinations you use, but the small amount of time taken to carry out this task is amply rewarded by good and above all consistent negatives.

Once you have the ability to control these basic but most useful materials you will be in a better position to start experimenting to find techniques which will help you. To be successful, all such experimentation must be founded on a secure basic knowledge; otherwise you may find yourself merely groping in the dark and not ever really knowing quite what you are doing, or even precisely what you hope to achieve.

CREATIVE CONTROL

Creativity in monochrome is really all about plan-

ning and controlling your picture taking. A considerable amount of this control for effect can be carried out during the film development stage of the process. However, this can only really be done successfully if your entire film has been committed to a particular shot, or series of pictures, requiring the same technique. It is obviously not possible to process a film in such a way as to obtain different effects for each frame taken on it, and a film which contains many different and varied exposures is best processed in a normal manner.

Provided, however, that you are able to devote an entire film to perhaps only one subject or technique, there is much that can be achieved in the development process so long as it is directly linked to the exposure already selected. It is no good exposing a film at its normal speed rating, then deciding to up-rate it for a 'grainy' effect when it is time to develop the film. These decisions must be taken before you take the picture.

Contrast is one aspect that can be controlled, to some extent, by exposure and development techniques. For example, if you have a subject which presents problems by being excessively contrasty – that is, the contrast range of the subject is too great for your film to handle properly – it can result in burnt-out highlights if you expose for the shadow detail, or blocked-in shadows if you expose for the highlight detail. A way to improve the situation is to slightly overexpose and underdevelop the film. This will lower the contrast to a level where an acceptable print can be made. In similar manner, a scene which is low on contrast (flat looking) can be improved and given some 'life' by slightly over-developing the film to increase contrast. You will, of course, have to carry out some experiments to ascertain how much you can modify contrast in this way with your own chosen brand of film and developer, but by using these methods it is often possible to tailor your negatives to suit a particular subject, or treatment of that subject.

Grain size is another area which can be controlled, or exploited, to some degree. With the right choice of film and developer, coupled with the right exposure and development technique, it is possible to obtain images from those that are almost totally grain free to those which feature grain as an important element of the picture (in which case the grain may be enormous).

A slow speed, fine grain film such as Ilford Pan F may be developed in a developer such as Perceptol to produce extremely fine grain and sharp results capable of being enlarged to 20×16 in without the grain really becoming evident.

A medium speed film such as Ilford FP4 is versatile, in that it can be rated at its normal speed to produce fairly fine grain results in a developer such as ID-11, or it can be processed in Perceptol to produce very fine grain pictures. Although a medium speed film like FP4 can also be *push processed* – where you can rate the speed of the film higher than its nominal speed, and extend development to compensate for the resulting underexposure – this sort of technique will usually increase contrast. This means that there is really little point in push processing slow or medium speed films to produce this apparent increase in film speed, when there are more suitable, higher speed films available for low light work. Ilford HP5 is one such film.

With a nominal speed rating of 400 ASA/27 DIN, Ilford HP5 will produce quite fine grained results when processed in ID-11. These faster, or more sensitive films are, however, extremely versatile indeed. With the right choice of film developer they may be rated anywhere from 200 ASA/24 DIN in a developer such as Perceptol, when it will produce remarkably fine grain for this type of film, right up to speeds of 3200 ASA, or sometimes even higher, when developed for extended times in developers such as ID-11 or Microphen.

These extended development techniques can increase the grain size quite remarkably, and can be used very effectively to enhance mood or atmosphere. It is also well worth experimenting with the use of print type developers for film processing, specially if pushing speed. Acuprint print developer, diluted 1 to 5, for example, can produce very good results with Ilford HP5 film when rated at 3200 ASA/36 DIN, providing good shadow detail while retaining detail in highlight areas, with a very large and prominent grain structure.

There are several different film and developer combinations which can be used either to assist you in achieving the particular result you require or else simply to enhance an effect or mood that you wish to put over in your final print, and a chart is provided here as a guide to these combinations and their effects. However, use them to achieve a result. Don't be tempted merely to try them out on every subject, as this is rarely successful. If the subject choice, treatment and techniques are right, you will produce a good picture but if you don't pay proper attention to any of these stages and fail to pre-plan your result, the entire affair will become very hit or miss, and more miss than hit.

THE PERFECT PRINT

Having now produced the 'perfect' negative to suit your requirements, the next step is to produce a good – preferably perfect – print. Although this, at first, might appear to be a very simple task, a great deal of care and consideration is necessary in order to obtain a really first class monochrome print. If you do not put every effort into this stage of the process, all the work you have done previously will be wasted. When producing creative monochrome images, the print is the final product and should be the reward for all your efforts. You must therefore be prepared to put at least as much effort into this as you have put into the previous stages, and perhaps even more. Never expect to produce the perfect print on your first attempt with any new negative, as it is most unlikely that this first print will be the best that it is possible to obtain from that negative, and you may need to print several times to obtain a final – exhibition quality – print that you truly believe cannot be improved any further. Only this should be your final print!

It is often an advantage to produce a set of contact prints from any newly developed film. This enables you to view them as miniature positives, which are much easier to assess for selection, before attempting to produce an enlargement.

Contact prints are produced quite simply by placing the negatives with their emulsion side in contact with a sheet of printing paper. This is best achieved if the negatives are cut into strips of six for 35mm, four for 6 × 4.5cm, three for 6 × 6cm, or two for 6 × 7cm. These strips may be held firmly in contact with the printing paper by placing a piece of plate glass of an appropriate size over the top of them. Alternatively, you can use a purpose-made contact printing frame which you can buy at most photographic shops. All that is now necessary is to expose this sandwich to light. The most satisfactory method of doing this is to use the light from your enlarger without a negative in the negative carrier. Place the contact frame on the baseboard of the enlarger, raise the enlarger head some way up the column and stop the lens down two or three f-stops.

Now it will be necessary to make a test strip to ascertain the correct exposure for your contact prints. To do this, turn on your enlarger for an exposure of 4 seconds, then turn it off. Now cover a section of the contact printing frame with a piece of opaque card and expose for a further 4 seconds, and then turn off the enlarger once again. Now cover a further section of the printing frame, and repeat this procedure once again, so that you have exposed your contacts in three separate steps. These steps will represent exposures of 4, 8 and 12 seconds. Now remove your printing paper from the contact printing frame and gently, but quickly, slip it into a dish of suitable developer. Develop for the full recommended time at the correct temperature, and then after a 15 second rinse in a stop-bath solution, place in a dish of suitable fixer. Fix for the required time, and then give a short wash. From this test strip you will be able to ascertain the most suitable exposure for your proper contact strip. Now place a fresh piece of printing paper in the frame, and expose for this time. Process as before, but this time wash more thoroughly. You now have a correctly exposed contact sheet.

From your contact strip you will be able to select the negative that you wish to print. However, before moving on to making an enlargement, it is worth considering the various different types of printing paper available, as the choice of paper will have a considerable effect on the final result.

There are two readily-available types of light sensitive emulsion in general use for printing papers, these are *bromide* and *chloro-bromide*. The first of these is the most commonly used and produces 'cool to neutral' tones, whilst the latter produces very much warmer tones, some almost brown. One such chloro-bromide paper – Agfa Record Rapid – can, however, produce tones ranging from almost neutral to very warm, by the use of special developers and dilutions.

The base tint of a paper can also influence the 'colour' of your final image. Although the most commonly used base colour is white, some can be warm white or a stronger cream white. These base colours tend to affect the highlight areas of the print more than the darker tones, whereas the differences between bromide and chloro-bromide papers have more effect on the dark and mid tones.

The actual surface texture of the printing paper is probably the most noticeable characteristic of the differences between papers, and the choice of surface will have a marked effect on the final reproduction. *Glossy* prints will exhibit the fullest possible range of tones, from deep rich blacks to bright clean highlights, and will also provide the utmost possible sharpness and detail. *Smooth* or *Pearl* surfaces also provide good blacks and clean whites, but do not quite have the bite of a glossy surface: these surfaces do, however, have an advantage in that they are free from annoying or distracting reflections, which can be a real problem with the glossy papers. *Lustre* surfaces can look very attractive indeed, and are particularly suitable for portraits, etc. Although such a surface does tend to destroy very fine detail, this can be an advantage when dealing with portraits as skin blemishes will be somewhat disguised. This type of surface also has a very pleasing sheen to it. *Matt* surfaces should be used with care. It can be very difficult to produce a true black tone on such papers and they can tend to appear rather grey. However, this type of surface can be very suitable for 'high-key' photography – pictures which consist of predominantly light tones.

Another important aspect that can change the appearance of your final print is the base type onto which the light sensitive emulsion is coated. Although the modern resin coated, or RC papers as they are known, are very quick and convenient to use, in that they require a shorter processing, washing and drying time (and dry flat without any annoying curling), they are still – at the moment – unable to compete with the ultimate quality and depth of image available to the user of the older fibre-based printing papers. Although these fibre papers are very much slower to work with and require very thorough washing, they produce superior quality. Moreover, whilst virtually all the RC papers are only available in 'medium weight', these fibre papers can be purchased in what is known as 'double weight', and this really does impart body to a print, even after it has been mounted.

Variable contrast printing papers such as Ilford's Multigrade resin coated paper make it unnecessary to purchase several different contrast grades in order to accommodate different negatives.

Similar printing papers are also produced by Kodak and Barfen, and with such papers it is possible to alter the contrast of the material simply by utilising special filters, either placed in the enlarger's filter drawer or positioned beneath the enlarging lens in a filter holder. Contrast grades of between 0 to $4\frac{1}{2}$ are thereby available on just one type of paper. It is even possible to print different parts of a scene to different contrasts on one sheet of printing paper. This is all made possible by the light sensitive emulsion being made up from three separate layers, each sensitive to a different colour. The use of the special printing filters affects certain layers, or combinations of these layers, to produce the variable contrasts. However, the ultimate quality of a multi-contrast paper cannot equal that of a normally graded fibre based paper, although it will certainly match any other resin coated type.

Having selected a suitable negative for printing, and the type of paper you wish to use, it will now be necessary once again to produce a test strip to ascertain the correct basic exposure for your finished print. Although there are many gadgets available which can be used to calculate the required exposure (such as enlarging exposure meters or exposure discs, etc), there is really no better way of

doing this than the old fashioned test strip method. By this method, you do obtain a true visual guide to assist you in the assessment of the correct exposure, whereas an enlarging meter will only give you a reading based either on an average of all the tones present in a particular negative, or a spot reading taken from one small area of tone. This does not tell you how this reading will be interpreted visually. An exposure disc, although providing a visual indication, is not very precise, as the steps in exposure increase are usually too wide and fine control is not available.

To make your test strip, proceed as previously described for producing a test strip of contact prints, but this time you will need to insert the negative that you wish to print in the enlarger's negative carrier. Set the enlarger head to a height on the column to produce an image of the required print size on your enlarging easel, and carefully focus the image. It can be an advantage to use one of the focus-finders which actually focus on the magnified grain structure of the negative for this purpose.

Now stop down the enlarging lens by about two f-stops, and turn off the enlarger. By the light from your safelight, cut a sheet of printing paper into strips of a suitable size to cover important areas of the image, and position one of these strips, emulsion side up, in your easel. Now turn on the enlarger for an exposure of 2 seconds, after which you should cover a small section, say 1½ inches, of the test strip with a piece of opaque card. Now make a further exposure of 2 seconds, then cover a further 1½ inches of paper. Repeat this procedure until you have exposed several sections of the paper in stepped exposures of 2, 4, 6, 8, 10, 12, 14, 16, 18 and 20 seconds. Now develop this strip for the full recommended time, followed by a 15 second immersion in a stop bath, and then fix. Follow this with a short rinse, and then examine the test strip in good light to determine the most suitable exposure time. If the resulting contrast in this test strip is not satisfactory, it will be necessary to repeat this operation with a fresh test strip on a more suitable grade of printing paper.

Once you have decided on the most suitable exposure and paper grade, place a full size sheet of paper in the masking frame and expose for this time. Process as before, and then give the resulting print a quick rinse. As this is not your final print, it will not be necessary to wash this thoroughly. The purpose of this print is for assessment, as it is necessary to be able to view the entire image in order to decide how that particular picture should be printed. All you have actually done so far is produce a print at the basic exposure. To achieve the ultimate from the negative you will almost certainly find it necessary to carry out shading or burning-in to some areas of the image. With this in mind, take this assessment print and examine it carefully to see how it could be improved. Perhaps there are one or two areas that would benefit from being printed either a little darker or lighter? With this in mind make another print at the same basic exposure, but shade any areas which you require to print lighter during this exposure.

This can be carried out in several ways, depending on the size of area to be shaded. For large areas – and particularly if these are at, or near, the picture edge – you can use your hands, held in the beam from the enlarger so that they throw a shadow over the area you wish to shade. Alternatively, you

A) illustrates the basic principle of burning-in – a small part of the image is given extra exposure through a hole cut in a piece of opaque card, while the rest of the image is protected by the card. *B*) illustrates the basic principle of shading – small areas of the image are shaded by a piece of opaque card attached to the end of a thin piece of wire, and so receive less exposure than the rest of the image.

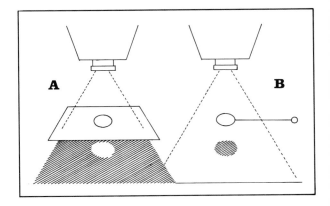

can cut pieces of card to shape and position them in the light beam supported either on a piece of glass, or on thin pieces of wire. Always try to keep the shadow moving slightly so as not to obtain an obvious edge to the shaded area. The longer an area is shaded, the lighter it will become. Be careful, however, not to overdo this as the shaded area may start to appear grey.

Burning-in, to darken an area, is best carried out after the initial exposure is completed. All that is necessary is to expose these particular areas for an extra period after the basic exposure. This can be achieved quite simply by using a large piece of opaque card with a suitably sized hole cut in it. Hold the card at a mid-distance between the lens and the masking frame, and turn on the enlarger. You can now expose a very small area of the image through the hole in the card. Raise the card nearer to the enlarger lens to increase the size of the area being exposed, or lower the card to decrease the area. With experience you will be able to use your hands for this purpose, and in many cases, you may only need to use the hole in the card method for very small areas. Experience will tell you by how much to shade or burn-in an area, but if a considerable amount of burning-in is required it may be necessary to open up the diaphragm of the enlarging lens to full aperture in order to keep the burning-in time to a minimum, as the light intensity will be cut down quite considerably as it is projected through a small hole.

Multi-Contrast Printing

When printing on a variable contrast paper such as Ilford Multigrade, it is sometimes beneficial to print different parts of the picture to different contrasts. An example of where this situation might arise, is when an interior shot of a room, etc features a window in which the intensity of light from outside has caused a very dense area on the negative, which ideally would be printed on a soft grade of printing paper. The actual room interior, however, might well have recorded as a rather thin negative density which would be better printed onto a hard grade of paper. This situation can be saved by making use of a variable contrast paper, and printing the interior of the room using filters to provide a high contrast, whilst masking off the window area with a piece of card, and then altering the enlarger filtration to provide low contrast for printing in the dense window area while keeping the rest of the room interior masked off. This sort of technique is really quite simple, and is no more difficult than normal shading and burning-in. The only difference is that, prior to carrying out the actual shading or burning-in, you must alter the contrast filters to provide the required contrast grade. It will, however, be necessary to make one or two test strips initially to determine the required contrast grade and exposure time for each area.

Even if after you have made two or three attempts at printing a negative it is still not satisfactory, don't give in. Although it can be very tempting to call it a day and accept a print that is less than perfect, if you have a potentially good picture you must be prepared to stick it out until you have a print which is completely satisfactory; one which you would not wish to alter or improve any further. Even if you waste perhaps ten sheets of printing paper in the process, the end result will be worth all the effort, and the expense!

4
THE FILM/DEVELOPER RELATIONSHIP

DEVELOPER TYPES

FINE GRAIN DEVELOPERS

These are probably the most widely used developers for both 35mm and medium-format photography, producing extremely fine grain with high resolution on slow speed films, and fine grain results on medium speed films. This type of developer may also be used to compensate for underexposure by extended development techniques, and such developers are therefore extremely versatile. The two best known examples of this type of developer are Kodak D-76 and Ilford ID-11, and although these have been around for a very long time, they still manage to set the standards by which all others are judged.

These developers are fairly slow working whilst retaining full emulsion speed, and when used in a diluted form – 1 to 1 or 1 to 3 – they produce an effect similar to an acutance type developer.

ACUTANCE (HIGH DEFINITION) DEVELOPERS

These developers produce increased sharpness to a negative through enhanced contrast at the edges of fine detail, producing what is known as an *edge effect*.

The developer quickly becomes exhausted in the heavily exposed areas of the image and meets the highly active developer at the borders of lightly exposed areas, when an interaction takes place to provide the enhanced contrast at the intersection of tones, producing an apparent increase in sharpness. Normal fine grain developers will produce a similar effect if used in diluted form with extended development.

HIGH ENERGY DEVELOPERS

These extremely active developers produce maximum film speed. However, due to their highly active nature they also produce very high contrast. Their use is, therefore, mostly restricted to compensating for extreme underexposure (push processing) when, perhaps, an extremely grainy and high contrast result is desired.

PRINT DEVELOPERS

Some of these can be suitable for developing negative film materials, particularly for push processing. Acuprint in particular can produce very worthwhile results when pushing the speed of fast films. It will, of course, be necessary to carry out your own experiments with times and dilutions but, as a guide, I have found that when working with Ilford HP5 film a dilution of 1 to 5 yields good results with development times of 18 minutes when rating the film at 1600 ASA/33 DIN, and 25 minutes when pushing to 3200 ASA/36 DIN. This seems to produce a quite large and clearly defined grain structure but maintains good standards of contrast, producing extremely printable negatives.

Film/Dev ~ Combinations

DEVELOPER / FILM TYPE	Fine Grain	Acutance	High Energy	Print
Slow	●	●	○	✕
Medium	●	●	○	✕
Fast	●	○	●	●
Very Fast	○	✕	●	○

● IDEAL COMBINATION
○ CAN BE USED
✕ NOT RECOMMENDED

5
SPECIAL TECHNIQUES

Although special techniques, effects or materials are often used in creative monochrome photography, it should be emphasised that none of these are truly creative in themselves and although, perhaps, most such techniques could have been considered creative when they were first thought of, developed or used, the passage of time and, to some extent, the overuse of many of these techniques has made them much more accepted and, indeed, even commonplace. So nowadays, for an effect or special technique to be considered creative, it must be through the technique's application.

Some techniques or special materials are either impossible or, at best, very difficult to use with any real knowledge or control over the finished result. Although it may be possible to know what sort of effect will be achieved, it cannot be foreseen precisely how this will relate to a particular picture. In order to maintain some element of control over creativity, however, it is often possible to apply a certain technique to a type of picture which *should* be suitable. In this way, at least some small degree of control is maintained.

INFRA-RED FILM

Infra-red film is one such material. Although the type of effect is very well known indeed, its application to any one particular scene is a fascinating game of chance, and its ability to produce, sometimes quite unexpected transformations to familiar scenes can be very exciting.

It is still possible, however, to use this material with some degree of control and, indeed, within certain limits, to be able to pre-visualise the final result.

Kodak Infra-Red film is available in 35mm cassettes which must be loaded into your camera in total darkness as the cassettes themselves cannot be made impervious to the invisible infra-red rays. The film cassette itself is contained in a plastic light-tight container on purchase, which must only be opened in total darkness when you are ready to load the film into your camera. If you are about to undertake a full days outing whilst using this film, when perhaps you will need to use more than one film, be sure to take with you a light-tight changing bag otherwise you will probably find it impossible to change film without fogging. Another problem that is sometimes encountered with this material, is that even your camera may not be impervious to the infra-red rays, with subsequent film fogging. If this does occur with your equipment, one solution is to wrap your camera in cooking foil which offers some form of protection. Unfortunately, infra-red light rays do not focus on the same plane as the normal visible light rays, so it will be necessary to focus, and then adjust the focused distance on your lens scale from its normal index mark to that for infra-red. Most modern lenses are provided with an infra-red focusing index.

As its name might suggest, Kodak infra-red film is sensitive to the longer end of the light spectrum – the invisible infra-red rays. However, it is also sensitive to the normal wavelengths – the visible spectrum. Consequently, if the film is used without any filter on the camera, results will not be all that dif-

ferent from those obtained with more conventional films. It is therefore necessary to use filters to cut out some, or virtually all, of the visible spectrum in order to obtain truly infra-red photographs. A Hoya × 8 or Kodak 25 filter may be used to good effect, but the best results are to be obtained with the almost opaque Hoya R72 filter. This does present some further problems, however, in that it is totally impossible to view and focus through an SLR camera when this filter is fitted. It will therefore be necessary to use a tripod – framing, composing and focusing before fitting the filter.

Just to make this film even more unpredictable and exciting to use, it does not really have a film speed as such, by which to set your exposure meter. Although Kodak do recommend a nominal speed of 50 ASA/18 DIN, they do make it quite clear that this may not necessarily be very accurate. So in use, it really comes down to guessing exposures! This, of course, makes a mockery of all the highly sophisticated metering systems built in to SLRs. The problem is that exposure meters do not respond to the invisible infra-red rays, and only the visible spectrum will record a reading. The problem is further aggravated by the fact that different materials reflect varying amounts of infra-red light. Human flesh and the chlorophyll in living vegetation, for example, reflect infra-red very strongly and an exposure meter reading from these may give widely inaccurate readings. It is therefore best to use your exposure meter merely as a guide for some sort of starting point, around which you must be prepared to bracket exposures.

If all the uncertainty and obvious problems tend to put you off using this material, don't let them. With a little perseverance and practice – particularly if you are wise enough to keep notes of exposures and original meter readings, compared to results – you will ultimately produce some very striking images indeed.

Characteristics of Infra-Red Film

The results obtained can be extremely surreal, almost un-worldly or magical. Some subjects can record as if taken by moonlight; and when used in well sunlit conditions, green foliage and grass, etc can be rendered almost white, providing an ethereal quality to the picture; whilst blue skies may be recorded almost black due to the very strong red filtration, which will almost entirely filter out all the blue light. Any clouds present will record brilliant white due to the high reflectivity of infra-red by the water particles which make up the clouds, and the contrast between the black sky and white clouds can be most dramatic. This particular effect can sometimes be further enhanced by the additional use of a polarising filter.

Although the nominal speed of this material is only 50 ASA/18 DIN, the grain size is extremely large and coarse, and this combined with another of the film's strange characteristics – the spreading of strong highlights into surrounding areas – can provide a sort of luminous quality to many subjects.

Processing Infra-Red

The film must, of course, be removed from your camera in total darkness and either placed immediately into your developing tank, or back into the original plastic cassette container. Stainless steel developing tanks are preferable for use with this film, as some plastic ones are not impervious to infra-red rays, with subsequent fogging of film. However, once in a suitable developing tank, the film may be developed in the conventional manner and, once processed, can be handled just like any other film.

Enclosed with each Kodak infra-red film are Kodak's own processing recommendations, and it is best to start with these. Although most other developers are suitable, no figures for development times are given with these and you will therefore have to carry out your own experiments, to determine suitable times for any other developer which you may wish to use. Kodak HC-110 and D-76 are the most commonly used developers and with a little personal 'fine tuning' these will provide excellent results. Many infra-red negatives are extremely dense, and may require very long printing exposures. Don't let this worry you, as it is quite normal with this material. If you wish to exploit the

large grain structure of this film, print on a hard grade of printing paper.

Availability

Unexposed infra-red film is not very stable, and should not be kept for long periods. Furthermore, even for relatively short periods of storage, it should be kept refrigerated or it will deteriorate very quickly. For these reasons it may be slightly difficult to find a shop which carries supplies of this material in stock and, although some of the large specialist dealers may carry it, it is often better to order it from your local supplier to ensure fresh stock. Infra-red film is, at present, only available in 35mm cassettes or 5 × 4 in. sheet film, and is only manufactured by Kodak.

LITH AND LINE FILM

Although many photographers think of derivatives – including the use of lith or line film – as a means of salvaging an otherwise unsatisfactory picture, this really should not be the only or even the main use to which these materials are put. Although some reasonable results may be obtained in this way, there is little doubt that in order to obtain good results the subject matter must be suitable for this type of treatment and the most effective and successful results will usually be obtained when the picture has been pre-planned, and perhaps even taken specially for this effect.

The bold and graphic simplicity of high contrast images of pure black and white, with no intermediate half tones whatsoever, can impart an enormous amount of impact to a picture. However, such techniques should be used with care, for although it is true that almost any photograph given this treatment will certainly look different, this will not necessarily make it a 'good' picture.

Materials

Both lith and line films are used mainly in the printing and graphic arts industry, but they are quite easily obtained through your normal photographic retailer; although it will probably be necessary to order them, as it is unlikely that these kind of materials will actually be kept in stock. The same will apply to the special developer necessary to obtain the maximum contrast from lith film. Both Kodak and Ilford produce lith film, and this is usually obtainable in either 35mm or 5 × 4 in. cut film. Although both sizes work well, the larger size is certainly preferable for darkroom work, as it is very much easier to handle in this size. As these films are orthochromatic, they may be used under a deep red safelight in much the same way as ordinary bromide printing paper.

Although Kodak do make their own lith developer, this is only available in relatively large quantities. It comes in two parts – Part A and Part B – which must be mixed together immediately before use. However, once these two parts are mixed, their working life is extremely short. A more suitable alternative for the amateur photographer therefore, who only uses such materials occasionally, is Tetenal 'Dokulith', which is a single solution that is diluted 1 to 3 with water for use. This solution will keep for some hours in a dish, and the concentrate will keep for months in an air-tight bottle. Line film does not require a special developer, and may be developed in any contrast type developer. All processing can be carried out in print dishes, and all that is required is the developer, a normal stop bath and your regular fixer.

The Process

It should be understood that although both lith and line films produce very similar results, they are not quite the same. Lith film, when developed in the special lith developer, will produce very high contrast quite easily. However, it does suffer from pinholing. This means that after processing, the dense, or black, areas of the film are often covered in very small pin-holes which will have to be masked out with a liquid opaque. Failure to do this will result in these pin-holes reproducing as tiny black specks in the white areas of your print. Liquid opaque is available from most photographic shops. Lith film

is also not capable of resolving extremely fine detail, whereas line film is. However, line film does not produce quite such high contrast as lith film, and will often require more stages in the process in order to obtain the required degree of contrast.

In order to produce your high contrast lith or line negative, it is first necessary to make a lith positive. This is achieved by contact printing a normal continuous tone negative onto either one of these films, in much the same way as you would contact print with normal printing paper. Commence by making a test strip, in steps of two second intervals, but make sure that your original negative and your sheet of lith film are held in close contact, and emulsion to emulsion. When using 35mm original negatives and 5 × 4 in. lith film, it can be an advantage to position your 35mm negatives in two strips of three on the sheet of lith film. A fairly heavy piece of plate glass should be placed over the top to ensure full emulsion to emulsion contact. To enable identification of the emulsion side of cut film, a notch is provided near one corner. When this notch is positioned so that it appears at the top right-hand corner when you are holding it, the emulsion will be facing you. Develop your lith film test strip in a suitable lith developer for 2 minutes. Agitate by rocking the dish continuously for the first 30 seconds and then only occasionally after that, until the time is completed. Rinse in a normal stop bath, and then fix. From this test strip you will be able to determine the most suitable exposure time.

Now simply re-position your negatives onto a new piece of lith film, and expose for this time. Process as before, and then wash. You will now have produced a lith positive. When this is dry, it will be necessary to repeat the entire procedure using your new positive in place of your original negatives, in order to obtain a high contrast lith negative. Once again, it will be necessary to make a test strip to ascertain the best exposure.

Once your finished high contrast lith negative is dry, it may be found that it is necessary to cover any pin-holes which may be present with liquid opaque. During this stage, you can also take the opportunity to block-out with the liquid opaque any unwanted detail you do not wish to print. After this, you may use the lith negative to produce prints on normal bromide printing paper in the usual way. However, if using line film, it may sometimes be necessary to produce another positive from which to produce the final high contrast negative. This is because line film does not give quite such high contrast results as lith film, and this extra stage can be necessary in order to remove all traces of half tones in the final negative.

Variations

It is possible to experiment with effects other than a print straight from a lith negative, and interesting results may be achieved by printing from a lith positive, to produce a high contrast 'negative print'. It is also possible to produce interesting results by combining a lith or line negative and positive together. This is easily achieved by sandwiching the negative and positive together, preferably between two sheets of glass, or in a glass-type negative carrier. This will produce a line drawing effect, and can be very effective with bold and simple subjects. Another alternative is to sandwich a high contrast lith negative with the original continuous tone negative. If these are positioned slightly out of register, you will obtain a thin black line around parts of an otherwise normal photograph, imparting a new sense of depth to the picture.

Although it is certainly worth while experimenting with these techniques and effects, once the basic techniques have been learned it is far better to use them on a specially-selected subject which will benefit from that particular treatment.

SABATTIER EFFECT (Pseudo Solarisation)

This strange and sometimes almost eerie effect is often referred to as print solarisation. However, this is not strictly correct, as true solarisation only applies to film, and not printing paper. True solarisation is brought about by a film being vastly

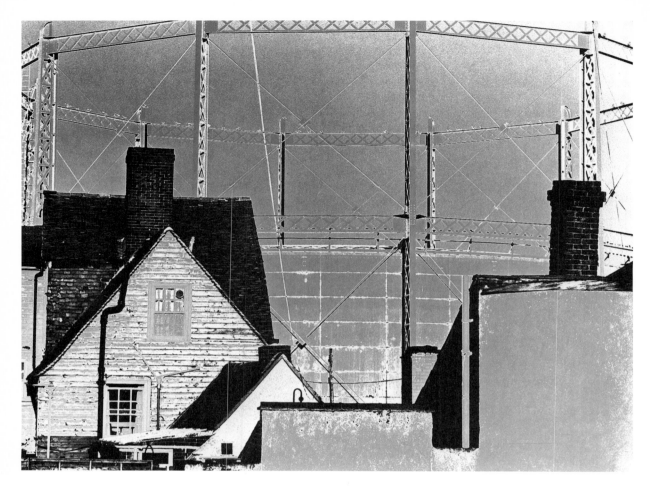

Strong geometric shapes provide good subject matter for the *sabattier effect*.

overexposed – approximately 1000 times that required for a normal exposure – which results in a reversal of the negative image to form a positive, or part positive image on the film. This can occur with an extremely bright light source in the picture, but with the vast improvements which have been made in film technology in recent years, this phenomenon is becoming increasingly rare.

The Sabattier effect, however, is named after a French photographer and scientist – Armand

An ideal method of carrying out the re-exposure is to position the developer dish, during development, on the baseboard of the enlarger. Re-exposure can then be precisely controlled by the light from the enlarger (with no negative in the negative carrier) using the enlarger's timer and lens aperture settings.

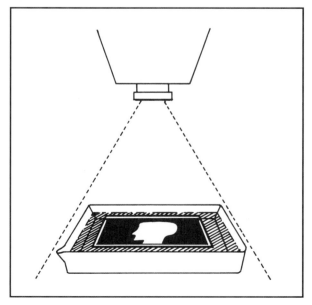

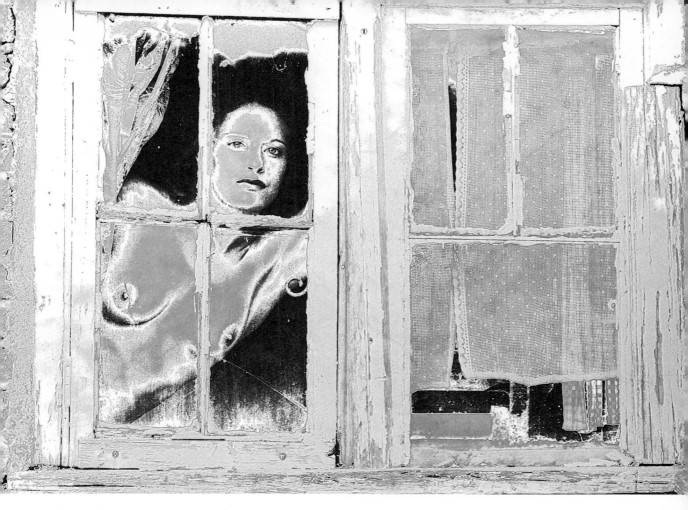

Sabattier – who discovered this effect quite by accident while developing a photographic plate. While developing this plate, daylight was accidentally allowed to strike it, and a partly reversed image was formed. Nowadays, however, it is this Sabattier effect which has become commonly known as solarisation, and as it is an extremely rare occurrence for true solarisation to take place, it is perhaps now acceptable to refer to this as 'solarisation'.

'Solarisation' The Process

Although, in principle, the theory of how this technique works is very simple, in practise, it is somewhat unpredictable and results can never be guaranteed. The effect is, to some extent, dependent on the make-up of the picture on which the technique is to be carried out, and so its success

Shadow tones often provide interesting contrasts if care is taken with the re-exposure. To make the most of this effect it is necessary to experiment, to provide just the right amount of re-exposure at just the right moment in the development process.

or the type of result will vary with each individual picture.

The effect is created by a print being exposed to light during its development, after having been exposed with a negative image in the normal way. What actually happens is that the already developed image acts as a sort of negative through which the remaining unexposed, or partly exposed, light sensitive emulsion is re-exposed. This causes some of the image to reverse, and the result is a part negative and part positive image.

The re-exposure to light has little effect on the areas of the print which are already dark, as the exposed light-sensitive crystals have already been

converted to black silver by the development already carried out. The light areas of the print, however, where the crystals have been little changed by either exposure or development, will be changed by the re-exposure quite strongly, and these will turn grey. They should, however, remain lighter than the shadow areas. Between areas of light and dark tone, the light sensitive crystals react and development is retarded, forming very light or almost white lines between the lighter and darker areas. These lines are known as Mackie lines and are a well known characteristic of a solarised print. These Mackie lines will be most pronounced where a picture has strong contrasts between the light and dark areas. It can therefore be an advantage to carry out this technique with a fairly contrasty original negative and a hard grade of printing paper.

The Method

Using a suitable negative, make a test strip on a hard grade of printing paper in the normal way to determine a suitable exposure. Once you have done this, continue as if making a print in the normal way. However, about three-quarters of the way through the development time, re-expose the partly developed print to light whilst it is still in the developer.

This can be done in several ways and you will need to experiment to find the method that best suits you. You may find that a 15 or 25 watt light bulb held approximately one foot (30cm) above the developer dish and flashed on and off very quickly gives a suitable result. Alternatively, you may find that a very small and low power flashgun – either flashed from directly above, or perhaps bounced off a ceiling – provides a good result. Some people prefer to position the developer dish on the baseboard of the enlarger, and flash the print by the light from the enlarger with no negative in the negative carrier, during the development. After the re-exposure, complete the full development, and then rinse in a stop bath and fix.

If you are not successful first time, don't give up: try again. Perhaps the re-exposure was too long, in which case the print can go too dark or even completely black. The same result can cccur if you do not develop long enough before the re-exposure. On the other hand, if you give too little re-exposure, or develop for too long before the re-exposure, very little difference may occur.

Although this technique is rather hit or miss, if you are prepared to spend a little time and a few sheets of printing paper on experimentation there is no doubt that you can come up with some very pleasing and extremely unusual results.

The same techniques may be carried out with a film during its development. However, it will be necessary to remove the film from its tank in total darkness, and place it in a white container, submerged in water, to ensure even exposure during the re-exposure stage. A transparent plastic spiral will be necessary to allow light transmission throughout the entire film. This technique offers the added versatility of producing a solarised negative from which you can produce a further solarised print. One warning though, it can be extremely risky to devote an entire film to such an unpredictable technique.

MULTIPLE PRINTING

By using multiple printing techniques it is possible to manipulate an image to make the impossible apparently real, or to create surreal images. Besides being a lot of fun, these techniques can be used to combine picture elements in a way that would be either impossible or extremely difficult to achieve in any other fashion.

Multiple printing is simply the printing of more than one image onto a single sheet of printing paper. Although this might, at first, seem quite difficult, if approached in an organised manner and with a little practice, it really can become quite easy to do. The key to success with this technique is *masking*: the holding back of an area of one nega-

A simple multiple print which was produced using only two negatives. Simple card masks were used to ensure a white background behind the hammer. The negative for the breaking glass was produced from my own original artwork.

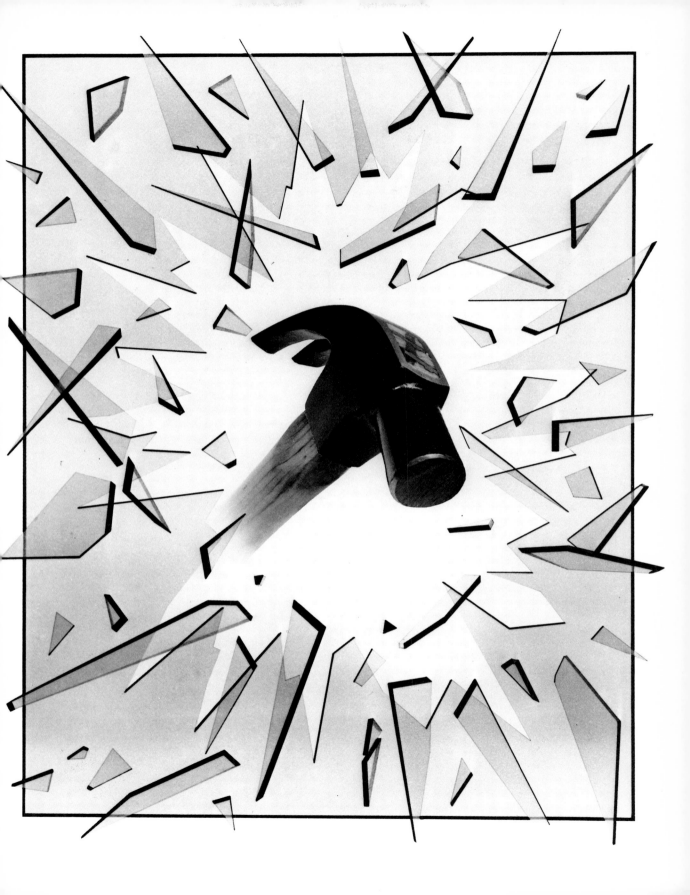

tive, so that a part of a second negative may be printed into that area.

Although dense, overexposed areas of a negative might provide some degree of natural masking, even these near black areas of film will allow some light to penetrate during a long exposure and a very light tone may be recorded. Although it is possible to hold back these areas with either a piece of card, or your hands during the exposure, far more precise and accurate results are obtained by utilising either a lith film mask, or an accurate card mask. The principle is much like that of shading and burning-in during normal printing except that, in this case, it is necessary to burn-in a part of an image from a totally different negative.

The most simple type of mask to produce and the most commonly used is a card mask. This is simply a piece of opaque card cut into an accurate shape and placed in contact with the printing paper, to mask efficiently one area of the image, while another part is printed in.

As with all multiple printing, it will first be necessary to make a master sketch. To do this you will need to trace the outlines of each of the elements (from each individual negative), in their desired positions on a piece of thin card. This master sketch will enable you to position and compose each of the separate picture elements so that they align in their correct positions on the printing paper. Next, you will have to make the cardboard cut-outs for masking. Trace the same outlines onto fairly thin but opaque card, making sure that each mask is in contact with the paper stops of the enlarging easel, and cut these out very accurately. A fine scalpel is best for this job.

Printing with Card Masks

After having made test strips to determine the correct printing exposure for each of the picture elements, place the first negative to be printed in the negative carrier, and with the master sketch positioned in the enlarging easel, compose and focus to position accurately the part of the image you wish to print. Now remove the master sketch, and insert a sheet of printing paper into the easel. With the red filter positioned under the lens of the enlarger, turn on the lamp and position your first mask into the enlarging easel, on top of the printing paper, being particularly careful that the mask is accurately in contact with the paper stops of the easel. Now make your first exposure.

Remove now both the mask and the printing paper from the enlarging easel, making sure you know which way round to re-position the printing paper, and replace the master sketch. With the second negative in the negative carrier, compose and focus on the master sketch and ensure that the image is positioned correctly. Remove the master sketch, and re-position your sheet of printing paper in the easel, being careful to ensure that it accurately contacts the paper stops. Over the top of this, carefully position the second cut-out mask, and check image positioning with the aid of the enlarger's red filter. Now make your second exposure. If you have further elements to print, proceed in the same way until you have printed all the required elements of the picture, then process in the normal way.

Lith Film Masks

Although lith film masks work in exactly the same way as card masks, they can provide extremely accurate masking. They are, however, very much more time consuming to produce, and are not really necessary for most multiple printing. When such accuracy *is* required, proceed in the following way to produce these masks.

You will require lith film in the same size as your intended print, or even a size larger and – as it is necessary to enlarge each element of the multiple print onto a separate sheet of lith film, to produce individual masks for each element – you will also require a register bar, which ensures accurate positioning of several masks as they are positioned in turn, over the printing paper.

On opaque card, make a master sketch as previously described and use this (hole punched and set on the register bar), as a guide for setting up each negative to print the masks. With the first negative in the enlarger, compose and focus the image on the

Simple lith film masks produce more accurate masking for multiple printing than is generally obtained from card masks. However, it is necessary to use this type of mask either on a register bar or in a register frame.

Frame incorporating a register bar. *A*) Register frame. *B*) Unexposed film or printing paper. *C*) Lith film mask.

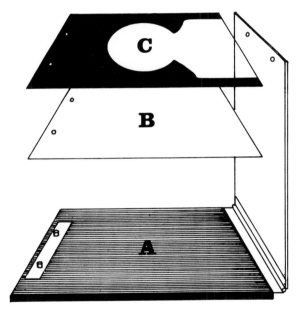

master sketch, and then make a test strip on the lith film to determine the correct exposure. Now, with a fresh sheet of lith film, punched and positioned on the register bar, make your exposure. Develop this to obtain a positive high contrast image. It is now important to isolate the part of the image you wish to print. To do this, it will be necessary to paint out all the other areas with liquid opaque on this lith positive if the picture element has recorded as a light tone or, if it has recorded as a dark tone, it will be necessary to opaque that area itself. Now

make a contact of this to produce a high contrast negative, and carry out any further isolation of the picture element with liquid opaque once again. It may be necessary to repeat this operation several times, in order to obtain a sheet of film which is totally opaque with the exception of those areas that you wish to print from the first negative. You will have to produce one of these masks for each negative you have to print. All of these masks must be produced using the register bar, so that all the separate elements align accurately in the final print. When you have completed all the necessary masks, place them in the correct printing order on the register bar.

Printing with Lith Masks

After making the necessary test strips to determine exposure for each of the picture elements, stick down a sheet of printing paper onto the baseboard of the enlarger with masking tape, and also stick down the register bar so that the masks can be positioned over the printing paper. Now place the opaque master sketch on the register bar so that it covers the printing paper, and place the first negative in the enlarger. Compose and focus this on the master sketch, turn off the enlarger, and remove the master sketch from the register bar. Replace this with the first lith mask, and make the first exposure. Remove this first mask and replace the master sketch. Compose and focus the second image, and once again, remove the master sketch, replacing it with the second lith mask. Now make the second exposure. Repeat this procedure for each element to be printed, after which the print may be processed in the normal way.

Double Printing Without Masks

Quite often two images may be printed onto one sheet of printing paper without the need for any purpose-made masks, and this can result in a nice smooth (or soft) transition from one image to another. However, it is still advisable to make a simple master sketch so that each of the images may be positioned and proportioned accurately without

53

fear of fogging the printing paper.

Using the master sketch, simply compose and focus the first negative, then remove the sketch, replace it with the sheet of printing paper and expose while shading the part of the image reserved for the second negative with your hands. Now remove the printing paper, replace the master sketch and set up the second negative. Remove the master sketch, replace the printing paper the correct way round and expose the second part of the image whilst shading with your hands the area previously exposed. It can be an advantage to check your shading technique with the aid of the enlarger's red filter prior to actually carrying it out.

MONTAGE

Photo-montage is similar to multiple printing in that several separate images are used to make up one picture, however, a totally different kind of technique is used to create this sort of multiple image. Montage is the physical assembly of completely separate existing prints, or parts of these existing prints, carefully cut out with a scalpel and then pieced together rather like a jig-saw puzzle.

In a way similar to multiple printing, montage makes it possible to put together different images which would otherwise be impossible in reality, and this technique is frequently used to produce extremely 'weird' surreal images. Almost anything the mind can easily imagine, and even some things it can not, can be accomplished with the aid of montage, and many record sleeves and posters are produced by this technique. The total freedom given over the choice of the picture elements, their juxtaposition, scale and perspective allows dreams to become reality with such a technique.

You may find suitable images for a montage in your own negative files. More often than not, though, you will have specially to photograph at least some of the elements to complete an idea. Once you have all the separate elements of the image, you must then decide precisely what you want to achieve. Although most montaged images look best if done very carefully, so that the finished result is similar to a multiple printing technique, a few look more interesting as an obviously 'made up' image, with the elements very roughly cut out to produce a deliberate cut and stuck effect. However, once you have decided on the type of effect that you require, make a sketch of the intended picture and use this as a guide to scale, etc when producing the prints for the montage.

It is always best to start with a basic background image, to which the other elements can be added. This print should be as large as possible. Mount the basic background print onto a piece of card and then make prints of the various elements, being careful to match the print densities where possible. To obtain the correct scale for each of the elements, it can be an advantage to place the master sketch, which should be the same size as the basic background print, on the baseboard of the enlarger. In this way it will be possible to adjust the proportions of the separate elements to match the master sketch.

Having produced all the pictures from which the separate elements will be taken, it is now necessary to cut these out with a sharp scalpel. It is best to reduce the thickness of the printing paper at the edges, so that they mount as flush as possible and to minimise any hard edges. For this, use a very fine grade of sandpaper and carefully rub down the back of the print around all the edges. For the same reason, it will be best to use a single-weight printing paper for all the printing of the separate picture elements. Mount the elements in place on the basic background print. Use a non-permanent spray adhesive, as this does allow some re-positioning should you not get everything right first time.

Once the montage is assembled, retouching may be carried out to help disguise the joins, and the over-all effect can often be helped by adding shadows and other simple shapes with an airbrush.

Once the whole assembly is satisfactory, it will be necessary to copy this with your camera to produce a negative from which you can make a normal print – with no raised edges – any time you wish. If you print this picture somewhat smaller than the original montage, any imperfections or retouchings will be further disguised.

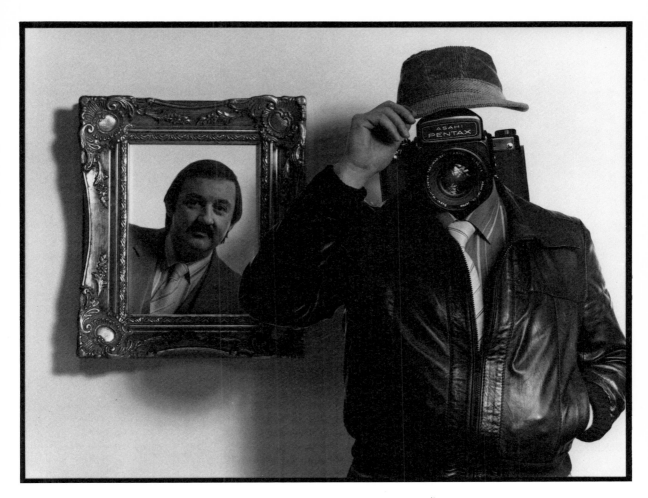

An unusual self portrait produced by montage. Three separate photographs and a real picture frame were used to produce this picture.

Firstly, I took a self portrait of myself wearing a leather jacket and touching my hat. *Secondly*, I photographed one of my Pentax 6 × 7 cameras attached to a tripod. Large prints were made, and I was particularly careful to print the subjects to their correct scale. These were then accurately cut out with a scalpel and mounted onto thick card, which was then trimmed to the same shape as the prints, with the camera replacing the removed image of my head. *Thirdly*, a further self portrait was then taken of my head and shoulders only, and this was mounted into a picture frame. The picture in the frame was then fixed to a large sheet of thick white card with sticky gum and the cardboard cut-out of myself with camera head was positioned a little way in front of this. This three dimensional montage was then copied using a single light, so that realistic shadows were cast onto the background from both the cut-out figure and the picture frame.

6
SUCCESSFUL FLAT COPYING

The techniques of flat copying have many useful applications for the imaginative photographer, and these techniques offer further control over the creative potential of the final image. In more general terms, the ability to successfully copy photographs, artwork, drawings or plans is extremely useful to many people. However, although copying might at first appear to be a very simple technique, a good understanding of the techniques and a considerable amount of care is necessary in order to produce really top quality results.

ESSENTIAL EQUIPMENT

Although for optimum quality a large format camera is generally necessary – either 5 × 4 in. or even 8 × 10 in. – very good quality may be obtained with both roll film and 35mm cameras. A camera with full reflex viewing is essential for accurate copy work, as no other type of camera will allow precise framing of the work to be copied. An SLR camera, either roll film or 35mm, with a mirror lock-up or pre-release mechanism is the ideal choice, as this will ensure vibration-free results. A cable release to allow remote tripping of the shutter is another essential piece of equipment, although a satisfactory alternative can be found by using the self timer mechanism to trip the shutter if your camera has this facility. This allows time for any vibration, after having touched the camera, to die down before the shutter is actually tripped.

You will also require a camera lens which will focus close enough for the copying work to be carried out, and preferably one which is corrected for close-up work. Enlarging lenses are well corrected for such work, and it may be possible to adapt such a lens for use on your reflex camera with the aid of an extension tube, or special adaptor, etc. Another fairly satisfactory alternative can be found by using a short, or medium telephoto lens on an extension tube. This will provide a more comfortable working distance, and a somewhat flatter field than most standard lenses.

TECHNIQUE

The two essentials to the techniques of copying flat artwork, photographs and so on are that the camera must be set up perfectly square and parallel to the work to be copied and that the work should be illuminated as evenly as possible.

Without a doubt, the best way of achieving this is to use a purpose made copying stand, complete with its own lights. However, as these can be rather expensive a suitable substitute can be found in most photographic enlargers. Many enlargers feature a removable head, and with your camera attached in place of this (via the screw that previously retained the enlarger head) you immediately have a very efficient copying stand. If this is not possible with your own particular enlarger, it is quite often possible to make up an adaptor of some sort which will enable your camera to be fitted in place of the enlarger head. Alternatively, it may even be preferable to purchase an inexpensive second-hand enlarger, which you can then convert for permanent

Special copying stands such as the one illustrated here tend to be rather expensive. However, it is often possible to adapt an enlarger for copystand use.

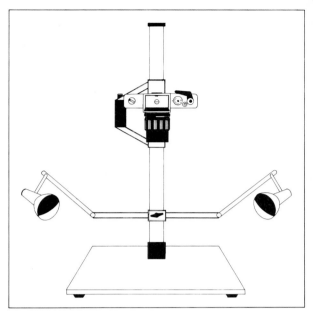

use as a copy stand. In this case, it would not be too difficult to make up a two or even four light, lighting system which could be attached to the stand by a home-made bracket. This would provide you with a lighting system similar to that found on a far more expensive, purpose-made copying stand.

If you propose to carry out little copying work, it may be that the investment required in either of the above alternatives is not worth while. If this is so, it will be necessary to use a sturdy tripod for the camera and mount the work to be copied onto a wall with Blu-Tack or double sided sticky tape. You will have to be extremely careful to ensure that your camera is central and parallel to the work to be copied. Use a tape measure and spirit level to set everything up correctly.

Two lights should be positioned, one on either side of the camera, at the same height and at an angle of 45° to the copy work. If the lights are placed too near the copy work they may cause glare, hot spots or reflections on the surface of the work to be copied. Position the lights so that the illumination is as even as possible. This can be checked by holding a pencil in the centre of the work to be copied, and ensuring that an equal shadow is cast on each side by the pencil. It is preferable with monochrome copying to use tungsten lighting, as it can be very difficult to assess the uniformity of flash, even if modelling lamps are provided, as these may not reliably indicate the level of illumination from the individual flash tubes when they are fired.

If the surface of the material to be copied is glossy or shiny, it may be necessary to position a large piece of black card in front of the camera with a hole cut in it, through which the camera lens can protrude. This, in effect, will provide a kind of hide for the camera which will, at the same time, eliminate the reflection of any surroundings. Another alternative is to use a polarising filter over the camera lens and, if necessary, also over the lighting units.

Ideal lighting set-up for copying flat artwork/material fixed to a wall. Two lights may be used. Alternatively, four will provide more even lighting if the item to be copied is large. The lower diagram illustrates how the lights should be directed towards the furthest edge of the item to be copied. This helps to avoid 'hot spots'.

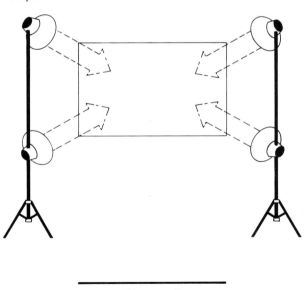

FILM, EXPOSURE and DEVELOPMENT

Unfortunately, many of the special film emulsions designed for this work are not readily available in either roll film or 35mm cassettes, as most are available only in sheet film for large format cameras. However, very satisfactory results can be obtained by using a slow speed, fine grain film which, developed normally, will provide fairly high contrast. Films such as Ilford Pan F, or Kodak Panatomic X, are suitable and are capable of producing extremely good results.

Exposure is more critical with copying than with any other form of photography. This is because 'correct' exposure will depend very much on the contrast range of the original; and different types of original will require different exposures for optimum results, even under identical lighting conditions. For this reason it is best to use an 18 percent grey card from which to take a basic exposure meter reading. Place this card centrally on the work to be copied, and take a reflected light reading from this. As the quality of final reproduction depends very highly on obtaining the optimum exposure, it is essential to bracket exposures by one-and-a-half stops, in half stop increments, on either side of the basic exposure.

The ideal negative is one in which the white areas of the original register as a density that will just print out pure white, while the black areas of the original produce the maximum black that the printing paper can produce. Unfortunately, the only really accurate method of testing this is to actually make a print.

Negative contrast can be controlled to some extent by development. If your resulting copy negatives are not contrasty enough, increase development by up to 50 percent. If they are too contrasty, try overexposing by up to one f-stop, and then cut the development time. You will need to experiment with your own equipment, and the type of work you copy will also have some influence on this 'fine tuning' but the effort will be well worth while.

CREATIVE POTENTIAL

The ability successfully to copy your own monochrome prints offers several real benefits, not least of which is the ability to produce a master negative of a creative monochrome print which may have required a great deal of work to produce the original. For example, a print which has required much burning-in and shading during printing may be very difficult to repeat. A copy negative of this original print will enable a virtually straight print to be produced whenever necessary, incorporating all this hand work.

Another very useful aspect is that some effects, such as print solarisation, can be impossible to repeat exactly and a copy of a successful effect-type picture will enable such a picture to be reprinted as often as required. Copying can also be used to produce master negatives of montage or multiple printing techniques, and if any retouching is carried out on the original before copying, this will be further disguised in the copy print. In a similar way, damaged or degraded photographs may be repaired and retouched, or contrast modified, and a copy will be obtained which, in many respects, is superior to the original.

Copying can be used to produce very striking results which combine perhaps, bleaching of parts of the image with artwork, and the original photographic image. Many things which are not possible either at the taking or printing stages may be carried out afterwards, and then copied to produce a negative of the finished work. The only limitation to these techniques is your own imagination!

7
PRINT FINISHING AND PRESENTATION

A photographic print is by no means finished immediately it has been printed. The final impression of the picture – the impact, style and quality – will greatly depend on the standard of print finishing, mounting and the actual style in which the picture is presented. Never underestimate the importance of these final aspects, as a picture may be made or destroyed by the final finishing and presentation. Do not, however, make the mistake of believing that a poor picture can be transformed into a masterpiece by any elaborate mounting or an unusual presentation as this is simply not true. All the same, an already good photograph, properly printed, spotted and mounted, with a carefully judged form of presentation will stand above other 'good' photographs which are not finished quite so well. This should be as important to you whether you produce prints only for yourself and family, or enter your work in local, national or international photographic exhibitions.

It would seem that although many photographers accumulate a fairly large collection of their photographs, most of these are no more than loose, unmounted and dog-eared prints. Very few people ever take the bother to finish properly their pictures. This is extremely unfortunate, for a well finished photograph demands to be looked at and will indeed be noticed. Treat print finishing and presentation with as much respect as you do the other associated techniques of photography and the rewards will be considerable.

SPOTTING

No matter how meticulous you are in your darkroom technique, almost certainly your prints will still have some small white dust spots, black marks or other imperfections that it will be necessary to remove. Spotting a print improves its appearance enormously by eliminating otherwise distracting blemishes.

Spotting is normally carried out on a dry print when the small white spots, caused either through dust on the negative or on the printing paper during printing, are 'filled-in' with many very small dots of spotting dye, or watercolour, applied on the tip of a very fine brush.

You will need one or two, good quality, very finely pointed artist's brushes. These should be size 00 or smaller. You will also need some tissue or blotting paper to wipe the brushes, a small flat dish in which to mix the colour, and either a scrap print or margin trimmings on which to test the colour. Dyes are often available in different shades of black. Some of these may be blue-black, brown or warm-black, or neutral-black. If you use different types of printing paper it may be necessary to have all of these. If you only use the one type of paper it may be possible to match a dye to this, and only buy the one colour.

Place a drop of dye in the flat mixing dish. If this does not match the tone of your printing paper, it may be necessary to add either some of the blue-black or warm-black, until the required tone is obtained – test for tone match on a scrap print or margin trimming. Begin by spotting with undi-

luted dye any spots which are in the darkest areas of the print. Dip your brush into the dye, and then wipe it almost dry on either a tissue or blotting paper, making sure that you maintain a good tip to the brush. Now very gently touch it onto the print in a series of dots. Don't try to cover a spot in one go, build up the tone slowly by applying one series of light dots, followed by another until the required density is obtained. It is most important to use the brush almost dry. If you overload with dye a blob will result. For the spots in lighter areas of the print, dilute the dye with a little water. Once again, use the same technique of building up density with a series of dots applied from an almost dry brush. Do not be in a hurry.

Black marks are a little more difficult to deal with, but if the right approach is adopted, these too can be dealt with efficiently. First, the black mark must be removed. Etching works well with small black specks or thin scratches on a fibre based printing paper. Simply scrape very gently on the surface of the paper with a sharp scalpel. Use short light strokes gradually to scrape off the black spot. Once again, take your time and don't try to dig out the spot in one go, rather gently scrape away the silver, gradually reducing the density without gouging the surface of the print. Don't try this technique with resin coated printing papers as the plastic surface will be irreparably damaged. For these, you must use some sort of bleach or reducing agent. This may be applied in a similar way to spotting, until the black mark has been totally bleached out to white. Once the black spot or scratch has been removed, it is simply a matter of spotting in the correct density with either dye or water colour.

REDUCERS

Gentle bleaches such as Falmer's Reducer may be used to lower the density of either an entire print, or small selective areas of a picture where it may be an advantage to lighten or brighten-up a highlight area.

This work should be carried out on a wet print, and it is quite common for an experienced worker to carry out this work while the print is still in the fixer bath. For the not quite so experienced it is best to start with a print after it has been fixed and washed, and the excess moisture sponged or blotted off the surface. Dilute the reducer and apply it on the moist print with a brush or cotton bud, until the required amount of reduction is obtained. If the print does not lighten enough apply a little more reducer until the required tone is obtained, then immediately immerse in fixer to halt the action. The print must, of course, be thoroughly re-washed after this operation. Do not try to over-reduce a dark area of a print, as it may begin to take on a yellow or brown stain, which cannot be removed.

TONING

Toning is an optional process which may be used for one of several reasons. These can be to alter the overall warmth or coolness of a picture, in harmony with the subject type; to provide an 'old fashioned' effect to impart mood to a picture; or to create modern dramatic impact. Some types of toner, however, produce very little real change in colour and are used primarily to preserve a print by changing the silver image to a different compound, which is longer lasting and more fade resistant.

A range of chemical toning kits are readily available in photographic shops, and these can be used to change the colour of the image to brown, sepia, red or blue. However, some toning kits are not really chemical toners but dye toners and, although these are available in a vast range of colours, it must be pointed out that unlike most chemical toners these can tint the white areas and highlights of your print. Toners which produce a chemical change to the silver crystals normally require the print to be bleached prior to the toning. Dye toners do not require this process.

It is possible to tone selectively a small area of a black and white print using one of the chemical toners, and this technique can be used to good effect to emphasise one aspect of a picture. All that

is necessary is to carefully mask any areas of the print not to be toned with either masking film or fluid. Masking film has a light tack adhesive backing to it, which enables it to be stuck securely onto the surface of the print, but allows it to be removed easily when necessary.

The entire print should first be covered with the completely transparent masking film. The area to be toned is then carefully cut out of the masking film with a sharp scalpel and removed. Be very careful to cut only through the surface of the masking film when carrying out this operation and not the surface of the print. It may take a little practice to get the feel, but once you have it this is really quite an easy task. This will leave the emulsion of the printing paper exposed in this one particular area, and the print can now be bleached and toned in the normal way, following the instructions provided with the particular kit being used. When the toning is completed, the masking film can be carefully peeled off and the print thoroughly washed. Masking fluid is used in exactly the same way, but in this case, it is painted on, and allowed to dry before the toning is carried out.

Toners such as gold toner or selenium toner alter the colour of the image very little, and are used when archival permanence is required. Although such toners are very expensive, they do provide very subtle changes in image tone which can be extremely attractive and may therefore be worth using for 'special' prints. Any kind of toning, however, demands good processing. Most importantly, a print that is to be toned must be thoroughly washed beforehand. Do not carry out any local reduction on such a print, for it will probably show in uneven toning. Likewise, any spotting may show as a different colour after toning, so it is best to leave this until toning has been completed, when it will be possible to match the colour of the spotting dye to that of the print.

PRINT BORDERS

Very little consideration is usually given to the humble print border, but this apparently insignifi-cant aspect of presentation can contribute a surprising influence to the overall impression of a photograph. The correct choice of border colour and width – combined with a complementary mount – will set off a picture to its best, and thought should be given to this.

Although it is possible to add print borders to an existing print by means of double mounting, a far more finished appearance is obtained by producing the borders during the actual printing of the photograph.

The only really satisfactory method of producing neat white print borders is to use a good quality masking frame during printing. Don't underestimate the importance of this apparently simple piece of darkroom equipment – buy a cheap one and you will almost certainly regret it every time you use it. Spend as much as you can afford on this item and, even then, check to make certain that it will perform adequately. A model with fully adjustable border widths is certainly desirable and, if you can afford it, a four-bladed model provides real value for money in its superior versatility.

Most prints with a normal and full range of tones benefit from the addition of a white border, and look attractive when mounted either on grey or black card. Predominantly dark toned pictures can look particularly striking when printed with a white border and mounted onto black card. The most common mistake made in the use of print borders is to make them too wide. This can distract the eye and take the viewer's attention away from the subject matter of the print, which should never be allowed to occur. It is worth remembering that a small print requires a very much narrower border than a large print and, even with masking frames featuring fully adjustable border widths, it may be necessary to trim the border to obtain the desired width. This is best carried out with either a steel 'straight-edge' and scalpel, or a purpose made trimmer of either the rotary or guillotine type.

A high key, or print of predominantly light tones, can often benefit from the addition of a black border which can provide a very simple yet attractive frame around the picture when mounted onto white card. There are a number of different

Three methods of producing black borders on prints *1)* Negative carrier method. *2)* Card method. *3)* Straight-edge method.

methods which can be used to produce black print borders, and all are really quite simple.

If you always print your pictures full frame (that

is using the entire area of the negative) the most simple method to use is probably to very slightly enlarge the negative frame in your enlarger's negative carrier. This can be done with a small and very fine file. Only enlarge this aperture enough to provide a suitable border around the negative, revealing an equal area of the clear negative rebate.

This method is, however, totally unsuitable if you intend to crop any of your images during printing. In which case you will have to use one of the following two methods.

The first is neatly to cut a piece of black card, slightly smaller than the size of printing paper you are using. After the initial negative exposure, simply position this piece of card over the sheet of printing paper so that an equal border of paper is revealed around all four edges of the card. Now, with the negative removed from the carrier, and the enlarger head raised up the column, open up the enlarging lens to full aperture and expose for about 15 to 20 seconds, making sure that the card is in close contact with the printing paper around all the edges. Now develop in the normal way – and you will have a black border.

Although this method can work quite well, it can be difficult to maintain close contact between the card and printing paper and, of course, you will have to ensure that you trim the card straight and very smoothly to obtain a good neat border. Another problem is that it will be necessary to cut a new piece of card for each size of print that you produce.

A second, somewhat slower alternative but one which does eliminate all the problems associated with the other methods of producing black borders is to use a steel straight-edge, somewhat longer than the longest side of the largest printing paper you are likely to use. Having made the initial exposure for the negative, remove the negative from the carrier, slide the enlarger head a little further up the column and open up the aperture of the enlarging lens to full aperture. Now, with the enlarger's red safety filter positioned beneath the lens, turn on the enlarger. Aided by the filtered light from the enlarger, position the steel straight-edge along the top edge of the sheet of printing paper leaving an equal border of paper revealed above the straight-edge. Now cover the rest of the sheet of printing paper by placing a large sheet of card over it, so that its top edge sits on top of the straight-edge. Swing the red filter away from the enlarging lens and expose for 15 to 20 seconds.

Repeat this procedure for the remaining three sides of the printing paper and then process in the normal way. You should now have a very neat and accurate black border which can be trimmed to a more narrow dimension if required. This particular method is extremely useful, in that it is readily used with any size of printing paper, and a clean straight edge is assured every time.

MOUNTING

There are several methods which can be used to mount a photographic print onto a piece of card, and the method you decide upon will depend on several things, such as expense, time, convenience and durability or permanence. Some mounting techniques require either very little or no special equipment and skills whatsoever, while others require access to quite expensive equipment.

The wet method of print mounting is commonly used, as it provides a very simple, fairly quick and certainly inexpensive means of mounting prints. However, unless a reasonable amount of care is used in the application of the adhesive, results can become rather messy.

Rubber solution/Cow Gum is probably the most commonly used mounting adhesive, and is readily obtainable from either a photographic shop or graphic art suppliers. It is first necessary to mark out the position of the print on the card mount. The adhesive is then applied to both the mount and the back of the print, in a thin but even coating. This is then allowed to dry, after which the print is placed in contact with the mount, and either rolled or gently but firmly pressed down to flatten it in place. Be careful to avoid any air bubbles. There are other similar adhesives available which may be applied in much the same way. You should, however, be careful to check that these are suitable for mounting photographs, as some adhesives may

cause staining over the course of time.

A highly satisfactory and simple to use alternative can be found in one of the spray-on adhesives which are now widely available from art suppliers. Most of these simply require an even coating of the adhesive to be sprayed onto the back of the print. After a brief period to enable the adhesive to dry the print is placed in position, and either pressed or rubbed down. Some of these spray-on mounting adhesives allow a certain amount of re-positioning to be carried out before the bond becomes permanent. These sprays, however, should be kept away from eyes and should only be used in well ventilated conditions. There will inevitably be a certain amount of over-spray of quite toxic adhesive which can, without doubt, damage your health. It is advisable to fit a good extractor fan if you have to use this type of substance in an enclosed area.

Without a doubt the best method of mounting photographic prints is with a dry mounting press and proper dry mounting tissue. Although it is possible successfully to mount smaller prints with a domestic iron, it is extremely difficult to obtain satisfactory results with larger prints in this way and access to a dry mounting press is essential. These are fairly expensive pieces of equipment, and unless you intend to mount large numbers of prints the initial outlay required to own one may not be economical.

Mounting with a dry mounting press provides the most durable and permanent bond possible, and if the correct materials are used, combined with care, the finished mounted print should last for a very long time indeed, with little likelihood of staining.

Both the print and the mount should be scrupulously clean, and both should be thoroughly dried to remove every drop of moisture before mounting begins. Resin coated printing papers are not suitable for this kind of dry mounting, due to the high temperatures involved which can melt the plastic surface of the printing paper. Only fibre based printing paper should be used, and 100 percent rag content mounting board should be used for the most permanent results. A sheet of dry mounting tissue is tacked, in one central area only, to the back

Method of producing an 'over-lay' mount A) Base mount, usually thin card. B) Print. C) Over-lay with bevel-edged aperture.

of the print with a special tacking iron. The excess tissue is then trimmed from around the edges of the print, and the print positioned on the mount. The print is then lifted carefully by one corner, without the position of the print on its mount being altered, and the tissue is lightly tacked to the mounting board with the tacking iron. The print and mount can now be placed in the mounting press, and heat applied permanently to bond the print and mount together. Be careful how the print is handled when it is removed from the press, as the bond will not be secure until the print has cooled.

A similar technique is used to dry mount with a domestic iron, but in this case you should cover the print with a smooth surfaced paper, and smooth out the print with the iron from the centre over the top of this paper being careful to remove any air bubbles.

A satisfactory alternative method of dry mounting, and one which can be used equally well for resin coated papers as it requires no heat to form the bond, is the Scotch PMA system. This material is only available from graphic art suppliers, and

comes in the form of a roll. Scotch PMA (position-able mounting adhesive) is available in widths up to 16 inches (40cm), which enables 20 × 16 in. prints to be mounted, and is an adhesive substance on a release backing paper. The adhesive is only light-tack until pressure is applied, thereby allowing accurate positioning of the print on the mount before making the bond permanent.

Simply unroll an area of the adhesive large enough for the print, and lay the print on the light-tack adhesive. Now cover the surface of the photograph with a special sheet of rubbing down paper which is provided with the kit, and apply pressure with the plastic rubber which is also provided. Next, trim the print around its edges to remove it from the roll of adhesive, and gently peel off the backing paper so that only the actual adhesive remains, evenly coated onto the back of the print. This can now be positioned onto the mounting card and, with the special paper placed over the surface of the print, pressure can be applied in even strokes to form a permanent bond. Although the initial outlay for a 30 metre roll of Scotch PMA is high a considerable number of prints may be mounted from such a roll and the unit cost of each print mounted is therefore reasonable. Furthermore, there is no mess whatsoever and certainly no health risk.

A very attractive form of print presentation can be provided by using an overlay type mount. With the use of the correct tool this can be very simple to do. The print should first be mounted normally, as described, and the overlay mount cut and glued afterwards.

Begin by accurately measuring the picture area of the photograph, excluding any print borders and transfer these measurements to the back of the board to be used for the overlay. These measurements will be the actual size of the print which will be visible through the rectangular cut-out and should therefore be measured and drawn out very precisely on the back of the overlay. The mount should then be securely attached to the work top by pushing drawing-pins through the part of the mount that is to be cut out. Space these drawing-pins so that no movement can occur during cutting. Now, with the aid of a bevel-edge cutter (which can be obtained through most drawing office supply shops), and a steel straight-edge, cut along the lines you have marked on the back of the mount, but avoid cutting too tightly into the corners, as it is very easy to over cut. A sharp razor blade or scalpel should be used to complete the corner cuts.

The bevel edged overlay mount can now be mounted over the previously mounted print, and the two pieces of card can be glued together, either by using adhesive or double-sided sticky tape. A very neat finish is obtained by trimming the edges of this double mount with a sharp scalpel, so that the edges of both the base mount and the overlay are completely flush. A bevel edged overlay, cut from black card, can look most attractive with the right choice of print with the cut edge of the bevel providing a white relief against the black mount and a dark toned photograph.

8
FOLIO SECTION

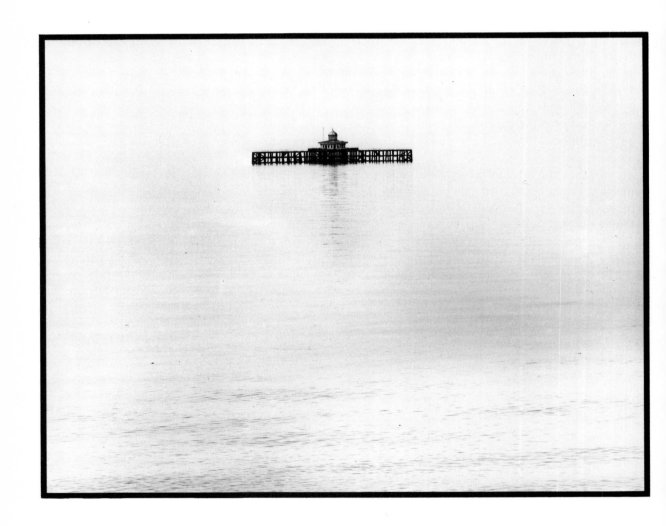

HERNE BAY PIER – END

Technical Details

Pentax 6 × 7 medium-format SLR camera
165mm – f 2.8 SMC Pentax lens
1/4 second at f 22
Ilford Pan F rated at 50 ASA/18 DIN
Developed in ID-11 diluted 1 to 1

Description

Although this picture may, at first, appear to have been taken from the seaward side of the pier it was in fact taken from the promenade. It was decided to demolish this pier when it fell into disrepair and became dangerous. However, a short section of the pier remains at the shorebound end, and is indeed still in use. The part you see here is the remains of the pier head – stranded quite some way out to sea.

The day on which this photograph was taken was one of those peculiar seashore days when both the sea and the sky appear strangely white. It was impossible to see the horizon or tell where sea met the sky, and I made good use of this phenomena to isolate completely the disconnected pier head.

Techniques

Although the light was quite bright it was necessary – due to the slow speed of film in use, and the small aperture required to obtain maximum depth-of-field – to mount the camera on a tripod. A reflected light reading was taken from the general scene, which was very light in tone. Knowing that the exposure indicated would be insufficient and would produce a tone on the negative that would reproduce a mid-grey, my exposure was increased by two f-stops to make the scene very light, much as it actually appeared.

The black border to this picture is essential as it provides the correct amount of space around the pier.

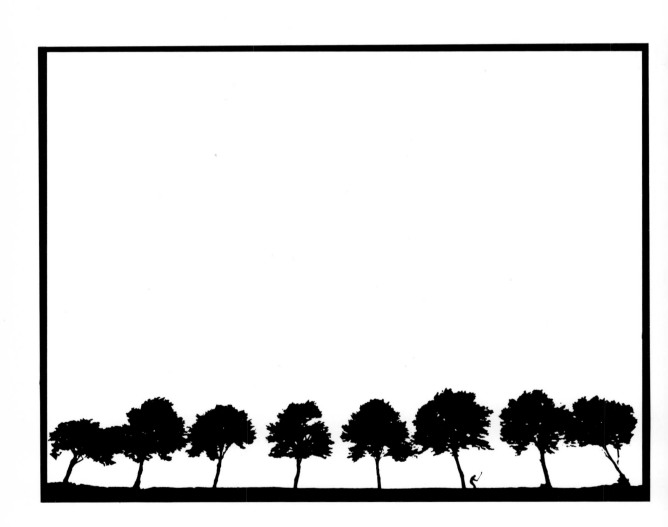

THE LAST HOLE

Technical Details

Contax RTS 35mm SLR camera
18mm – f 4 Zeiss Distagon lens
1/60 second at f 8
Ilford FP4 rated at 125 ASA/22 DIN
Developed in Acutol

Description

I have always found 'minimal' composition and almost total simplification very attractive and, for this reason, I set out to take this picture in that particular style. Well nearly!

My intention was to photograph only the row of trees without the little figure of the golfer, who only arrived on the scene at the last moment. At first I was somewhat upset that he should be spoiling my composition, not knowing at this stage that he was indeed a golfer. Suddenly I spotted the golf club just as he brought it up for a swing. Click. Couldn't be better!

Techniques

The row of trees are situated on a high ridge of land at the top of a steeply sloping field. I positioned myself a little way down the slope and took a very low viewpoint – lying face down on the wet grass. This looking-up attitude towards the trees imparted a convergence of verticals to the trees, particularly noticeable because of the extreme wide-angle lens in use, which produced a more interesting composition in that all the trees seem to lean towards the centre of the picture.

In the darkroom, a high contrast lith negative was produced from the original and the image was 'cleaned up' by removing unwanted details with liquid opaque, applied to this lith negative with a 000-sized spotting brush. In order to achieve this masking with some accuracy on the small 35mm format, the lith negative was attached by its edges with sticky tape to a light-box, and a jeweller's eye glass was used.

Technical Details

Mamiya RB67 Pro-S medium-format SLR camera
180mm – f 4.5 Sekor C lens
Studio flash at f 22
Ilford HP5 rated at 1600 ASA/31 DIN
Developed in ID-11

Description

Being always conscious of the restrictions of the viewfinder frame and the format of printing paper, I wanted to make a point of these feelings with this picture. I therefore decided to make the black border of this print the seat on which the model is posed and, at the same time, the frame through which she can be seen.

The model is behind this border at the top of the picture, and this effect has been emphasised by the hair plait hanging down into the picture. At the base of the picture however, the model is actually sitting on the border, and is therefore almost forward of the picture border.

I find it both interesting and rewarding to produce 'pictures of my personal ideas' in this way, and I know that such pictures provide me with valuable experience in producing imaginative ideas.

of the model's body.) The selected lighting set-up – combined with slight overdevelopment of the film, to increase contrast – produces an almost 'pencil drawing' effect when printed on a moderately hard grade of printing paper.

The lower black border was produced by sticky-taping two steel straight-edges together, leaving a border-width gap between them. These were then positioned on the printing paper (using the image of the negative projected through the red filter of the enlarger), to align with the top edge of the drawing board on which the model was seated. A simple card cut-out was then positioned on this to protect the image of the model's bottom. The negative was then removed from the enlarger, and a fogging exposure was given to produce the border. The remaining borders were printed in my normal manner – see last chapter.

Techniques

The model (my wife) sat on the (cold and hard) edge of my white melamine drawing board. The white wall in front of her was lit by two studio flash units and a further two flash units were used, one on either side of the model and at an angle of about 45° to her. These two lights were fitted with white 'brolly' reflectors and were positioned quite close to the model. Also on each side, and quite close to the model, were placed two black reflectors. (These black-painted sheets of hardboard absorb some of the light and help form local shadows, thereby producing a slight darkening to both sides

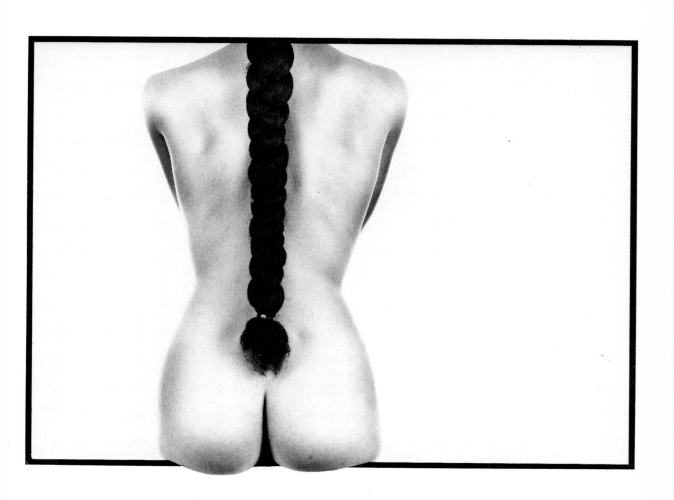

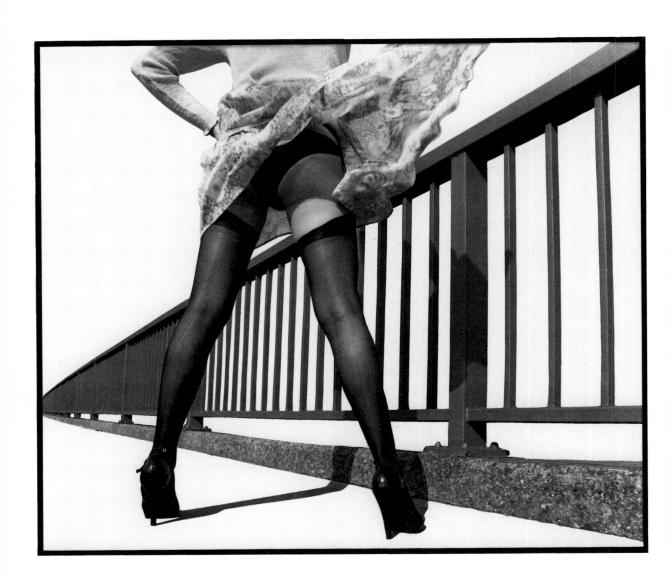

SUMMER BREEZE

Technical Details

Mamiya RB67 Pro-S medium-format SLR camera
50mm – f 4.5 Sekor C lens
1/125 second at f 16
Ilford HP5 rated at 400 ASA/27 DIN
Developed in Acutol

Description

A visually exciting image for me – not only due to the subject matter! The stark simplicity of the composition is, for me, very pleasing; but, although simplified considerably, a wealth of interest is maintained within this photograph. The elimination of all unnecessary detail has strengthened the remaining 'vital' elements of the composition. Very strong geometrical shapes are provided not only by the obvious diagonal and steep perspective of the railings, but also by the model's pose. The position of her legs in particular, her left arm and even the way in which the skirt has been blown by the wind all provide further interesting geometry in this picture.

The shadow produced by the model's left leg is an extremely important element of the picture, as it serves to produce a connection between the model and the railings. Without this connection, the picture could easily be mistaken for a montage.

Techniques

The photograph was taken from a very low viewpoint – almost at ground level – using a wide-angle lens to produce the enhanced perspective of the railings. It was an extremely windy day and the skirt was selected for its lightness, so that it would easily be blown up. However, I am certain that this was assisted by breeze from lorries which were passing very closely, all sounding their horns, and the shot was taken on a footpath at the side of a motorway.

A virtually straight print was produced, with only slight burning-in of detail to the model's skirt and the top part of her body, and this was then masked completely with Frisk masking film. All the areas that I required to be base white were then carefully cut out from the transparent masking film with the aid of a sharp scalpel. The picture was then placed in a dish containing ordinary household bleach and rocked until all the unprotected areas of the print were bleached out. The print was then thoroughly washed and the protective masking film gently peeled off.

Technical Details

Mamiya RB67 Pro-S medium-format SLR camera
90mm – f 3.8 Sekor C lens
Studio flash at f11
Ilford FP4 rated at 100 ASA/21 DIN
Developed in ID-11

Description

A fascinating picture utilising the simple graphic black and white striped design of the model's leotard and knitted leg-warmers. The angle of the model's pose harmonises nicely with the flow of the striped pattern of the garments, and the plain white background tends to push the main subject boldly towards the viewer.

Although many people condemn a picture in which no 'space' has been provided for the subject matter to move into, I find it very interesting to experiment with the positioning of the format frame around the subject. We are free as photographers to position this format frame as and where we wish, and the unusual relationship in this picture between the subject matter and this frame produces, for me, a strange sort of excitement – almost as if the subject might have been completely missed if the exposure had been made a few seconds later. The black border serves to outline the format frame, and provides an impression of space behind the model through which she may have moved.

The omission of the model's head, by positioning this just outside the corner of the frame, removes all personality from the human figure and helps to concentrate the attention on pure design.

Techniques

A very simple picture really: all that was necessary was to illuminate evenly a white wall with two studio flash units placed on each side of the wall and at an angle of about 45°. This eliminated completely the possibility of any shadows recording on the essentially plain white background.

The model herself was lit by the light reflected back from this white background to provide a very soft backlighting effect. Further fill-in light was provided by another studio flash unit placed very near the camera position and fitted with a large white brolly reflector. This fill-in light was used on half power setting.

Very slight overexposure was given and the film was then slightly overdeveloped (by about 20%) to increase contrast.

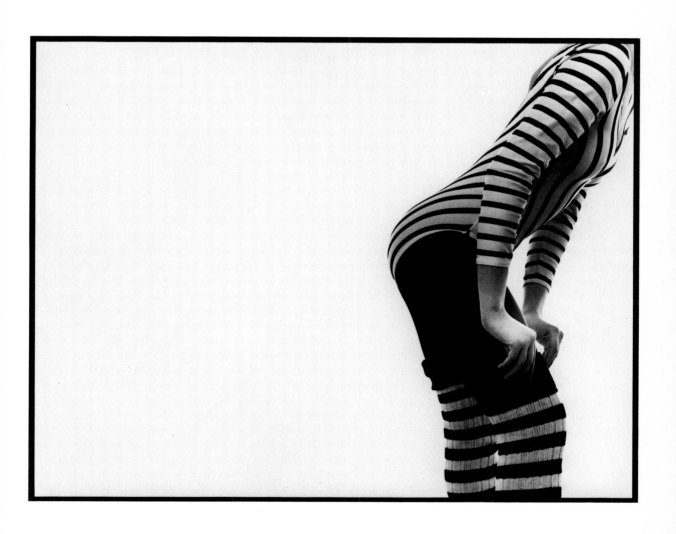

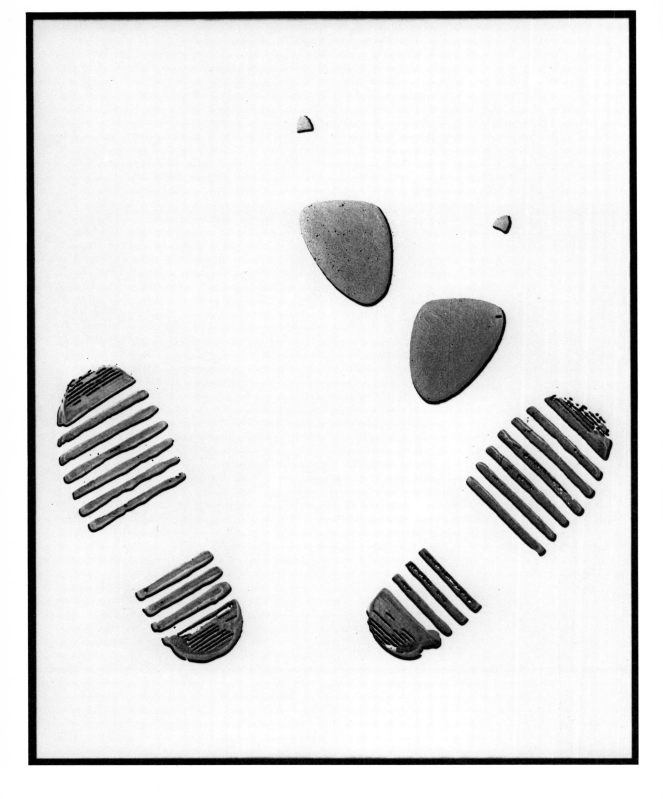

THE MEETING

Technical Details

Mamiya RB67 Pro-S medium-format SLR camera
90mm – f 3.8 Sekor C lens
Studio flash at f 16
Ilford FP4 rated at 64 ASA/19 DIN
Developed in Perceptol

Description

A preconceived idea intended to be symbolic of a meeting – perhaps between lovers – without actually including people in the picture.

The choice of shoes to make the footprints, and their careful positioning, clearly illustrate just such a meeting and, at the same time, form a very simple and graphic style of composition.

It is sometimes surprising to me that such a simple picture can be appealing to other viewers, but it is some indication of the success of this shot in that it has been almost universally liked by everybody who has seen it.

Techniques

Dark coloured emulsion paint (which is water washable) was used to produce the original footprints. Both my wife and myself stood in a shallow tray of this paint, and then transferred our footprints, in the desired position, onto a large sheet of white card. This left an impression which picked out every detail of texture from the bottoms of our shoes. The footprints were then simply copied using two electronic flash heads for lighting.

From this original half tone negative, a high contrast lith film negative was produced. This was bound together with the original negative, very slightly out of register, to produce a thin black line around some of the edges of the image, which gives a slight impression of depth to the finished picture.

PINE CONES

Technical Details

Contax RTS 35mm SLR camera
50mm – f 1.4 Zeiss Planar lens
1/15 second at f 8
Ilford FP4 rated at 125 ASA/22 DIN
Developed in Acutol

Description

A simple and pleasing still life picture which, through the use of a limited range of tones, exhibits quite strong graphic impact.

Although there are four main elements in this picture and four is often considered unsatisfactory, in this instance, the grouping of these elements within the composition produces a pleasing design. The group of three pine cones situated at the bottom of the picture provides a solid base and the single cone positioned separately at the top is neatly linked by the stem of grass, thereby tying the composition together.

Techniques

This is one of the few instances where I have used tungsten lighting rather than flash as, in this case, I felt that more control was possible with a tungsten type of system.

The pine cones and grass were laid on a piece of white card in the desired position, and a further piece of white card was suspended some way above this. Two photofloods were then positioned pointing upwards onto the piece of suspended card. This provided extremely soft bounced lighting almost directly from above, producing an almost shadowless and fairly low contrast result.

To boost contrast, a print was made on a hard grade of printing paper and this was then copied onto Ilford Pan F film and developed for high contrast. From this resulting negative, satisfactory prints were produced of the required limited tonal range.

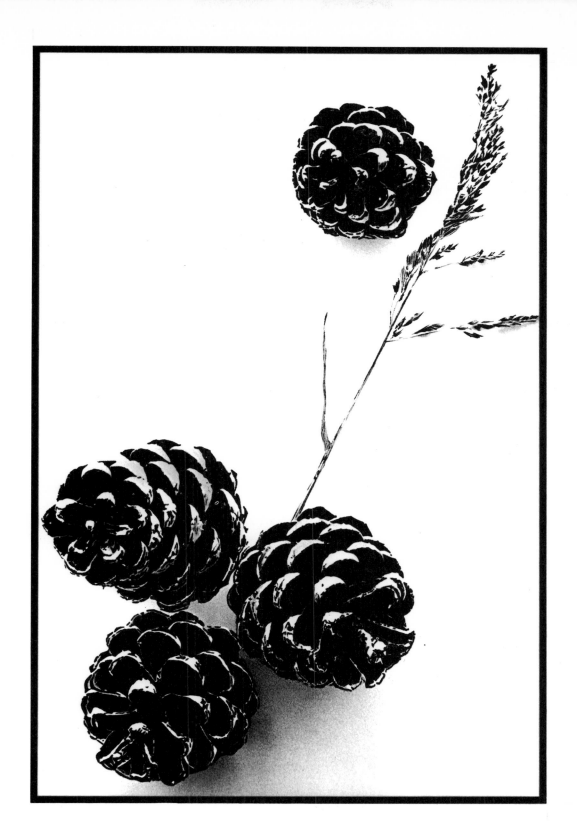

Technical Details

Contax RTS 35mm SLR camera
16mm – f 2.8 Zeiss F-Distagon lens
1/60 second at f 16 with red filter
Ilford HP5 rated at 1600 ASA/33 DIN
Developed in Microphen

Description

The local castle at Rochester in Kent has been photographed countless times before, and it was a challenge to attempt something different in the way of an image of this mighty Norman keep.

I wanted to try to put over some of the feeling of dominance that this castle still has over the River Medway, and the threatening feeling that it must have produced in the hearts of the conquered or any would-be conquerors. It works for me, and I hope it does for you.

Techniques

With a full frame fish-eye lens fitted to my camera to provide extremely steep perspective, a viewpoint was selected at the very base of the keep so that a 'looking up' attitude would be adopted. A red filter was used to darken the blue sky to almost black, and this is what has become the 'black cloud' above the castle.

In my darkroom, a high contrast lith negative was produced from the original and all unwanted detail including other areas of sky were masked out with liquid opaque.

The addition of the black border is an essential part of this composition, providing a certain amount of space for the keep. By uprating the film and using a speed increasing developer, a very coarse grain structure has been produced. This further assists the feeling of foreboding, particularly in the black cloud.

Technical Details

Contax RTS 35mm SLR camera
25mm – f 2.8 Zeiss Distagon lens
1/60 second at f 11
Ilford HP5 rated at 400 ASA/27 DIN
Developed in ID-11

Description

The already very strong geometrical design of this building was considerably strengthened by the very powerful diagonal composition and the total simplification of tone to pure black and white.

The design and construction of the factory provide plenty of interest in the mass of vertical lines and the contrasting white band which runs the length of the upper half of the building, and this lends itself very well indeed to the high contrast treatment given and provides an extremely dramatic composition.

The blank white sky is as important as the image of the factory itself in providing a balance to the composition. It is worth noting that it is necessary for this triangular white area to be somewhat less in proportion than the factory, which is predominantly darker in tone. This is because with an equal area of black and white, the white area will always appear to be visually the larger of the two.

Techniques

Once again, a wide-angle lens was used from a close viewpoint to emphasise the effect of perspective. The camera was tilted slightly to produce the diagonal composition. This, however, could only be achieved successfully because the ground was not to be included in the picture.

A high contrast lith negative was produced by contacting from the original negative and all unwanted detail was blocked out by painting over these areas with liquid opaque. A high contrast print may be produced on almost any grade of printing paper from this lith negative – as the negative only contains the two extremes of black and white.

Technical Details

Mamiya RB67 Pro-S medium-format SLR camera
50mm – f 4.5 Sekor C lens
Studio flash at f 32
Ilford Pan F rated at 25 ASA/15 DIN
Developed in Perceptol

Description

A totally preconceived idea designed to illustrate the use of black borders as an integral part of a composition.

The very steep perspective of the timber board leads the viewer's eye straight to the further black border and the pot of paint. This inner black border has been left incomplete as a means of producing a sense of time – as if the author of the picture has just left the scene, and may perhaps return in a short while. The brush resting in the paint pot reinforces this feeling.

Techniques

A six foot/two metre length of board was purchased new from a timber yard, so that I could select the grain I preferred. Also purchased especially for the picture were the paint pot, brush and a small tin of black paint (no expense spared!).

These items were then set up as seen in the photograph but, at this stage, resting across the top of two chair backs. They were then photographed with a wide-angle lens to produce the enhanced perspective. Two studio flash heads were used for the illumination. Due to the very small lens aperture required to provide the necessary depth-of-field, and the slow speed of film in use, it was necessary to fire the flashes four separate times in a darkened room while the camera's shutter was locked open on the 'time' setting. This enabled the exposure to be built up, as my flash units were not powerful enough to provide enough light in a single flash for this film/aperture combination.

A large print was then produced, and the board and paint pot were carefully cut out from this with a scalpel. The cut-out was then mounted onto a sheet of white card and the black borders added by drawing them in with a draughtsman's pen. The work was then copied to produce a master negative.

Technical Details

Mamiya RB67 Pro-S medium-format SLR camera
90mm – f 3.8 Sekor C lens
Studio flash at f 11
Kodak Tri-X professional – 320 ASA/26 DIN
Developed in Acutol

Description

A light-hearted picture this one, although the reasons for taking it are sincere enough.

In all of my photography I am – as I have said – always very aware of the limitations or restrictions imposed by both the frame of the viewfinder and the shape of the printing paper on which the picture is to be printed. This is my own way of illustrating these limitations and the need to try to expand beyond them. I am still left with the feeling, ultimately, that we are always to be confined by this border.

Techniques

In order to obtain a realistic stretching of the black border, a piece of thin black card was used from which the thin border was trimmed with a sharp scalpel and a straight-edge. Double sided sticky tape was then fixed to the back of this border. It was then a fairly simple matter to mount the border, in a stretched fashion, onto a large sheet of thick white card. The area of card inside this border was then removed with the scalpel, and an unsuspecting friend was enlisted to act as a model.

A plain white wall was lit by two studio flash units set up to provide bright even illumination and my model was positioned in front of this background, holding the cut-out in front of him. A third flash, fitted with a brolly reflector, was used to provide the lighting for the card and a flash-meter reading was taken from this to obtain the correct exposure.

A high contrast lith negative was produced from the original, and all unwanted detail was blocked out using liquid opaque. This lith negative is now the master from which prints are produced.

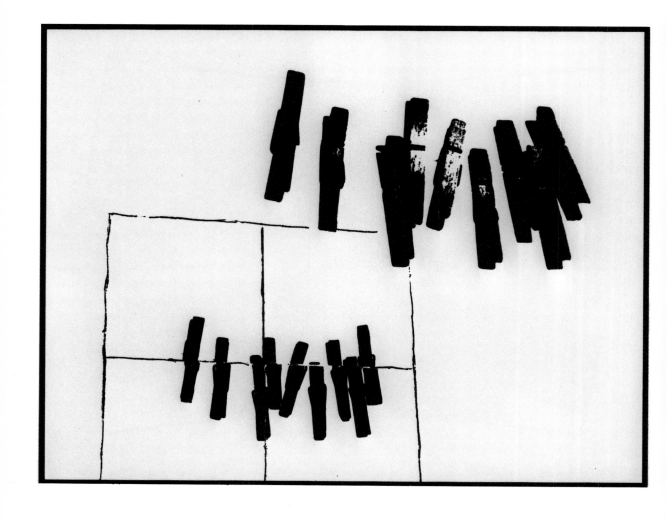

Technical Details

Contax RTS 35mm SLR camera
50mm – f 1.4 Zeiss Planar lens
1/2 second at f 16
Ilford FP4 rated at 200 ASA/24 DIN
Developed in Microphen

Description

A very 'strange' sort of picture which has proved quite controversial. While many people do, in fact, like this picture there are also a great many who don't and who wonder why on earth I bothered to take it. I will endeavour to explain!

This is a 'found' picture within my own home. A length of string had been fixed over the bath from which I hung my films to dry. It was only months later that I noticed the unusual composition produced from the reflection of these pegs in part of a panel of mirror-tiles on the bathroom wall. Although I immediately liked this composition, I realised that there were far too many distractions, all of which tended to break up the simple graphic picture I required. For this reason I decided to simplify the picture to pure black and white.

This simplification has been taken to the point of removing from the picture the string on which the pegs are suspended – as I found that it seemed to cause an imbalance within the composition. As the picture stands, I like the simple repeated image of the pegs – one large and one small – which are ideally positioned in the picture area. The black outlined squares of the mirror-tiles bring a further shape into the picture, and serve to confine the smaller image of the reflected pegs. The black border itself reflects this, and contains the entire composition.

Techniques

The camera was placed on a tripod, as a long exposure was necessary in order to be able to select an aperture which would provide enough depth-of-field. A mixture of available daylight from the bathroom window and flash was used for the exposure for, although the wall on which the mirror-tiles were situated was white, the opposite wall which was reflected in these tiles was covered with a heavily patterned wallpaper. To eliminate this from my picture it was necessary to position a large piece of white card so that this would reflect in the mirror-tiles instead of the patterned paper. A small flashgun was fired onto this card during the main exposure to ensure that it reproduced as white.

A high contrast lith negative was produced in the darkroom from the original and all unwanted detail removed by blocking out with liquid opaque.

Technical Details

Mamiya RB67 Pro-S medium-format SLR camera
180mm – f 4.5 Sekor C lens
Studio flash at f 22
Ilford FP4 rated at 125 ASA/22 DIN
Developed in ID-11

Description

Because I use black borders extensively in many of my compositions I decided to produce an 'ultimate' black border image, making such a border the prime subject matter. I tend not to read things into my own work but in many ways this picture is almost symbolic of my views of monochrome creativity in its embryonic stage. The sheet of unexposed printing paper (other than the border outlining the limitations of the format) hanging from the line represents to me the freedom we have to put onto this, our own personal choice of image, and the drip might indicate this image to be 'in the making'.

Interestingly, this picture proved highly controversial, and while it is generally quite popular it does, at the same time, still attract extreme and often harsh criticism from some people. I have been informed that some of these critics have still been talking about this picture weeks after having seen it. Odd how a simple picture can arouse some people isn't it!

Techniques

A six by four inch sheet of printing paper was printed with only a black border, and this was mounted onto a piece of thin card to make it more rigid. A thin piece of black cord was then strung across the backs of two chairs which were placed back to back in my studio, and the 'print' was hung from this cord by a black-painted clothes peg. The white wall behind this set-up was lit by two flash units, and the 'print' and peg, etc were lit with another studio flash unit. The indicated exposure by my flash meter was increased by two f-stops to ensure that true white was recorded.

In the darkroom a print of this was produced complete with an outer black border, and when this was dry and mounted, the shadow and drip were added by using a useful graphic-arts industry material – low tack, transparent 'ruby' (red) plastic film. The drip was a simple cut-out of white paper. When photographed with panchromatic film, the ruby reproduces as a mid to dark grey.

Finally, the work was copied to produce a master negative from which straight prints can now be produced.

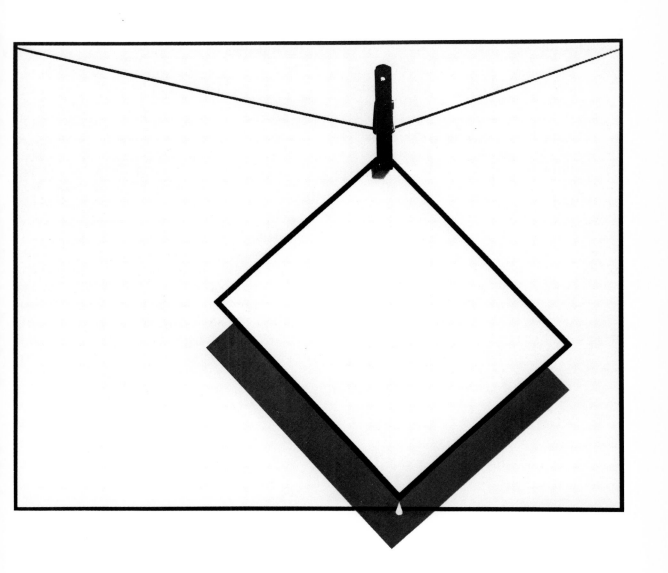

NO TITLE I

Technical Details

Contax RTS 35mm SLR camera
50mm – f 1.4 Zeiss Planar lens
Flash at f 11
Ilford Pan F rated at 50 ASA/18 DIN
Developed in Acutol

Description

A very simple nude study in fairly traditional style, which exhibits strong impact from the unusual lighting technique. The double side lighting has outlined the model's shape, making her stand out very strongly from the black background. The oblique angle of the lighting has also produced very good texture detail, making the skin's surface clearly visible.

Techniques

The model was positioned some way in front of a large piece of black fabric, which was pinned to a wall. In front of the model, between her and the background, were positioned two small portable flashguns. These were of the type normally used in the hot shoe of a camera and, for convenience, were fitted via adaptors to lighting stands. These lights were positioned pointing towards the front of the model and at an angle of about 45° to her. No further fill-in light was used as little detail was required on the back of the model.

The picture was taken during the winter months and the studio was deliberately left unheated – to produce the goose pimples. Fine grain film and an acutance type developer were used to render sharply the fine detail and the texture of the model's skin.

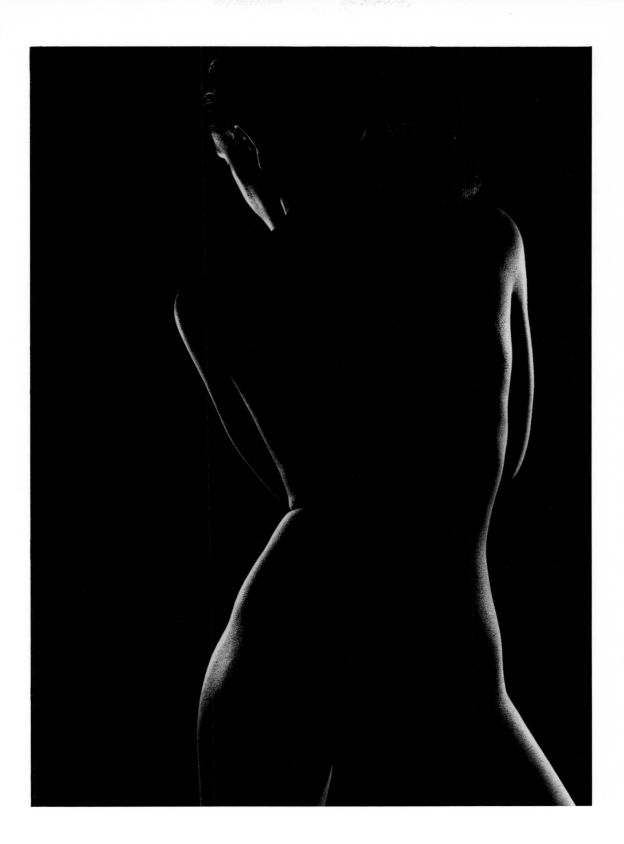

NUDE TORSO

Technical Details

Mamiya C220 medium-format TLR camera
80mm – f 2.8 Sekor lenses
Studio flash at f 16
Kodak Tri X Professional – 320 ASA/26 DIN
Developed in Ilfosol 2

Description

In almost classic style – with the lighting designed to show the shape and form of the figure, and pick out every detail – this is, once again, aimed at clearly showing the texture of the model's skin. A pleasing 'S' shape has been produced by the model's pose and by careful choice of camera angle and viewpoint.

Techniques

The model was positioned some way in front of a dark background and was lit by two studio flash units. One of these units was positioned to the left of the model some way behind her, while the other was placed in a similar position on her right-hand side. Each of the lights was moved nearer or farther away from the model, while the lighting balance was observed with the aid of the modelling lamps of the studio flash units. Once the lighting was satisfactory, a single flash-meter reading was then taken from the front of the model, and exposure was chosen in accordance with this measurement.

Although a fairly fast film was used for this picture, the larger 6 × 6cm negative ensures that there is plenty of sharp detail.

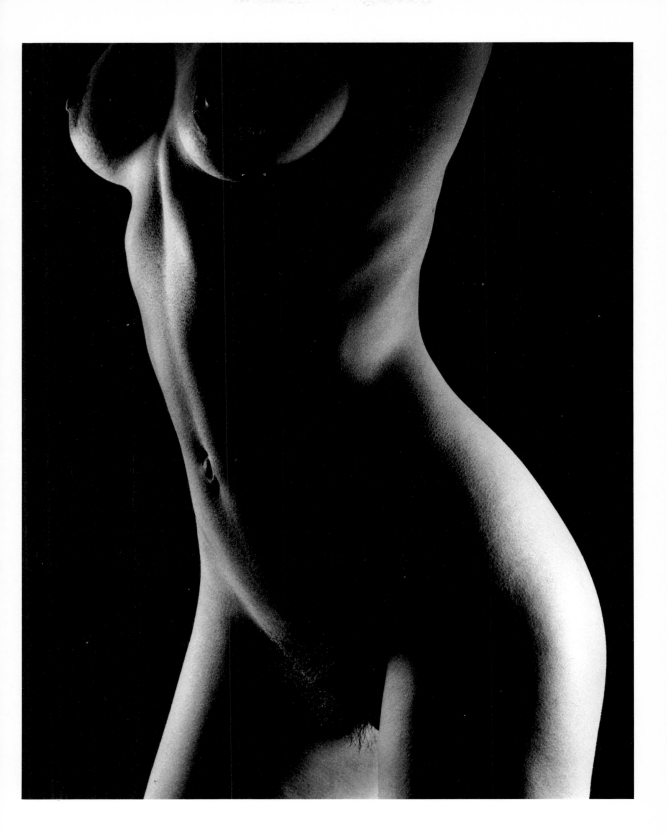

NUDE ON A STAIRCASE I

Technical Details

Contax RTS 35mm SLR camera
85mm – f 1.4 Zeiss Planar lens
1/60 second at f 8
Ilford HP5 rated at 1600 ASA/33 DIN
Developed in Acuspeed

Description

An unusually produced and successfully eye-catching composition, achieved by positioning the main subject within a triangular shape formed in one corner of the picture. With almost two thirds of the picture being black, the viewer's attention is immediately drawn to the lighter toned triangle.

This is a pre-visualised picture and so totally 'contrived' in the true sense of the word. The staircase did not, in fact, really exist at all and was manufactured merely to achieve this end result.

Techniques

The picture was taken by available light from a skylight window above and in front of the model, and the low light level made it necessary to uprate the film speed in order to obtain a satisfactory exposure.

The model was positioned on two piles of bricks, to create the impression that she was walking up a flight of stairs, and a viewpoint was selected from outside of the room in which the model was situated: the picture was taken through an open doorway, at floor level, to provide the slightly 'looking up' attitude.

The staircase was produced on my drawing board to the required scale using pen and ink, and this drawing was then copied. A high contrast lith negative was then produced from this, on which the staircase was clear film and the area in which the model would be placed was opaque. It was then simply a matter of first making an exposure on a sheet of printing paper for the picture of the model, and then replacing this first negative with the lith negative of the stairs. A further exposure was then made to provide the black of the staircase – the opaque area of the lith negative providing a protective mask for the image of the model.

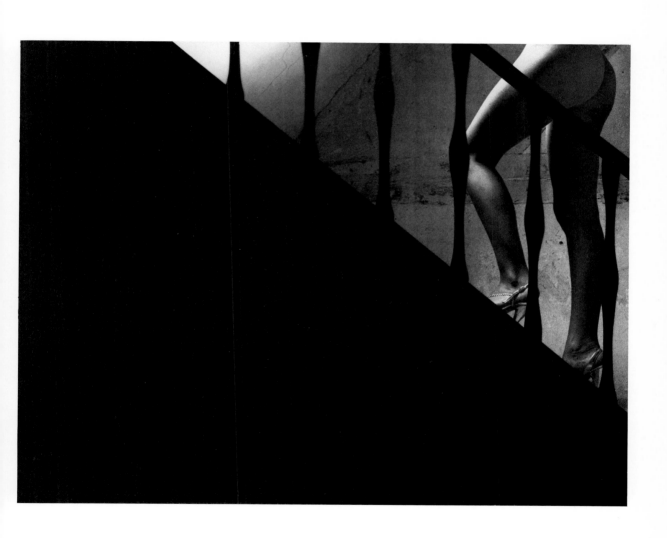

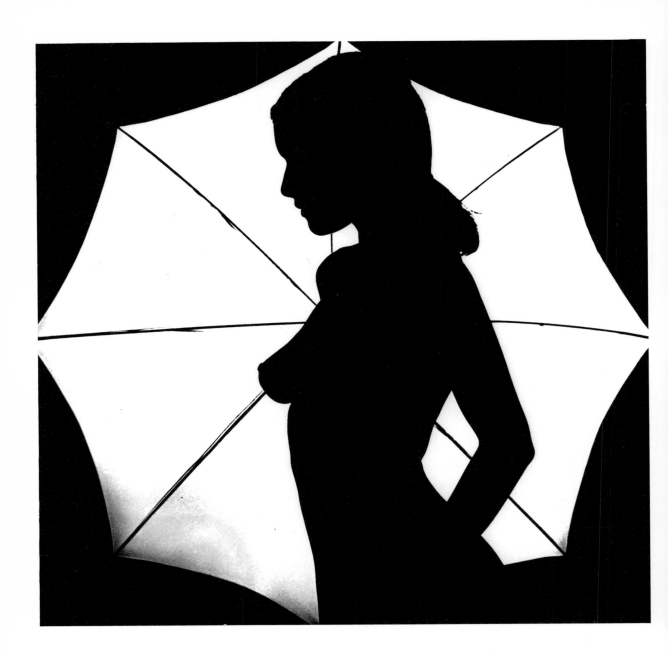

THE MODEL

Technical Details

Mamiya C220 medium-format TLR camera
180mm – f 4.5 Sekor lenses
Studio flash at f 22
Ilford FP4 rated at 125 ASA/22 DIN
Developed in ID-11

Description

Very simple pictures are often the most successful, and this picture is simple both in its content and tonal range.

The almost circular shape of the white umbrella forms a graphic shape within the black square of the background, producing a very bold image. The black radiating lines of the brolly's structure form a central point of interest somewhere within the figure of the model, which draws full attention to the beautifully silhouetted shape of the female figure.

Techniques

The picture was taken in a darkened room. A large piece of black material was pinned up behind the umbrella to eliminate the possibility of any of the surrounding room recording on film. A fast shutter speed was selected on the camera's leaf-type shutter, to cut down the possibility of any ambient light recording.

Fairly long focal length lenses were used on the twin lens reflex camera, to provide a suitable perspective – shorter focal length lenses produced too small an image of the brolly – and even with the 180mm lenses the positioning of the model in relation to the brolly was critical in producing the correct ratio in size between the model and brolly.

Exposure was set to provide very slight detail in the white canopy of the brolly as this ensured that when the print was produced on a fairly hard grade of printing paper, full detail of the brolly's spine structure would be recorded, while the model herself remained in full silhouette.

NO TITLE II

Technical Details
Mamiya C220 medium-format TLR camera
180mm – f4.5 Sekor lenses
Studio flash at f16
Ilford Pan F rated at 50 ASA/18 DIN
Developed in Acutol

Description

A near abstract nude study which – once again! – proved highly controversial. The idea behind this shot was to produce a black wavy line across a sheet of white paper, and to give this black line sexuality. The inclusion of the single highlight on the model's thigh and the pubic hair are very important to this image.

This picture has been entered for three international photographic exhibitions. In one it received the minimum marks and was rejected; in another it attained a mark just below the acceptance level; and in another it received very near maximum marks possible and was highly commended. Which gives you some indication of the subjectivity of photography!

Techniques

A white wall was evenly illuminated by two studio flash units, and the model was positioned a few feet in front of this wall. An exposure reading was obtained with a flash meter from the wall, and this reading was modified to over-expose the background in order to obtain a clean white background, leaving the figure to remain in silhouette. A piece of white card was positioned in front of the model to reflect a little light onto her thigh. This highlight was further lightened during printing by the application of a little potassium ferricyanide bleach while the print was still in the fixer. The print was simply lifted from the solution to apply the bleach, and then dropped back in to halt the action of the bleach.

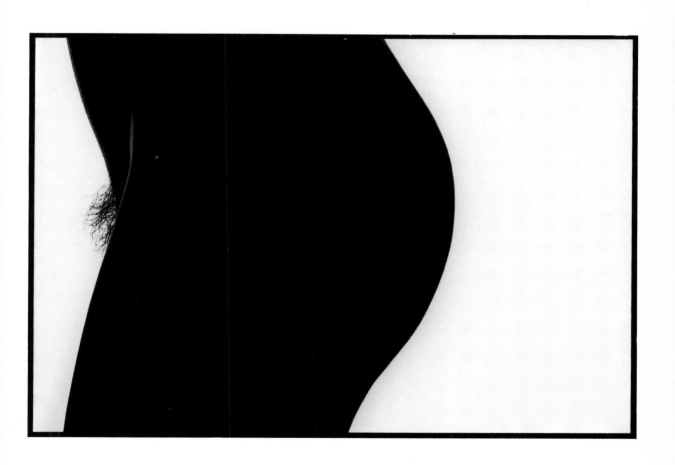

Technical Details

Contax RTS 35mm SLR camera
85mm – f 1.4 Zeiss Planar lens
Studio flash at f 8
Ilford Pan F rated at 50 ASA/18 DIN
Developed in ID-11

Description

A portrait which uses predominantly light tones throughout to emphasise the few but more important dark tones. The facial features are almost held in their position by the use of a black feathered hat and velvet choker. The viewer's attention is drawn to the model's eyes by the pattern created by the net of the girl's hat, and the slightly-angled head position tends to provoke a similar reaction from viewers.

The thin black border around this picture neatly complements the important dark areas contained within the picture itself.

Techniques

The model was positioned in front of a white background which was lit by two studio flash units to provide a shadow-free background. The model was then lit by a single studio flash unit fitted with a large white umbrella reflector, positioned in front and slightly to one side of the model. Some fill-in was provided by a white free-standing reflector which was positioned on the other side of the model.

Both the model's clothing and her make-up were carefully chosen to suit the effect required, and the film was given generous exposure with slight over-development to increase the contrast further. This did, however, result in a negative which required some burning-in on the lighter toned areas of the image to record hints of detail.

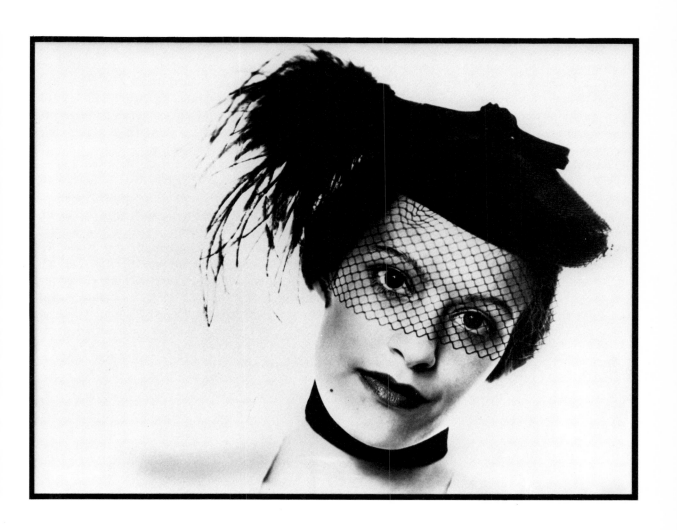

LA FEMME

Technical Details

Contax RTS 35mm SLR camera
85mm – f 1.4 Zeiss Planar lens
Studio flash at f 11
Ilford HP5 rated at 400 ASA/27 DIN
Developed in ID-11

Description

An unusual graphic composition based around the female face. The strongest elements of the human face are, without a doubt, the eyes and mouth, and for this picture I wanted to achieve a very bold and simplified composition while still retaining some of the personality of the model. I think this has worked and, indeed, feel that the essential elements have been enhanced by the exclusion of all unnecessary detail. The hair acts as a frame for the model's face, and also further enhances the starkness of the main features and the sweep of the facial shape. The picture is made even stronger by the fact that it seems to look straight back at the viewer.

Techniques

Taken in the studio using one flash unit fitted with a white brolly, positioned directly in front of the model and slightly higher than her face. A second flash unit was placed directly behind the model's head to provide back-lighting, which has produced the small highlights in her hair.

Normal exposure was given, but the film was over-developed by 50%, to increase contrast to a level which would normally be considered unacceptable: which allows the face to print 'very white' on a hard grade of printing paper. Ilford Multigrade printing paper was used with a number 4 filter in the enlarger to produce the high contrast of the main part of the picture and the model's lips were printed-in for a further 10 seconds, with no contrast filter in the enlarger. A simple lip-shaped cutout in a large piece of opaque card was used to achieve the required masking for this extra exposure during the printing-in.

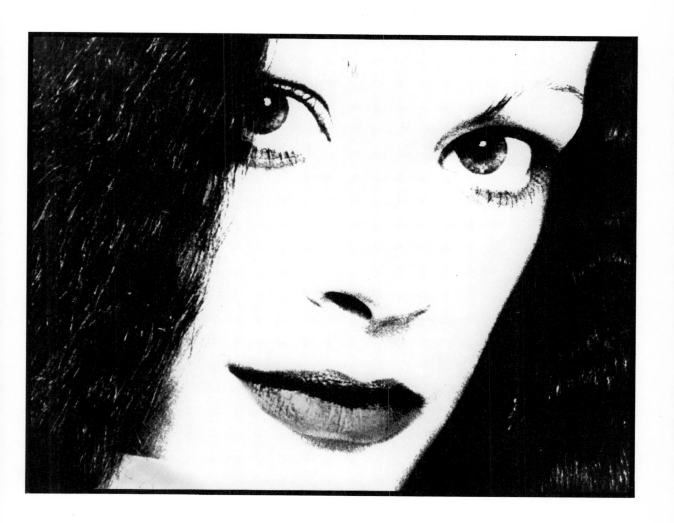

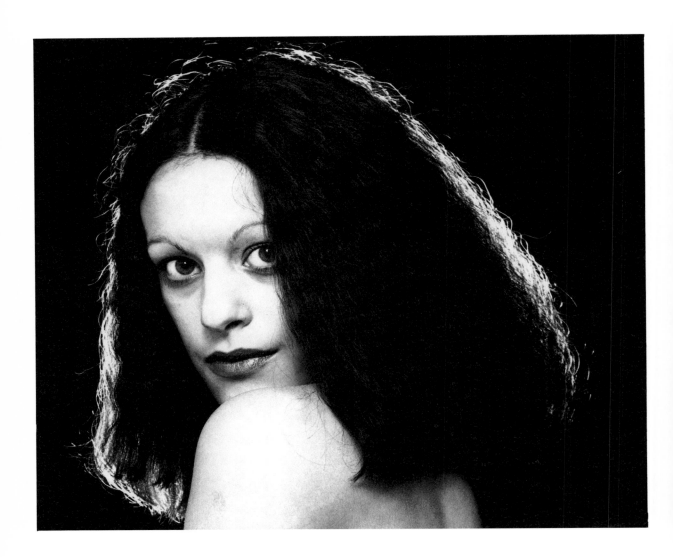

LOOK BACK WITH FONDNESS

Technical Details

Contax RTS 35mm SLR camera
85mm – f 1.4 Zeiss Planar lens
Studio flash at f 8
Ilford FP4 rated at 200 ASA/24 DIN
Developed in Microphen

Description

A very personal portrait for me of Angela who looks after our son Jay and yet still finds time to model for me. I particularly like the mood of this picture, as it does seem to capture a strong impression of Angela's personality. Interest is added to this portrait by the fact that the model is looking back at the viewer over her shoulder and this, combined with her direct glance towards the camera, produces a sense of involvement.

The use of fairly strong backlighting for her hair has created some pleasing highlights, which help to separate the hair from the black background. At the same time, this produces some very interesting angles within the composition.

Techniques

The model was positioned in front of a black fabric background and lit by a single studio flash unit, which was fitted with a large white brolly reflector, positioned directly in front and slightly above her head. Some fill-in lighting was provided by placing a free-standing reflector to one side of the model, and the halo rim lighting effect was produced with a single flash unit placed almost directly behind her hair.

A short telephoto lens was used to help compress perspective a little, thereby avoiding the problem of her shoulder appearing over-large, which would have occurred if a lens of shorter focal length had been used.

A medium speed film was used, and this was slightly push-processed to increase the contrast, producing a more lively quality. The print was produced on a grade three printing paper to further enhance this effect.

ANGELA REBECCA FERNANDEZ

Technical Details

Mamiya C220 medium-format TLR camera
180mm – f 4.5 Sekor lenses
Studio flash at f 16
Kodak Tri-X professional – 320 ASA/26 DIN
Developed in Ilfosol 2

Description

Once again I have tried to produce a slightly un-usual style of female portrait. Both the very hard directional lighting and the extremely low camera angle help to achieve a picture which is a little different.

The angle of the model's head has produced a strong sense of compositions, while the lighting has made a subtle but important feature of the model's hair.

Although the classic sin in portraiture of a low-camera angle has almost produced an effect of look-ing up the sitter's nostrils, this has been controlled by the use of lighting.

Techniques

A single studio electonic flash unit was used, with an ordinary reflector to provide the fairly hard and directional lighting needed. The reflector was positioned very slightly to one side, and quite high above the model. Exposure for this single light was measured with a flash meter directed towards the camera from the position of the model's face.

During printing it was necessary to burn-in parts of the lower half of the picture to tone down the highlight areas on the model's neck and chest. This helped to eliminate distracting detail and concen-trate attention on the model's face.

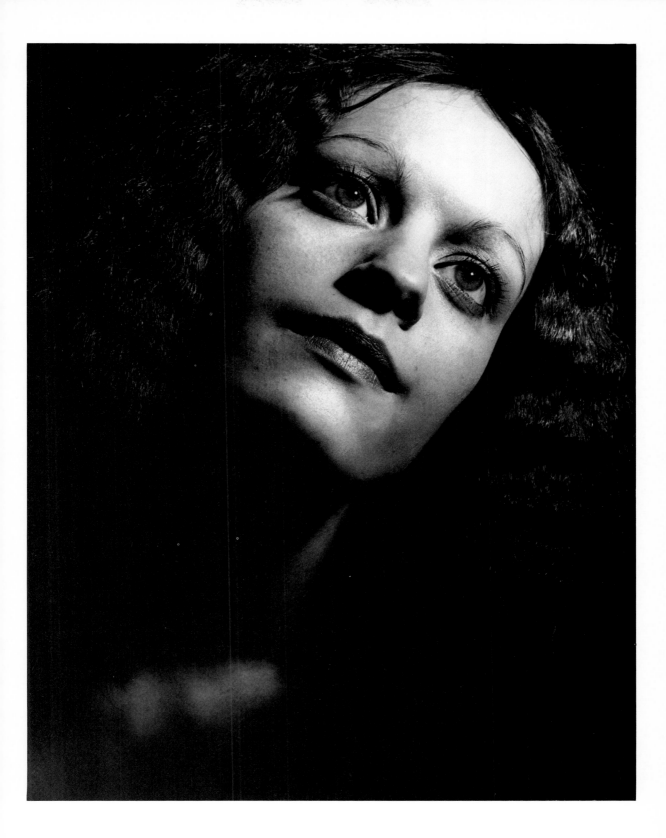

Technical Details

Contax RTS 35mm SLR camera
85mm – f 1.4 Zeiss Planar lens
Studio flash at f 11
Ilford FP4 rated at 100 ASA/21 DIN
Developed in Acutol

Description

This picture was preconceived with the intention of creating a sense of both drama and mystery, along with a very strong graphic impact. The eyes, which are essentially the most important element in almost any picture of a person, have deliberately been omitted by the use of the dark glasses. This has removed all personality from the picture, and immediately imparts a feeling of almost sinister mystery. This feeling has been further enhanced by the addition of the star bursts, which also help to give the picture a very strong point of interest where we would normally expect to see the person's eyes.

Techniques

A studio shot taken by a single electronic flash fitted with a diffusion panel. The model was wearing very light facial make-up with a very dark lipstick to enhance the desired effect. A large piece of black material was draped around the model and positioned around her neck so that virtually only her face would record on the film. The sun glasses were spray painted matt black so that no detail would be visible through these whatsoever.

The single studio flash was positioned slightly above and directly in front of the model's face, at a distance of approximately 3 feet/1 metre. Exposure was measured with a flash meter and the indicated exposure was given. The film, however, was deliberately overdeveloped by 50 percent to increase contrast.

From this resulting negative a 20×16 in. print was produced, and the star burst effects were added to this with an artist's air brush. The print was then copied to produce a master negative.

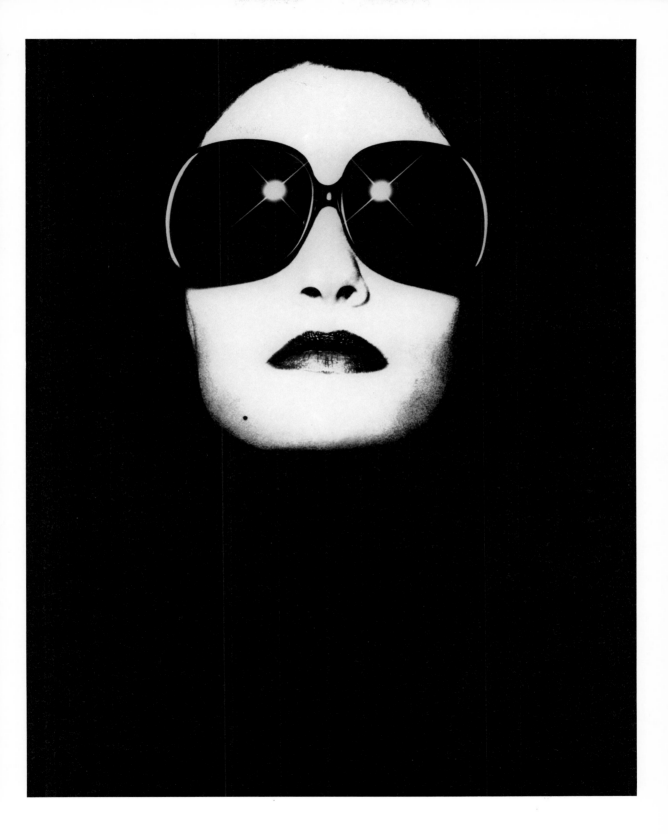

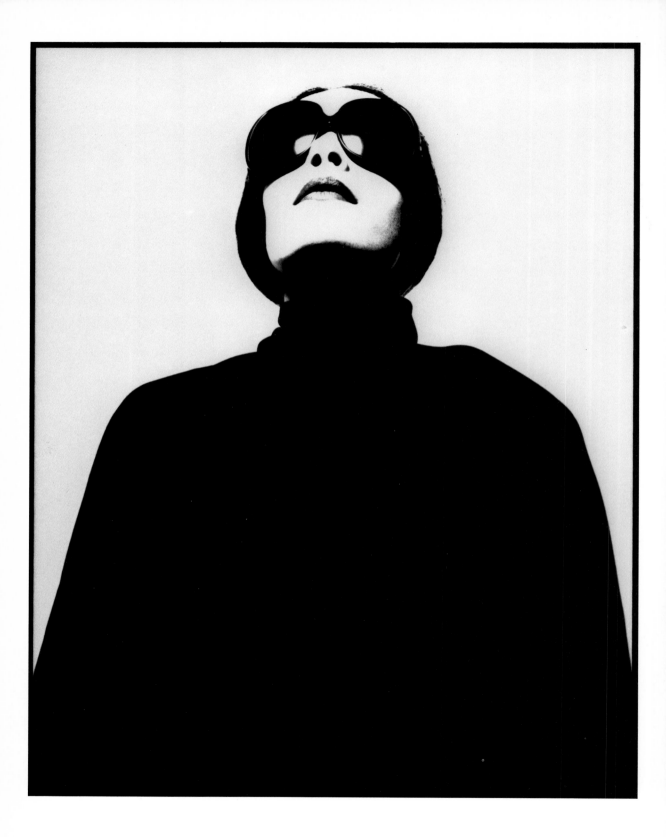

SHADES II

Technical Details

Contax RTS 35mm SLR camera
35mm – f 2.8 Zeiss Distagon lens
Studio flash at f 11
Ilford Pan F rated at 50 ASA/18 DIN
Developed in ID-11

Description

I find this a very exciting, bold and mysterious image. I don't really know why I took it, it just seemed a good idea at the time and it still does! Although this type of picture does not really mean very much, it does not have to: it is simply interesting to look at.

Techniques

A white painted wall was evenly lit with two studio flash units and the model was positioned a little way in front of this. A third flash unit, fitted with a standard reflector, was placed directly in front and quite high above the model.

With the model draped in a large piece of black material, and wearing matt black-painted glasses, a very low viewpoint was selected from which to take the picture. This has added a steep 'looking up' perspective, which helps add both a sense of drama and mystery to the picture.

Although exposure was as indicated by a flash meter reading, 50% extra development was given to the film to increase the contrast, and the print was then made on a fairly hard grade of printing paper.

Technical Details

Pentax 6 × 7 medium-format SLR camera
90mm – f 2.8 SMC Takumar lens
1/250 second at f 4
Ilford HP5 rated at 1600 ASA/33 DIN
Developed in ID-11

Description

An extremely unusual effect has been created by using the technique of 'de-focusing', and rather than producing a single image of this type I have produced a set of pictures which are held together not only by the use of this technique but also through the choice of subject matter, poses and style of presentation.

It is worth noting that several motifs which are evident in much of my other work are effectively incorporated into this set of pictures, the use of white backgrounds – which permit the single, darker, element of the main subject to stand out boldly, producing a highly simplified style of composition – the thin black border surrounding all the pictures, and the use of this black border in some of the pictures as an integral part of the composition. All of these are characteristic of my work, and clearly illustrate how, for photographers, certain elements of technique or style, which have gradually developed as you build up your creative ability, later affect the majority of images produced. Sometimes this may be very subtle indeed, in other cases it may be an obvious and very deliberate exploitation of these characteristics – as is evident in this particular set of pictures.

The technique of de-focusing can produce a truly beautiful fluidity to the picture, almost as if the image is melting or dissolving. Shape and tone are subtly blended to produce a highly simplified impressionistic style of picture which, I feel, is ideally suited to the mysteries of the female subject. Poses, and clothing if used, must be very carefully selected to suit this effect, and the model's limbs should have adequate separation from the torso if they are not to become confusingly blended into the body.

Techniques

Contrary to what one might at first believe, the technique of de-focusing is not simply a matter of taking an out-of-focus photograph! If success is to be achieved, quite considerable attention to detail is necessary.

It should be remembered that with such a de-focused image, the brightest areas will always tend to eat into the darker tones, thereby producing the dissolving or melting effect to the edges of the darker elements.

If the subject was of a very light tone and was placed against a dark background, the subject would tend to 'spread' into the background, producing a widening or fattening effect. For this reason a white background was chosen, producing a marked slimming of the model with limbs becoming almost sylph like and rather wispy.

A roll of white background paper was suspended from a wall, almost at ceiling level, and draped down the wall extending someway out across the floor, to provide a continuous, unbroken white background and foreground. This was lit by four tungsten lamps to provide very bright illumination, ensuring a totally white background, and the model was lit by a further lighting unit, fitted with a large white brolly reflector. At this stage, it was important to ensure that the model was receiving a lower level of illumination than the surrounding

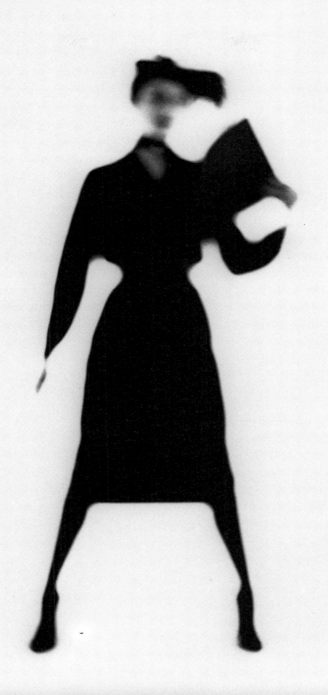

area of white, and hand-held exposure meter readings were taken to ascertain this.

Although studio flash could have been used to provide the lighting for this set-up, I required a slightly grainy image and, for this reason, I selected tungsten lighting with its very much lower output, so that it would be possible for me to uprate the speed of film I was using, thereby producing the required grain effect.

As the model's skin tone was the key tone for these pictures – being the lightest tone with some detail against the pure white of the background – my exposure measurements were taken from this, and adjusted to provide the required negative density. The actual aperture selected was unimportant as the technique does not require limited depth-of-field – the image being deliberately de-focused – and even a very small aperture would have recorded no detail in the burnt-out white background.

In order to produce the right amount of de-focus, some practice is required – not enough de-focus and the image will not melt or blend: too much, and the image becomes a mere blur. I found through experience, that the best criteria for judging the correct degree of de-focus, was to first focus sharply on the model's facial features, then gradually de-focus until these features were only just visible. Of course, this must be carried out at the aperture at which the picture is to be taken, and for this you will need a depth-of-field preview control on the camera. It would be an easy mistake to carry out the de-focusing at full aperture when the image would snap into sharp focus as the automatic diaphragm of the lens stops down to the pre-selected aperture, providing more depth-of-field than anticipated.

The pictures here which show the model apparently leaning against the black border were achieved by enlisting the help of a friend, who held a stout piece of board upright which the model leaned against. The board was positioned at the very edge of the viewfinder's frame so that, during printing, the board could be printed over with the black border, creating the effect that it was the border supporting the model's pose.

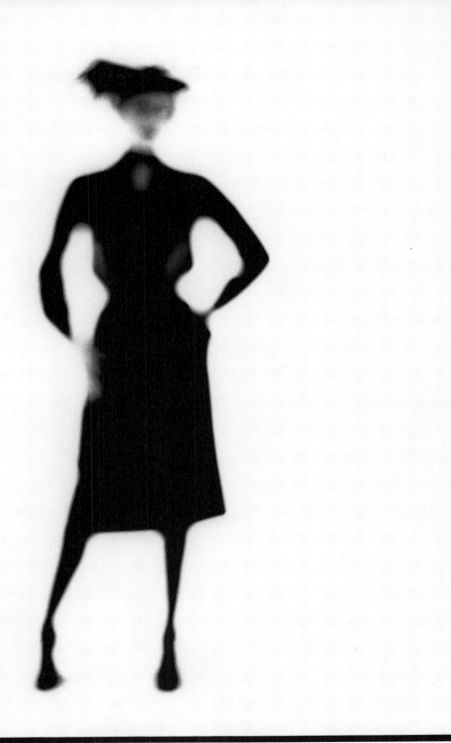

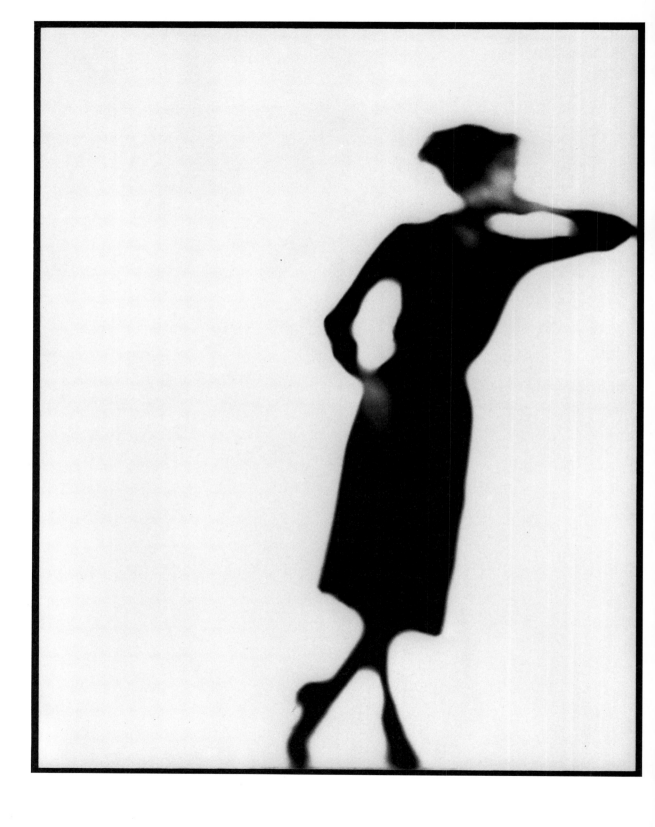

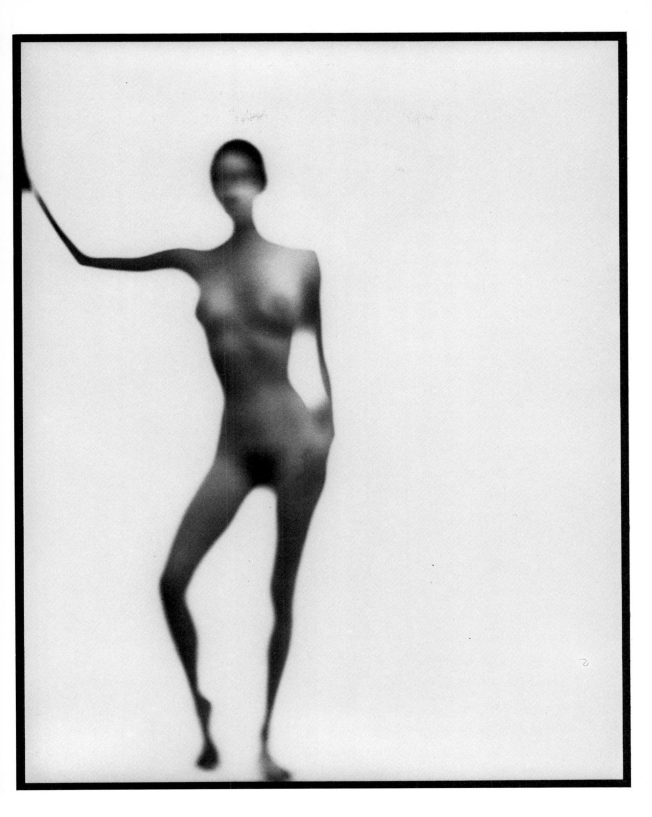

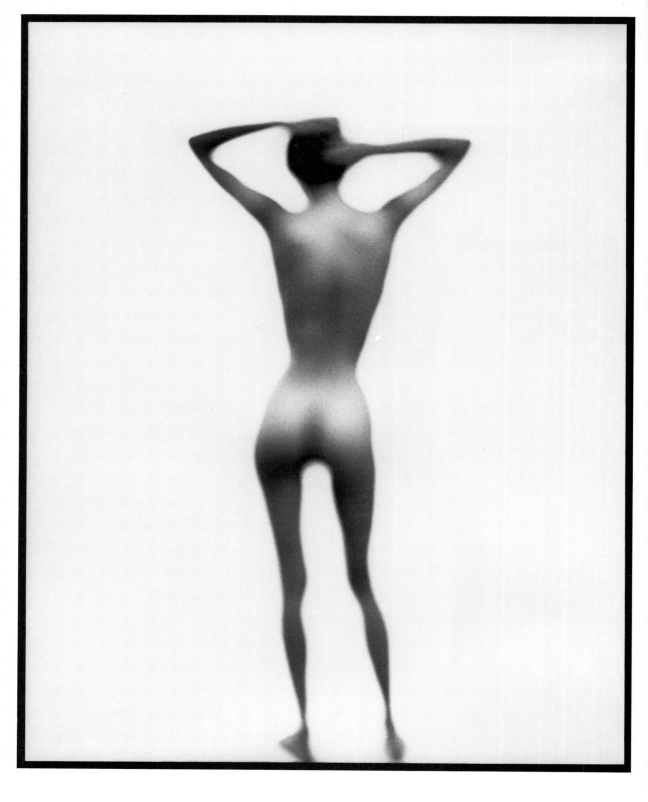

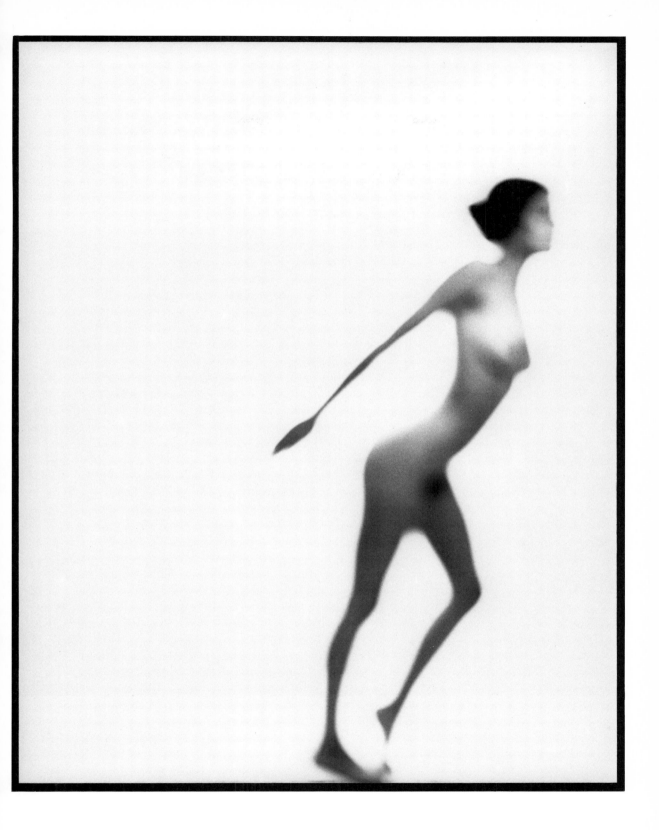

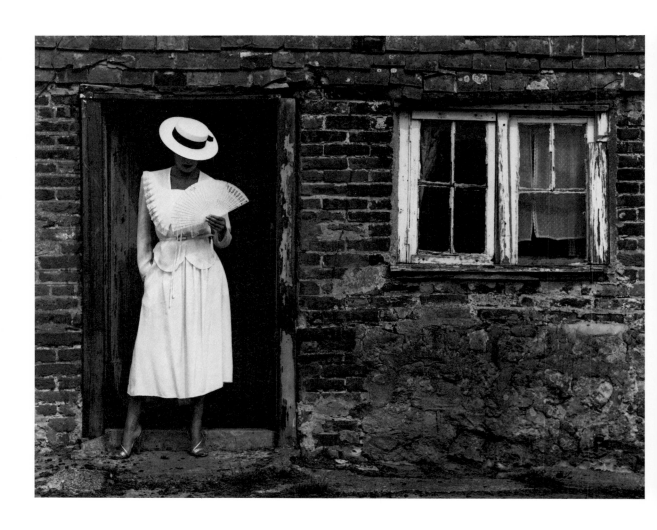

NO TITLE III

Technical Details

Pentax 6 × 7 medium-format SLR camera
165mm – f 2.8 SMC Pentax lens
1/125 second at f 8
Ilford Pan F rated at 50 ASA/18 DIN
Developed in ID-11

Description

An attractive, straight-forward 'fashion type' of picture making good use of the basic 'rules' of composition. The model herself is nicely placed on one of the vertical thirds, and the small white window frame provides a strong balancing element within the composition on a diagonally opposing third.

Plenty of interesting detail and texture is to be found in the brickwork and window frame, and the model – in her white clothes – stands out boldly from the dark shaded area of the doorway behind her. The lowering of the model's head to conceal her eyes does two things. Firstly, it ensures that the shape of the hat is illustrated more clearly, and secondly, it makes the image more impersonal as the model's eyes are excluded from the picture, which tends to concentrate more attention on the clothes.

Techniques

The use of a medium telephoto lens has helped to provide a more pleasing perspective than would have been obtained with a shorter focal length of lens. This has helped to produce a somewhat flatter, more two dimensional picture.

As the white clothing of the model was of utmost importance, hand held spot-meter readings were taken from the highlight areas of the white costume to determine precisely the brightest area. This turned out to be the very top of the hat, and a reading was therefore taken from this tone which was then adjusted so that it would reproduce as zone eight in the Zone System (*see* section on *Exposure-Meters and User Technique*).

LADY IN WAITING

Technical Details

Pentax 6 × 7 medium-format SLR camera
45mm – f 4 SMC Pentax lens
1/8 second at f 8
Ilford Pan F rated at 25 ASA/15 DIN
Developed in Perceptol

Description

Being lucky enough to live with a woman who is happy to model for me and, indeed, who much enjoys this work, I tend to produce a fair proportion of nude photographs. However, I would consider very few of these to be 'glamour' pictures and perhaps none to be erotic. With this in mind, I decided to produce a deliberately erotic photograph, whilst avoiding the obvious route through nudity.

Judging from the reaction of a general cross-section of viewers of this photograph including many women, I have been successful. Most viewers have, like myself, found this picture to be erotic while, at the same time, being in 'good taste': an unusual quality!

The fairly strong backlighting has produced a sensual quality to the folds and fabric of the model's clothing, further assisting the mood of the picture, and the model's pose, allied to the empty chair by her side, suggests that she might be waiting for someone.

Techniques

Although plenty of room was available to enable a longer focal length of lens to be used, I opted to use a wide-angle lens to produce some depth to the picture and to emphasise the model's legs, providing a lead-in to the carefully placed fan.

To provide a smoothness of tone and maximum detail, a slow speed film was selected. This, however, made it necessary to mount the camera on a tripod for a fairly long exposure, during which the model had to be very careful to keep still.

Hand-held spot-meter exposure readings were taken from various parts of the scene, and a setting which would reproduce the brightest highlights as pure white was finally selected. The picture was taken by available light and no form of reflectors were used to provide any additional fill-in.

The finished print is virtually printed straight, with only slight burning-in to the windows of the door to provide some detail of the exterior.

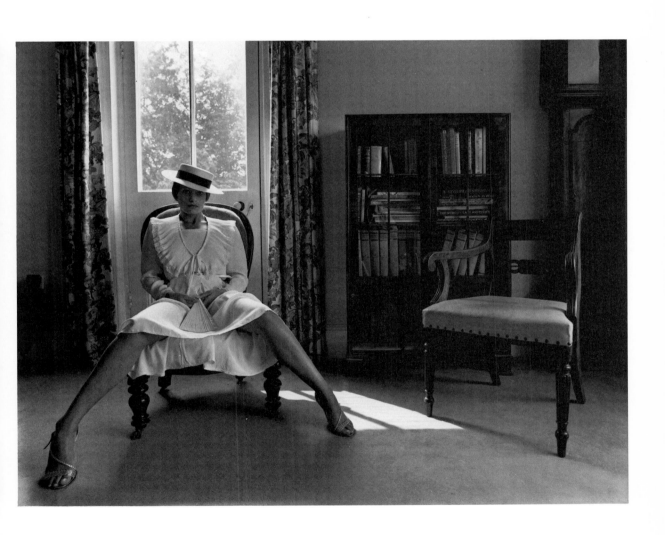

Technical Details

Pentax 6 × 7 medium-format SLR camera
165mm – f 2.8 SMC Pentax lens
1/30 second at f 8
Ilford Pan F rated at 64 ASA/19 DIN
Developed in ID-11 diluted 1 to 1

Description

Initially, I was quite attracted to this subject by the two rectangles formed by the door and window; both being almost equal in size, whilst one is black and the other white. The composition was made a little more interesting for me by the fact that the picture had both horizontal and vertical rectangles, and the brickwork of the building provided a miniature repeat pattern of these shapes. However, I still felt that the picture was somehow lacking in interest, and for this reason I decided to include the nude female figure in the white window, producing an almost 'spot the nude' type of picture. Well! . . . did you spot her?

Techniques

To avoid extremes of lighting contrast which could have made it difficult to obtain correct exposure for both the exterior of the building and the figure, the photograph was taken on a fairly dull and over-cast day. This also helped to avoid problems with bright reflections on the window itself.

However, as those conditions tend to produce a very flat picture with very little contrast, the film was developed to a slightly higher contrast in an effort to put life back into the finished result.

Rather than any special techniques, this sort of picture depends more on the photographer's own imagination for its success. The simple inclusion of the nude figure has allowed me to use the rectangles but made this picture vastly more interesting than would otherwise have been the case.

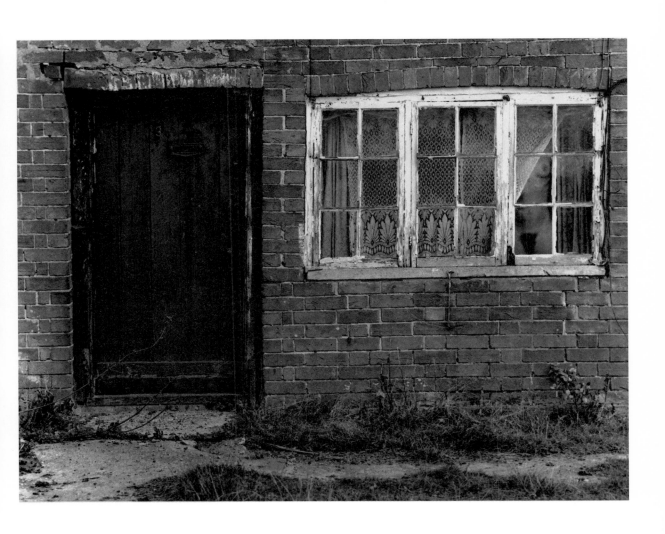

ALL AT SEA

Technical Details

Contax RTS 35mm SLR camera
135mm – f2.8 Zeiss Sonnar lens
1/125 second at f5.6 with R72 filter
Kodak Infra-red film rated at 50 ASA/18 DIN
Developed in ID-11

Description

Surprisingly perhaps, this is not a 'found' picture in the strictest sense, as it might at first appear to be.

It was the result of listening and reacting to a camera club competition judge's remarks about a picture which someone else had entered into a competition when the person judging announced that the prime subject matter was much too central within the composition. This recalled similar remarks made previously by other judges about similarly composed pictures.

It is my view that as soon as the basic fundamentals of composition are thought of as rules they become restrictions, on creativity and imagination. The 'rules' that I adopt are that if a picture looks good, it is good, and a centrally composed picture can work just as well as any other, provided that the composition is intentional. With these thoughts in mind I decided to produce this picture. Being totally pre-planned, all that was necessary was to find a suitable sailing boat which could be photographed from a suitable viewpoint. Several months later, the shot was completed.

Techniques

As I had visualised a bright white sailing boat on a very dark sea, I loaded the camera with infra-red film which I knew would provide dark tones for sea and sky. All that was necessary was to find a white sailing boat: well, I couldn't! Some had white sails and dark hulls, others had enormous numbers on their sails. Then one day, just as I was about to leave my chosen location, a red hulled sailing boat complete with matching red sails set out. I realised that the deep red filter on my lens would filter the colour from the boat, producing a totally white boat while, at the same time, producing a dramatic darkening of both the sea and sky. And they call it luck!

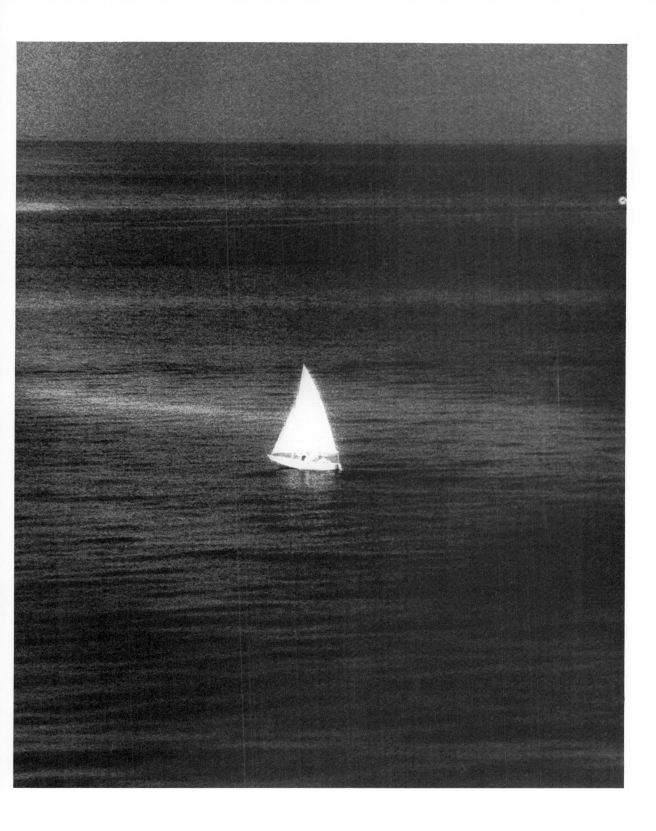

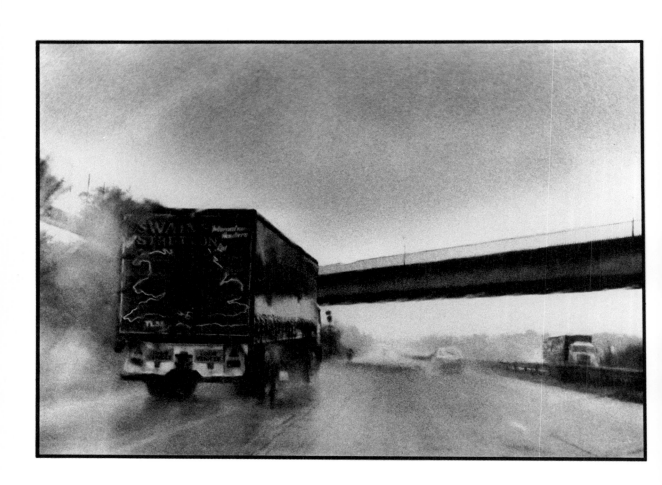

RAINYDAY MOTORWAY

Technical Details

Olympus 35 ED – 35mm compact camera
Fixed lens – 38mm f 2.8
Auto exposure
Ilford HP5 rated at 1600 ASA/33 DIN
Developed in Microphen

Description

This photograph depicts strongly the sort of weather experienced by many drivers on their daily trek to and from their place of work and, to me, gives some of that feeling of isolation and nervous tension that we sometimes experience in such filthy driving conditions. The very large grain structure of this image, combined with the predominance of grey tones, helps to create an impression of the dirty weather and poor visibility.

Compositionally the picture is pleasing enough with the shape and weight of tone of the main truck in the immediate foreground being neatly balanced by another truck of similar shape and tone, only very much smaller, on the opposite side of the picture. These are nicely linked by the dark shape of the bridge.

Techniques

This was, in fact, a very simple picture to take, with very little – other than composition and film choice – being under my control. The camera, a 35mm compact, has fully programmed exposure control and, other than alter the film speed setting, there is very little one can do to control the actual exposure. However, knowing the type of effect I wanted to achieve, I was able to make the decision to uprate the speed of the film. Firstly, this helped to guarantee a satisfactory exposure under the poor lighting conditions, and secondly, it produced the enlarged grain structure needed to enhance the impression of poor weather.

During printing, small areas of the print were shaded (with the aid of a small piece of card attached to the end of a length of thin wire), to lighten selected areas of the print – mainly just behind the large lorry – to enhance further the effect of spray thrown up by the lorry.

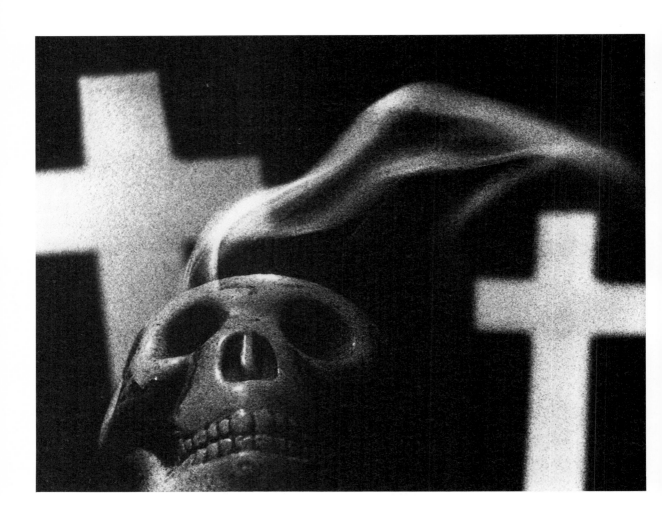

SMOKING CAN DAMAGE YOUR HEALTH

Technical Details

Contax RTS 35mm SLR camera
135mm – f2.8 Zeiss Sonnar lens (with
supplementary close-up lens)
1/2 second at f11
Ilford HP5 rated at 3200 ASA/36 DIN
Developed in Acuprint

Description

A picture which could, perhaps, be thought of as being a little macabre is lightened somewhat by its title, which adds a little black humour to the rather unusual image.

High contrast combined with very large grain structure has helped to produce a 'striking' picture, and the two featureless white crosses form an almost double diagonal composition with the smoke which is, in itself, quite unusual. The extremely low camera angle has helped to produce a further sense of drama.

Although the picture is of a semi-humorous nature, it does however carry with it a very sincere message – it even made me seriously consider giving up smoking!

Techniques

Technically I suppose this picture would be described as a 'still-life' shot although I think, in this instance, that this may not be such an apt description! Perhaps 'table top photography' might be a more suitable term.

The skull is, in fact a very small ornament measuring only three inches (7.5cm) in diameter, with the classic words 'Poor old Fred smoked in bed' inscribed across its top! Fortunately, the very low camera angle has enabled this inscription to be omitted. The two white crosses are simple cardboard cut-outs, positioned behind the skull at a suitable distance to provide the required amount of differential focus. These items were placed on a piece of black cloth, which was curved up towards the back to form the dark background. The smoke was provided by – yes, you've guessed – a cigarette! The ornament has a hole in the side into which a cigarette may be placed, allowing the smoke to permeate through the eye socket. Backlighting was provided for the smoke with a tungsten spotlight which has made the smoke stand out strongly from the black background.

The film was considerably uprated and developed to produce a very coarse grain structure which, I think, enhances this picture.

ENCHANTED WOODS

Technical Details

Contax RTS 35mm SLR camera
25mm – f 2.8 Zeiss Distagon lens
with deep red R72 filter
1/4 second at f 16
Kodak Infra-red film rated at 50 ASA/18 DIN
Developed in ID-11

Description

Although I had previously photographed this scene on conventional film, I had not been totally satisfied with my results. Although plenty of sunlight was breaking through the trees, this merely produced a high contrast result which came over as being a little heavy. In order to obtain a result which resembled more closely what I had 'seen' in my mind, I returned to the scene the following evening with my camera loaded with infra-red film.

The typical characteristics of this film have produced a far more attractive picture, with very light tonal rendering of the foliage and, in particular, the nettles in the immediate foreground. The very light area in the middle background, leaves you with the impression that it might be possible to walk into the picture. A rather mysterious, almost fairytale-like atmosphere is created for me by the strange white foliage and the very coarse grain structure of this film.

Techniques

Although infra-red film can be very unpredictable in precisely how it records many subjects, its light rendering of foliage is well known, making it an ideal choice for a subject such as this. This material can, however, be tricky to handle and work with. Firstly, it must be loaded into your camera in total darkness, as its own cassette cannot be guaranteed to be infra-red proof, and fogging may occur if this precaution is not taken. Secondly, as it is necessary to use an extremely deep red filter – almost opaque – to obtain true infra-red results, it is necessary to use the camera on a tripod and carry out the focusing (remembering to re-adjust the focused distance to the infra-red focusing index on the lens), before fitting the filter over the lens, as it is impossible to view or focus through an SLR camera once the filter is attached. It is also advisable to bracket exposures, as the indicated film speed cannot be relied upon as being accurate, and will vary depending on how much infra-red radiation is present with any particular subject.

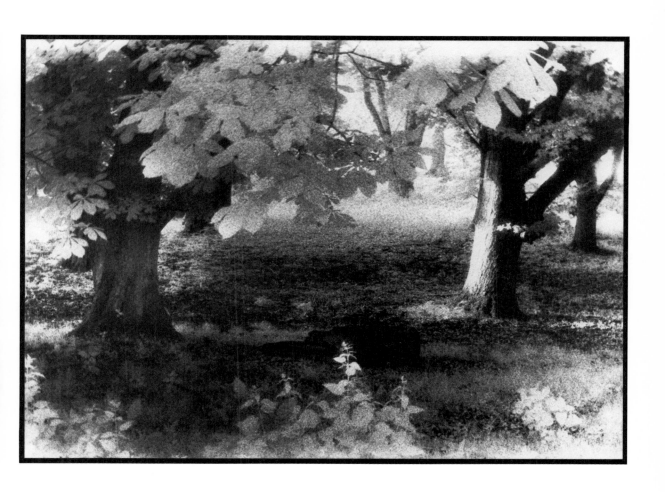

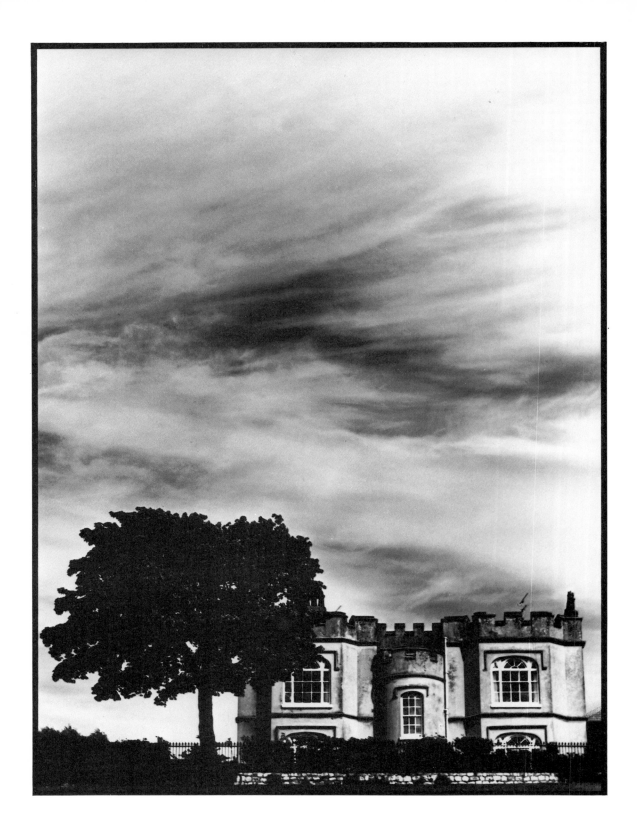

AN ENGLISHMAN'S HOME

Technical Details

Contax RTS 35mm SLR camera
85mm – f 1.4 Zeiss Planar lens
1/125 second at f 8
Ilford FP4 rated at 125 ASA/22 DIN
Developed in ID-11

Description

A windy day has provided an interesting sweeping of the clouds which, in combination with the high contrast treatment and the somewhat unusually low positioning in the composition of the main subject matter, has helped to produce a very dramatic effect.

The unusual design of the parapet wall of this building, resembling castle battlements, proves interesting and provides the motivation for the title of this picture, recalling the old saying 'An Englishman's home is his castle'. The very dark and heavy tones of the tree and immediate foreground, combined with the very oblique lighting on the building, provides a slightly sinister atmosphere to this picture.

Techniques

A short telephoto lens was used, so that a viewpoint some way from the building could be selected. This position has produced a more pleasing perspective, and has helped to create the impression that the tree is almost over-shadowing the building.

The use of a red filter (25A) has not only darkened the small area of blue sky, but also helped to increase the contrast of the scene overall. This effect was further emphasised by slightly over-printing on a harder than normal grade of printing paper. Although the bottom edge of the print is of predominantly dark tone, the black border serves to contain the large area of light toned sky.

CAST SHADOWS

Technical Details

Contax RTS 35mm SLR camera
135mm − f 2.8 Zeiss Sonnar lens
1/250 second at f 8
Ilford FP4 rated at 200 ASA/24 DIN
Developed in ID-11

Description

An unusual, even striking composition which makes use of the bold shapes of shadows cast by a rainwater downpipe and unseen guttering.

The texture of the wall becomes a backdrop for these shapes, which seem to thrust forward, radiating from the left-hand edge of the print. The inclusion of the single length of downpipe is very important, as this saves the picture from becoming nothing but shadows, and serves to reveal to the viewer more information about the unseen source of some of the shadows. The downpipe also helps to provide some sense of depth to a picture which would otherwise be entirely two dimensional.

With much of the weight of the shadows at the top of the picture, the composition might have appeared a little top heavy, however, this is remedied by the dark triangular area of shadow in the bottom left-hand corner, which provides a base for the picture, helping to balance, almost cantilever-like, the shadows above.

Techniques

Being one of the rare occasions when I did not have my tripod to hand, it was necessary to slightly uprate the speed of the film in order to obtain an acceptable exposure; so avoiding camera shake with a reasonably fast shutter speed while, at the same time, providing just adequate depth-of-field to render the entire subject sharply.

An exposure meter reading was taken, using the camera's through-the-lens metering but with the camera set to manual. This enabled me to adjust the exposure by overexposing by one f-stop on the indicated reading. This helped to avoid the problem of the light tones of the wall and downpipe becoming underexposed, and therefore reproducing as a mid-grey.

NUDE I

Technical Details

Nikon F3HP 35mm SLR camera
85mm – f2 Nikkor lens
1/60 second at f8
Ilford HP5 rated at 800 ASA/30 DIN
Developed in ID-11

Description

A fairly conventional nude study, which has been made more attractive by the tight cropping of the image and the use of predominantly light tones, producing a quality that suits the subject matter. Although this picture is composed very tightly, the model's gaze upwards intentionally suggests some continuation of interest outside the limitations of the picture's black border.

The very diffused lighting has produced attractive modelling, showing clearly the girl's shape, while the slightly enlarged grain structure of the image provides an almost sensuous impression of the texture of the girl's skin.

As I have said, I am not a great lover of 'glamour' photography, and do not feel that this picture falls into that catagory, but rather into some separate 'romantic' category.

Techniques

A very light-toned blanket was placed over a couch, covering both the seat and the back of the couch, to form a suitable background against which the model was posed. The couch was positioned approximately six feet (2 metres) away from a fairly large window, which received light from a bright but overcast day outside, allowing enough room to use comfortably a short telephoto lens. This has helped to provide a pleasing perspective.

The diffuse lighting from the window proved very pleasing, and did not require any reflectors or additional fill-in. However, as the level of lighting was low it was necessary to uprate the speed of the film by one f-stop. This has also had the attractive effect of increasing the grain size.

Development of the film was extended for slightly longer than was necessary, to compensate for the uprating of the film speed in an effort to increase a little the overall contrast of the scene. To further assist this effect, the print was produced on a fairly hard grade of printing paper.

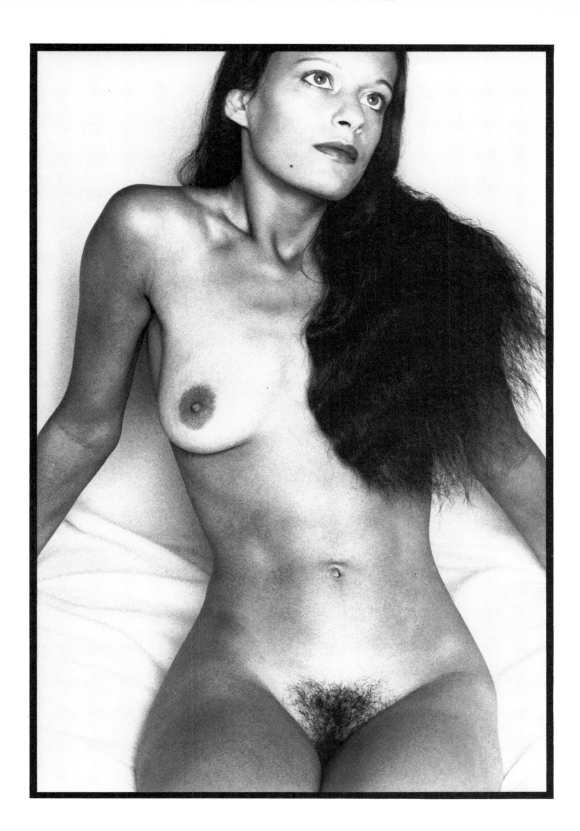

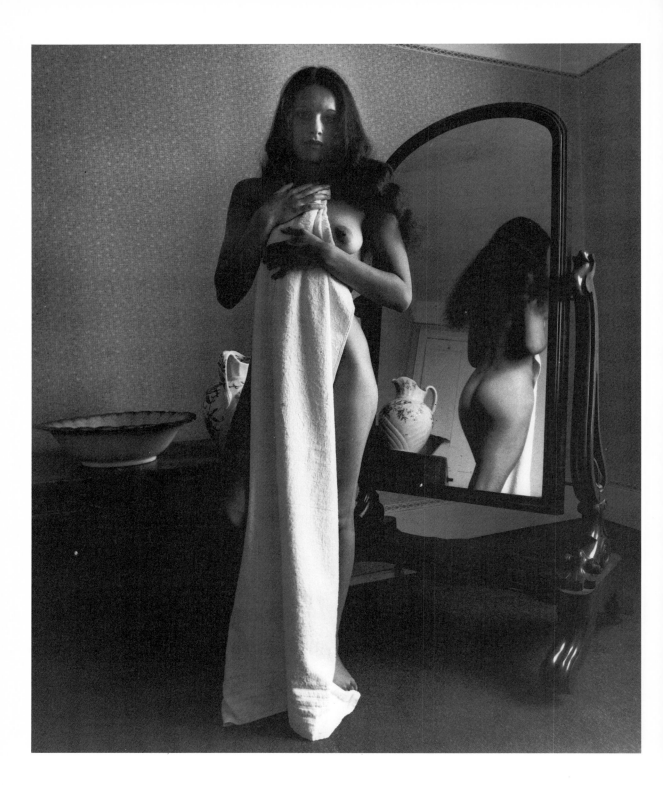

NUDE II

Technical Details

Pentax 6 × 7 medium-format SLR camera
45mm – f 4 SMC Pentax lens
1/15 second at f 5.6
Ilford HP5 rated at 1600 ASA/33 DIN
Developed in ID-11

Description

An element of apprehension is evident in both the model's expression and her pose, making this picture a little disturbing; almost as if the viewer has just disturbed the girl by entering the room unexpectedly. The wash-bowl and jug enhance this impression suggesting, perhaps, that she was in the middle of washing herself.

Although this picture has a large proportion of dark tones, the viewer's attention is immediately brought to the model by the bright area of her towel, which leads the viewer's eye up the full length of the figure to the girl's face and clasped hands. The nude three-quarter rear view of the girl, reflected in the mirror, provides an element of the unexpected.

Techniques

The creation of this picture threw up certain problems which proved difficult to overcome. To achieve the natural 'mood' of this picture it was essential to use available light from a window. As there was only the one window in the room, and the room's decoration and furnishings were generally dark, this caused problems with high contrast. The problem was made worse by the fact that the light level was low, making it necessary to uprate the speed of the film simply to obtain a satisfactory exposure, and this – in itself – has increased the contrast. However, by exposing to obtain some detail in the shadows, it was only necessary to burn-in detail during printing in the brightest highlight areas, the white towel and the model's left leg.

Although it was necessary to use a wide-angle lens due to the small size of the room, distortion was kept to a minimum by ensuring that the camera was as near to parallel as possible with the model.

NUDE III

Technical Details

Pentax 6 × 7 medium-format SLR camera
165mm – f2.8 SMC Pentax lens
1 second at f16
Ilford HP5 rated at 400 ASA/27 DIN
Developed in ID-11 diluted 1 to 1

Description

I had noticed that low evening sunlight, reflected from an open window onto one of my living-room sofas, was producing a well defined patch of light at about the same time each evening. This provided the idea of producing a picture using a reclining nude figure partially illuminated by this small patch of light.

A tightly cropped framing, using only the model's torso provides a nicely balanced composition, forcing the viewer's attention to the bright patch of light. The texture and detail within the bright area then leads the viewer's eye into the much darker shadow areas, where much detail is still present.

Techniques

The model was posed on the sofa in the desired position and the patch of light was positioned by a combination of adjusting the opening of the window from which the light was reflected, and bodily moving the sofa complete with model, to the required position.

Exposure was measured with a separate hand-held meter, using the reflected light method, and exposure adjusted to maintain detail in the brightly lit area. The model had to be very careful to keep still during a fairly long exposure, which was necessary as a certain amount of depth-of-field had to be maintained with the long focal length lens in use.

During printing, the light patch was shaded with a piece of card cut to the right shape and attached to a thin strand of wire. This was held above the printing paper, and kept slightly on the move, while the rest of the picture was given enough extra exposure to darken the image to the required amount.

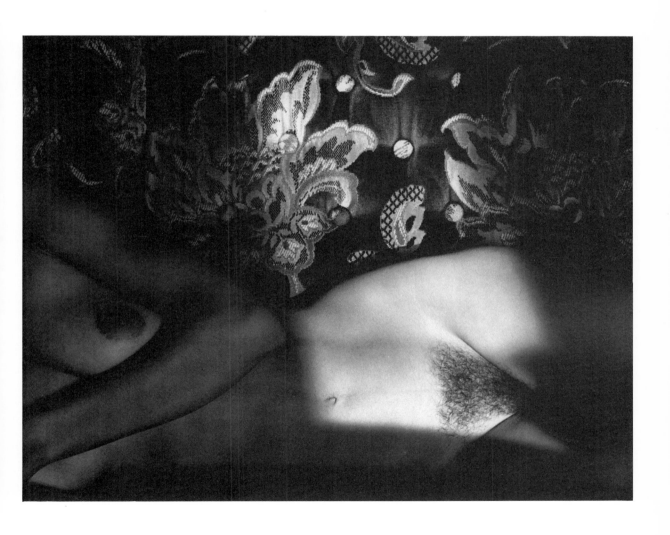

NUDE ON A STAIRCASE II

Technical Details

Nikon F3HP 35mm SLR camera
85mm − f2 Nikkor lens
1/60 second at f5.6
Ilford HP5 rated at 1600 ASA/33 DIN
Developed in ID-11

Description

An unusual style of composition, which makes use of the stair banister to provide a foil through which the viewer must look to see the dark and subdued figure of the nude. The very light tones of the banister's vertical bars provide an extremely prominent feature to this picture which, at a quick glance, could almost be taken for a simple pattern picture: for, as said, you have to look deeper into the picture, beyond this barrier, to see the figure of the girl.

Interestingly, I have found that most viewers notice first the girl's open eye, and only then discover the rest of the figure. Perhaps this is due to the almost 'ideal' positioning of the girl's face, on an intersecting third of the composition.

Techniques

Using distant available light, from a skylight situated high above, it was necessary to push the film speed by two f-stops in order to obtain a suitable hand-held exposure, as it was not possible to mount the camera on a tripod due to the awkward camera position necessary to achieve the picture. This pushing has produced a large grain size which serves well in helping to blend the girl's figure into the mottled background.

To avoid converging verticals in the railings of the banister, a short telephoto lens was used. This permitted me to stand a little further away from the banister which, in turn, produced a more natural perspective.

Exposure was measured with a hand-held spot meter, and readings were taken from the model's skin tones. These readings were then adjusted so that the tones would reproduce as zone 3 in the Zone System: about the darkest tone which still retains recognisable detail. Due to the uprating of the film, which tends to increase contrast, it was necessary to burn-in detail in each of the banister rails. This was quite easily carried out, by using a large piece of opaque card with a very small hole cut in it, making it possible to achieve very precise burning-in.

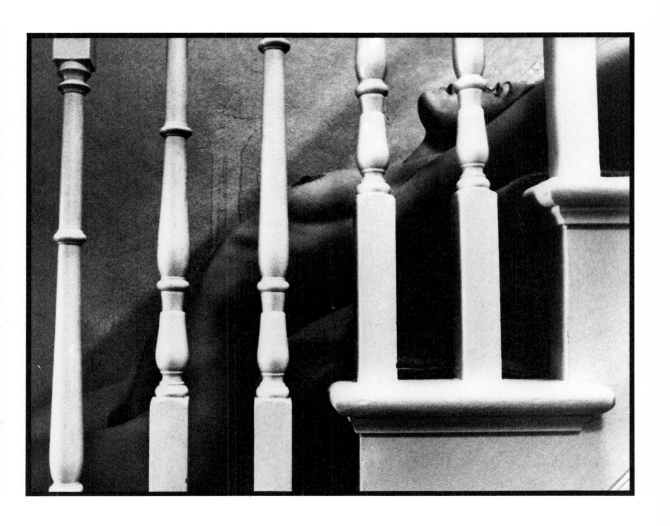

NUDE BY WINDOW

Technical Details

Contax RTS 35mm SLR camera
35mm – f 2.8 Zeiss Distagon lens
1/2 second at f 8
Ilford HP5 rated at 400 ASA/27 DIN
Developed in ID-11

Description

Sometimes a background or location can stimulate an idea for a picture, and the interior of this thirteenth-century cottage which is sadly in a state of decay, almost seemed to be calling out to be used in a photograph. The owner was approached for his permission to use the location, and he kindly agreed.

The strangely 'unreal' effect of a nude posed in the surroundings of decay provides an interesting conflict of elements and produces a very strong composition. The bright highlight area of the window is balanced by the highlights on the model's body, and the model's gaze towards the window is important in providing a connection between these.

Techniques

Problems were created here, due to the high contrast ratio of the lighting from the single window and the generally dark surroundings of the room. To help this situation a little, the film was slightly overexposed and development was curtailed. Although this helped lower the contrast to a more acceptable level it was still necessary to provide some fill-in light to the nearest side of the model. For this I used a large piece of foil-backed insulation board which I found lying around, as this made a very effective reflector.

Ilford Multigrade paper was used for printing, and the main area of the picture was printed with a number three contrast filter. The bright area of the window was then printed-in through a hole cut in a piece of card, using a softer contrast filter in the enlarger. This enabled detail to be maintained in an area which would otherwise have been burnt out.

It was, I think, the first time the owner of this cottage had allowed nude photography to take place on his property, as he insisted on bringing us regular cups of coffee!

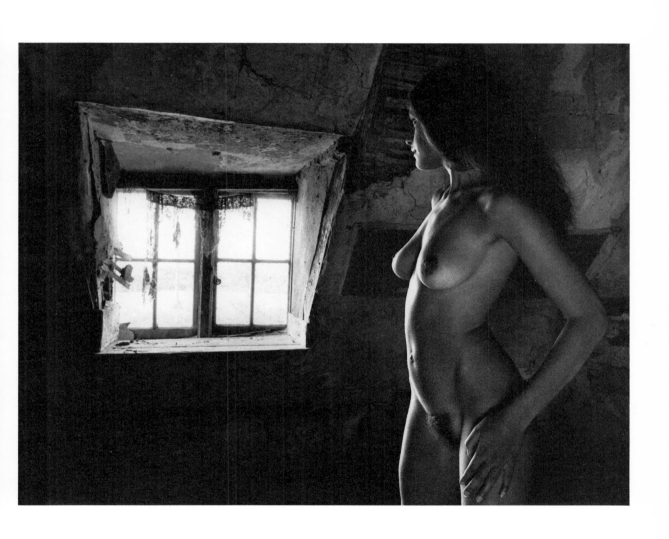

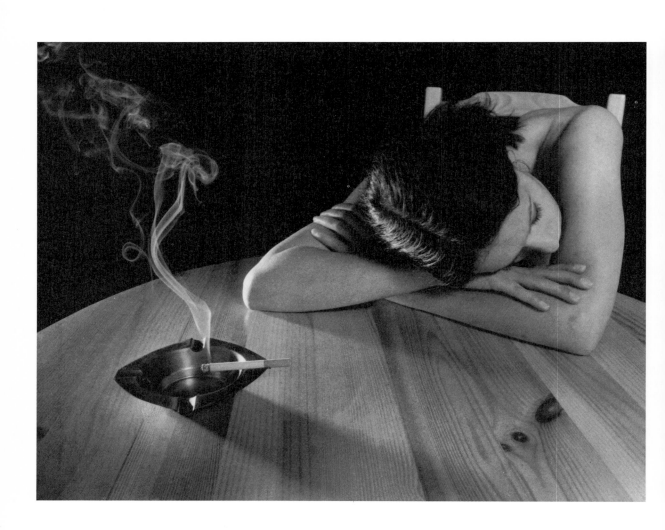

LIFE'S A DRAG

Technical Details

Contax RTS 35mm SLR camera
25mm – f 2.8 Zeiss Distagon lens
Studio flash at f 11
Ilford HP5 rated at 500 ASA/28 DIN
Developed in Microphen

Description

Depression was the motivation for this picture – I think my bank manager had just sent me another threatening letter – and the sombre mood of this photograph, along with the plain timber table and no visible clothes or jewellery on the model, helps to convey this feeling.

Smoking is often associated – in advertising at least – with the calming of nerves or the easing of worries; hence the inclusion of the cigarette. This also enabled me to give the picture a slightly humorous title, thereby lifting the gloomy feeling a little.

Techniques

A black piece of fabric was pinned onto the wall behind the table, and the model and the ash tray were positioned to form a strong diagonal composition. The use of a wide-angle lens has increased the feeling of perspective, with the boards and grain of the table leading the eye into the picture.

One studio flash was positioned very low behind the table and slightly to one side to provide the lighting for the cigarette smoke. This was fitted with a black honeycomb attachment to provide a highly directional light source. Another light, fitted with a white umbrella reflector, was placed in front and slightly to one side of the model to provide fill-in light.

The biggest problem with this shot was in persuading the smoke from the cigarette to travel in the right direction. I think I went through about twenty cigarettes in my efforts to get this right!

NUDE ON A STAIRCASE III

Technical Details

Contax RTS 35mm SLR camera
18mm – f 4 Zeiss Distagon lens
2 seconds at f 11
Ilford HP5 rated at 3200 ASA/36 DIN
Developed in Acuprint developer
diluted 1 to 5

Description

The steep perspective, brought about by the use of an extreme wide-angle lens used at close quarters, has effectively made a strong compositional feature of the white edges of the stairway; which tends to lead the viewer's eye up and into the picture. The effect is further strengthened by the highlight on the handrail, which forms a further diagonal, and helps to balance the weight of the figure.

The entire mood has been kept very sombre, and the darkness of the print tones, combined with the use of very coarse grain helps to strengthen this effect.

Techniques

Due to the extremely low level of illumination – just one 40 watt light bulb at the top of the stairs, and another similar light in front of the model in the lower hallway – it was necessary to uprate the film considerably. Even so, a full two seconds exposure was required, and a pose had to be adopted which would enable the model to remain still during this long exposure. The camera was, of course, attached to a tripod during this exposure. An aperture of f 11 was necessary to maintain depth-of-field to the top of the stairs.

The use of a print developer to develop the film helps to maintain detail in the shadows, even when pushing the film to 3200 ASA/36 DIN and also helps form a clearly defined grain structure.

The picture was printed on a hard grade of printing paper, to boost the contrast a little while still allowing some detail to remain in the darkest areas of the print.

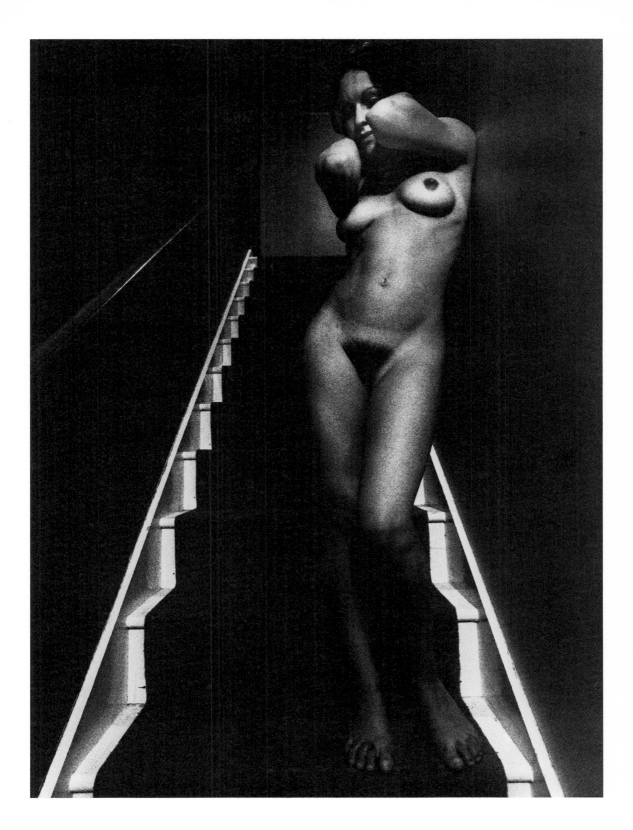

NUDE BY SKYLIGHT

Technical Details

Contax RTS 35mm SLR camera
18mm — f 4 Zeiss Distagon lens
1/60 second at f 8
Ilford HP5 rated at 1600 ASA/33 DIN
Developed in Acuspeed

Description

This is certainly one of my personal favourites. I particularly like the way the sunlight is bursting through the skylight, and this effect has been emphasised by the slight burning out of detail on the model's face and arm.

Plenty of interesting detail for the viewer has been maintained in the dark and decaying surroundings of the room, while the bright area of the skylight itself stands out very strongly from these dark tones, and is nicely positioned in the composition, forming a very strong element in the picture.

Techniques

It was necessary, due to the extremely small dimensions of the room, to use a very wide-angle lens. However, any distortion was kept to a minimum by the careful positioning and choice of angle for the camera.

As the room was so small, it was impossible to erect a tripod and it was therefore necessary to up-rate the film to enable a hand-held exposure to be made. The slight increase in grain size that this has produced is acceptable with this type of picture and, indeed, may well be judged more attractive than a fine grain result.

It was necessary during printing to burn-in the skylight area quite considerably, to produce some detail. I was, however, careful not to overdo the burning-in, as this would have made the skylight appear more like a fluorescent light, and completely lost the 'bursting through' effect of the sunlight, thereby killing the atmosphere of the picture.

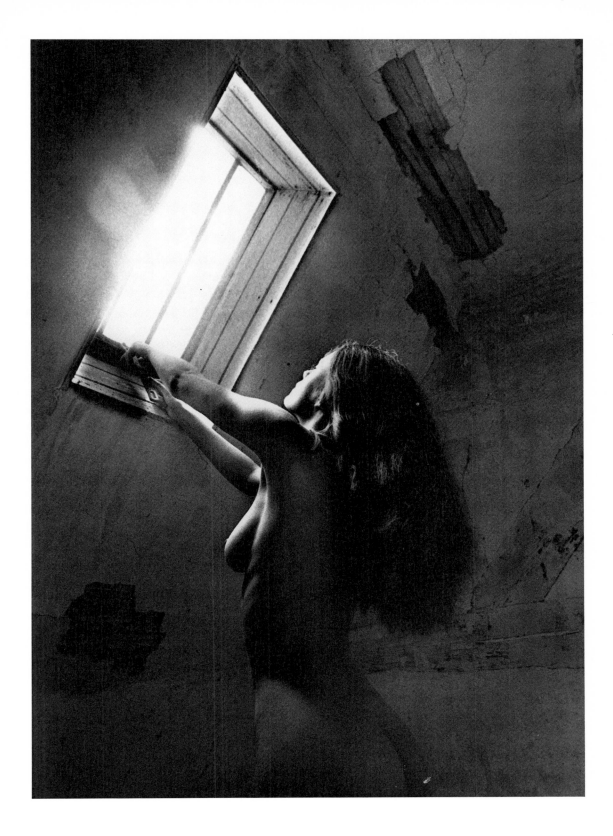

NUDE BY GATE

Technical Details

Pentax 6 × 7 medium-format SLR camera
90mm – f 2.8 SMC Takumar lens
1/125 second at f 5.6
Ilford Pan F rated at 25 ASA/15 DIN
Developed in Perceptol

Description

An attractive study has been produced by using an outside location. The line formed by the top of the hedge and the gate produces an interesting artificial horizon in the picture, over which the model is looking. This is reinforced by the model's pose, which is positioned to suggest that she is actually looking at something beyond the hedge.

This makes the picture something much more interesting than a mere nude study, and the viewer might be left wondering why the girl should be unclothed in such a situation, and what she is looking at over the gate.

Techniques

This shot was taken on a bright but overcast day, which produced an even lighting on the nude figure, with good modelling of form. A moderately large lens aperture (f 5.6) was used to provide selective focus on just the model and the gate, allowing the background to be recorded softly out of focus.

A very slow film was used, and this was developed for extremely fine grain as I required smooth skin tones and plenty of detail in the gateposts and hedge.

When printing, the sky was burnt-in slightly, to produce some tone in an otherwise blank white area, and the base of the picture was also darkened a little to provide a better balance of tones.

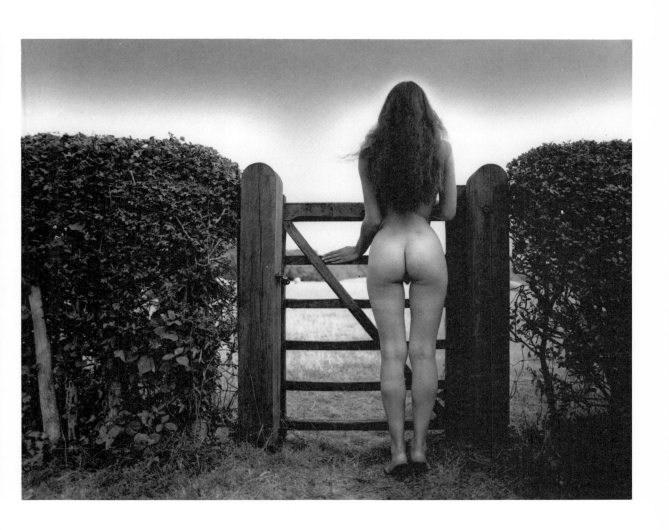

NIGHTMARE

Technical Details

Contax RTS 35mm SLR camera
18mm – f 4 Zeiss Distagon lens
1/4 second at f 8
Ilford HP5 film rated at 1600 ASA/33 DIN
Developed in Acuspeed

Description

A very good example of a location providing the motivation for an idea. This local subway with its spray-paint graffiti was found while out and about one day with my camera. The word *nightmare* sprayed onto the wall made me think about nightmare situations, and the feeling of vulnerability brought about by nakedness seemed very appropriate. The positioning of the model, almost in a white void at the end of the tunnel, and the model's pose, further enhance this feeling.

As this is a busy and well used subway, it was decided that we should take this picture very early on a Sunday morning to avoid being disturbed. However, even the best plans can go sadly amiss and while my wife was standing at the end of the subway – naked – a man, his wife and three children came down the entrance behind her. An extremely embarrassing situation was only avoided by my wife's previously unrealised sprinting ability, leaving me with tripod-mounted camera and nothing to photograph!

Techniques

Due to the very low light level in the subway, even with the camera tripod-mounted and a speed of $\frac{1}{4}$ second it was necessary to uprate the film quite considerably. The film was developed in a speed increasing developer, and this has had the effect of increasing the grain size of the film emulsion, which in this case complements the nightmare situation.

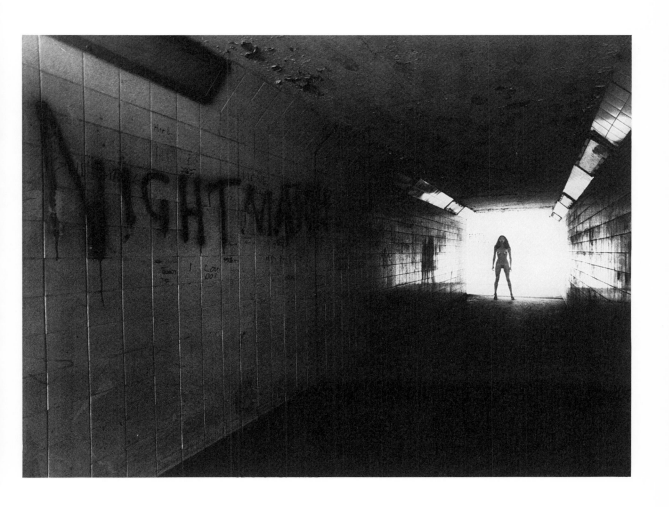

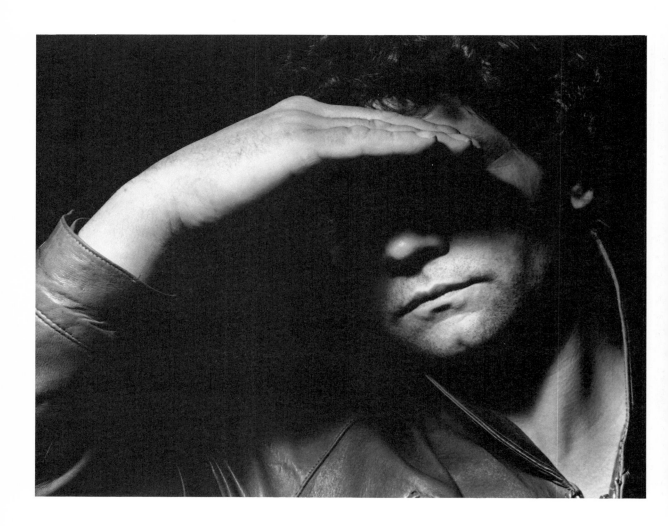

Technical Details

Nikon F3HP 35mm SLR camera
85mm – f 2 Nikkor lens
Studio flash at f 16
Kodak Plus X Pan rated at 125 ASA/22 DIN
Developed in ID-11

Description

High contrast lighting has been used to impart a sense of mystery to this rather strange picture. The brightly lit hand immediately takes the viewer's attention, and leads the eye from left to right, into the picture and towards the eyes of the subject. However, these being in deep shadow cast by the very hand that has led the viewer into the picture, this produces a slightly disturbing aspect – impact by absence. The viewer is then persuaded to follow the highlights down through the subject's face and into the deep V-shape formed by the collar of the subject's jacket. The highlight areas of the leather jacket then lead along the base of the photograph and back up towards the hand, to start the cycle all over again.

This almost circular type of composition is one that is difficult for the viewer to escape, and in this case seems to concentrate the viewer's attention on the darkened area where the subject's eyes would normally be seen, producing a feeling that the subject is looking back at the viewer.

Techniques

A single studio flash unit, fitted with a black honeycomb attachment to provide extremely directional lighting, was positioned quite high and slightly to one side of the subject, who was positioned in front of a black velvet background. The subject was then posed, and maintained this pose while the light was moved around slightly to produce the required lighting effect.

A single flash-meter exposure reading was taken from a position slightly in front of the subject's face, and this was modified for one f-stop underexposure to ensure that no detail would be recorded in the shadow areas.

The use of a short telephoto lens has helped to ensure a fairly natural perspective: a shorter focal length of lens, requiring a closer viewpoint, would have produced an over-large hand.

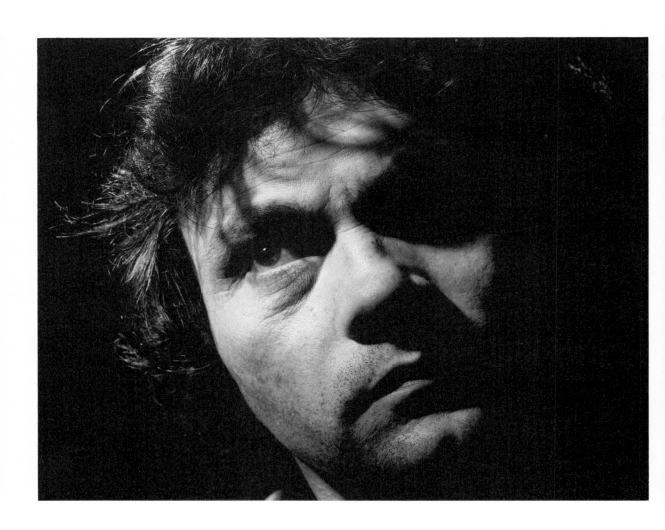

NO TITLE IV

Technical Details

Nikon F3HP 35mm SLR camera
85mm – f 2 Nikkor lens with 2x converter
Studio flash at f 11
Kodak Plus X Pan rated at 125 ASA/22 DIN
Developed in ID-11

Description

The high contrast of the lighting and the extremely tight cropping of this picture produce a very dramatic result. Although a good many photographers still associate portraiture with the use of lots of lights and reflectors, it should be remembered that while this may indeed be necessary for certain types of portraiture, it is quite possible to produce interesting and, sometimes, more exciting pictures with just a single light.

The oblique angle of the lighting has picked out plenty of detail and texture but has, at the same time, cast very deep shadows which obliterate great chunks of detail, forcing greater emphasis onto the remaining highlight areas. Particularly dominant is the only visible eye of the subject, which looks up towards the top left-hand corner of the picture, introducing a very strong diagonal element to the composition.

Techniques

The single studio flash unit, fitted with a standard 10 inch (25cm) reflector, was positioned almost directly in front of the model, but slightly to one side and quite high above him. This has produced the very oblique angle of lighting required to pick out detail quite clearly. No form of fill-in lighting and no reflectors were used, and the use of black velvet for the background has helped to absorb any extraneous light, ensuring deep and detail-less shadows. Minimal exposure was given to provide full detail in the brightly lit highlight areas, while helping to ensure that little detail was recorded in the shadow areas.

A 2x converter was used with a short telephoto lens to provide a frame-filling image from a reasonable working distance. This also gives a more acceptable perspective.

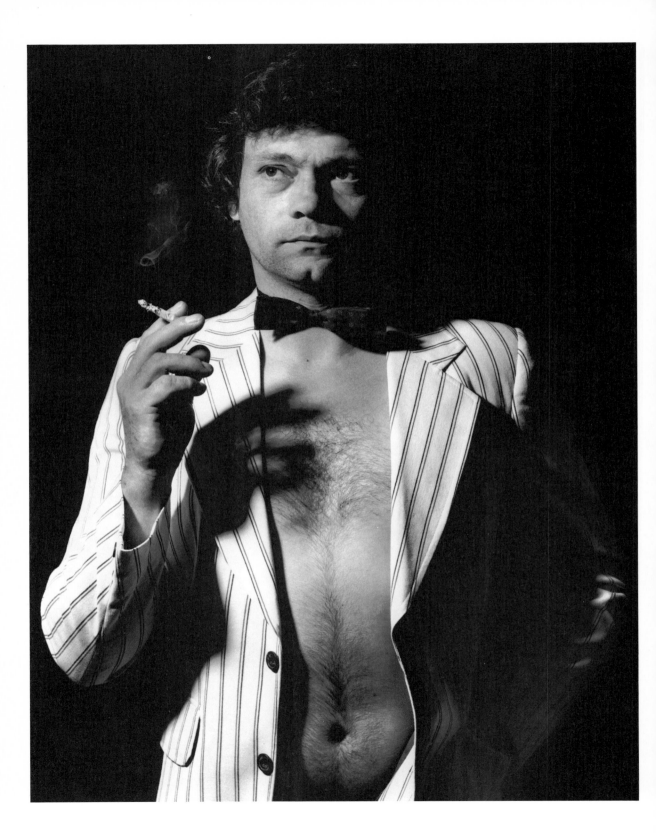

MALE/PORTRAIT

Technical Details

Pentax 6 × 7 medium-format SLR camera
165mm – f 2.8 SMC Pentax lens
Studio flash at f 22
Ilford FP4 rated at 64 ASA/19 DIN
Developed in Perceptol

Description

Portraiture can be tackled in several ways, and the particular style chosen may often be dictated by the personality or character of the subject. Sometimes sitters may have an interesting, sometimes peculiar characteristic to their lifestyles or personality, as was the case with my subject for this picture. It can be very interesting to emphasise this in your finished photograph.

My subject for this portrait, a personal friend, is well known for his smart and often fashionable style of dress. He is also slightly eccentric, in that he will sometimes walk around looking like a tramp! To put over an impression of this strange dual personality, I chose to portray him in a smart blazer and bowtie, but wearing no shirt. The lighting and pose further enhance the impression of eccentricity. The picture has certainly been a success, on one level at least, as the model declared it was the best photograph he had ever seen of himself . . . !

Techniques

A single studio flash unit, fitted with a standard reflector and positioned quite high in front of the model and slightly to one side, has produced an almost theatrical style of lighting. The very hard shadows provide a strong three dimensional effect to the picture, and to maintain this high contrast no form of fill-in was provided, allowing the unlit side of the model to fall into deep shadow.

While I was positioning the single light, I was careful to provide the small triangle of light which picks out the model's left eye from the deep shadows. This provides a strong sense of depth to the features, which was carried through to the shadow of the hand on the chest, also helping the impression of depth.

A medium telephoto lens has produced a very natural looking perspective, avoiding the problem of the subject's right hand – nearest the camera – being recorded as disproportionately large, as would have occurred if a lens of shorter focal length had been used.

NO TITLE V

Technical Details

Contax RTS 35mm SLR camera
18mm – f 4 Zeiss Distagon lens
1/60 second at f 8 with red filter
Ilford HP5 rated at 500 ASA/28 DIN
Developed in Microphen

Description

Three of anything in a composition often works very well, and the three very strong geometrical shapes of these warehouse roofs have been made to stand out even more strongly against the sky.

I can find many interesting shapes within this picture. Besides the roof tops themselves, there are the three small circular windows, themselves sub-divided into quadrants. Then there is the white outlined rectangle and square of the door and window, both strongly positioned in the composition.

The generally dark printing of this picture produces a rather sombre mood which is further enhanced by the stormy condition of the sky.

Techniques

Most towns and cities provide subject matter of this type. However, once located, it is best to wait until the weather conditions suit the subject. The rather drab and heavy appearance of these warehouses required a stormy day to make the most of them, and I kept this shot locked in my mind for just such a day.

It was ideal when I took this picture, being very cloudy but with short bursts of bright sunlight. One such bright spell provided the required contrast, and this was strengthened by the use of a red filter to boost further the contrast of the scene. The use of an extreme wide-angle lens has accentuated the angles formed by the roof tops, providing a pleasing perspective to the picture.

While printing this picture, the small area of the courtyard in the foreground was burnt-in quite strongly to provide a dark base more in keeping with the mood of the picture. The sky was also burnt-in slightly, by cutting a piece of card to the shape of the roof tops and positioning this a little way above the printing paper, which protected the image of the building while the sky was given extra exposure.

NO TITLE VI

Technical details

Contax RTS 35mm SLR camera
135mm – f 2.8 Zeiss Sonnar lens
1/125 second at f 5.6
Ilford Pan F rated at 50 ASA/18 DIN
Developed in ID-11 diluted 1 to 1

Description

A very simple picture, but one which contains some very strong geometric shapes. The angle formed by the shadow cast by a nearby roof top cuts into the rectangle of the window, and a straight narrow strip of dark-toned masonry forms a solid base to the picture. The stark geometry of this picture is relieved by the random, yet intricate, detail of the upper area of the flaking wall surface which contains many tones of light-grey to enjoy.

The picture is a small detail of an extremely large building – Aylesford Priory in Kent, England – and when visiting such a place it is very easy to become over-awed by the building as a whole, and smaller, sometimes more interesting details such as this may be overlooked.

Late evening sunlight provided this picture and, as in many cases, this last part of the daylight provided the best lighting; casting long shadows and picking out details and texture.

Techniques

Unfortunately, this was one of the rare occasions when I did not have my tripod with me. For this reason, my exposure was limited to a shutter speed which could be hand held, taking into consideration the focal length of lens in use. As the subject was very two dimensional, however, great depth-of-field was not required.

The camera's through-the-lens metering was used for this shot, and meter readings were taken from both the highlight and shadow areas. The camera was used in the manual mode, and an exposure which gave detail in both the highlights and shadows was selected. The film was very slightly overexposed and underdeveloped to keep contrast down to a manageable level.

Technical Details

Contax RTS 35mm SLR camera
135mm – f 2.8 Zeiss Sonnar lens
1/30 second at f 11
Ilford FP4 rated at 100 ASA/21 DIN
Developed in ID-11

Description

Any city or town can provide a wealth of potential subject matter for the camera. All that is necessary is to look, and learn how to interpret what you see. This picture was found on a stroll around my own home town, and is an example of turning an everyday mundane subject into an interesting picture.

Simply by using selective close cropping of the image and high contrast techniques, this gable-end to an end-of-terrace house provides a very graphic image with extremely strong geometrical composition. The very powerful diagonal formed by the line of the roof has been emphasised by the high contrast of this image, and an almost perfect triangle of brickwork is formed on the lower right of the composition. This stark geometry is relieved only by the chimney stack and the small timber strut set into the brickwork, both of which are nicely positioned in the composition near the intersection of thirds. The blank white sky is essential to this picture, providing a stark contrast between the two almost equal halves of the picture.

Techniques

Although this picture was taken from ground level, the problem of convergence has been avoided by using a telephoto lens from a fairly distant viewpoint, which has tended to flatten the perspective. Due to the fairly long focal length of lens in use and the necessary slow shutter speed, it was necessary to mount the camera on a tripod.

The high contrast of this picture was achieved by slightly overexposing the film and overdeveloping by about 50 percent. Printing onto a moderately hard grade of printing paper has also helped to increase the contrast further, making for a very bold type of image. The black border was produced in my normal manner, and complements the dark diagonal line formed by the edge of the roof tiles.

GUARDED FAITH

Technical Details

Contax RTS 35mm SLR camera
25mm – f 2.8 Zeiss Distagon lens
4 seconds at f 22
Ilford Pan F rated at 50 ASA/18 DIN
Developed in ID-11

Description

Many people have mistakenly believed that this picture is a montage, when in fact it is a genuinely found photograph, and is indeed a straight print with only the normal printing controls of burning-in or shading having been applied to it.

I knew of this church for some time, and had often intended to photograph it. So one fine Sunday morning I did. I spent about half-an-hour taking pictures of the entire church from the top of a flight of steps, and was preparing to pack up and go home, not being over-impressed with my efforts at that stage. As I made my way back down the steps, I was suddenly confronted by the scene that you see reproduced here. I had previously been taking my pictures over the top of the wall which runs through the centre of this picture – from the higher viewpoint at the top of the steps – and I had completely neglected to spot the barbed wire fence, which forms a remarkable diagonal element in the picture and, at the same time, seems to sum up the attitude of many people to their religion.

Techniques

A very precarious tripod position was necessary to obtain the desired composition from the flight of steps from which the photograph was taken. In fact, I had to go back to the location no less than three times before I was totally happy with the result – dedication or incompetence? Anyway, a very small aperture was necessary to maintain depth-of-field from the barbed wire, which was very close indeed to the church.

During printing, simple card masks were made to enable me to shade the triangle of the church roof and the uppermost fence post, while the sky was burnt-in with extra exposure. These masks were simply placed in contact with the printing paper and weighted, having been carefully positioned with the aid of the enlarger's red filter.

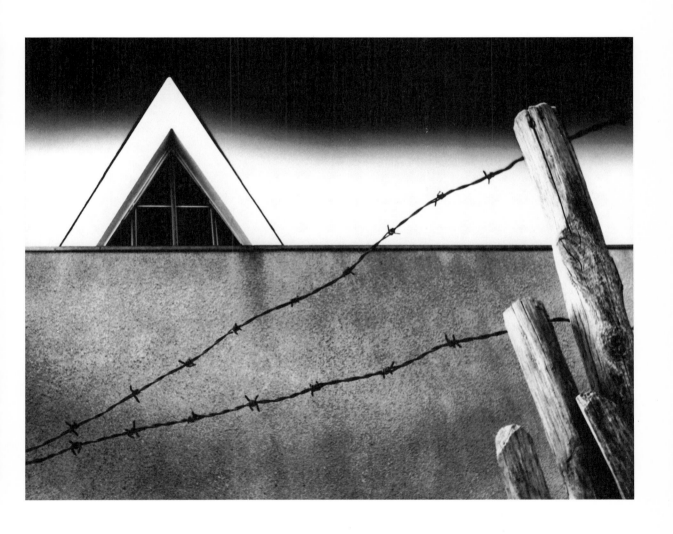

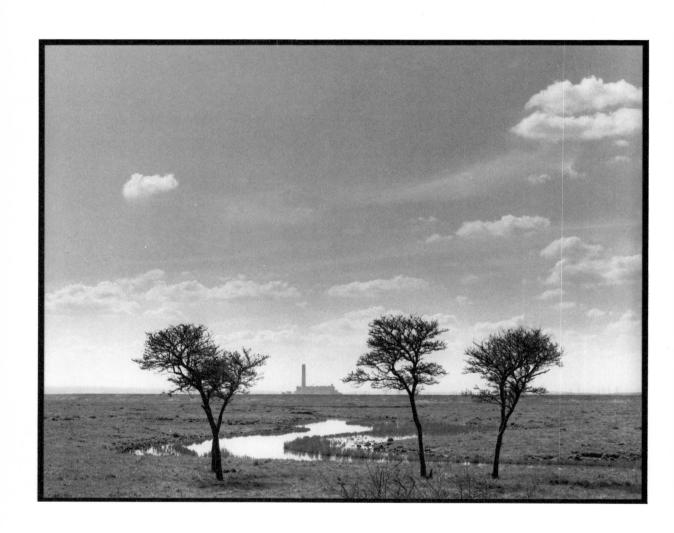

ISLE OF GRAIN – KENT

Technical Details

Mamiya RB67 Pro-S medium-format SLR camera
90mm – f 3.8 Sekor C lens
1/15 second at f 32 with orange filter
Ilford HP5 film rated at 400 ASA/27 DIN
Developed in ID-11

Description

A feeling of emptiness and distance is portrayed in this conventional landscape picture, which characterises this rather strange part of the English landscape. The dark tones of the trees in the immediate foreground contrast with the much lighter tones, which predominate the rest of the scene. The rather misty rendering of the power station on the horizon provides good aerial perspective, producing an impression of distance.

Particularly effective, for me, is the way the bright area of the water leads the viewer's eye from the trees in the foreground to the power station in the distance.

Techniques

Due to the larger format being used, it was necessary to use a smaller aperture than would have been necessary on 35mm equipment, in order to obtain the required depth-of-field. However, it was not a windy day and, even with the orange filter in use to provide cloud detail, the slow shutter speed (1/15 sec) produced no indication of subject movement.

Camera viewpoint was carefully selected to enable the four trees to be composed in a group of two separate trees on the right of the picture, with the two on the left positioned one behind the other forming almost a single tree. This viewpoint also positioned the water in the most attractive manner.

Correct exposure was obtained by taking an incident light reading from a much nearer substitute position, as the lighting was very even over the entire scene.

While printing, it was only necessary to provide a slight gradation of the sky tone, by giving a little extra exposure to the top part of the sky whilst shading the lower part of the print with my hand.

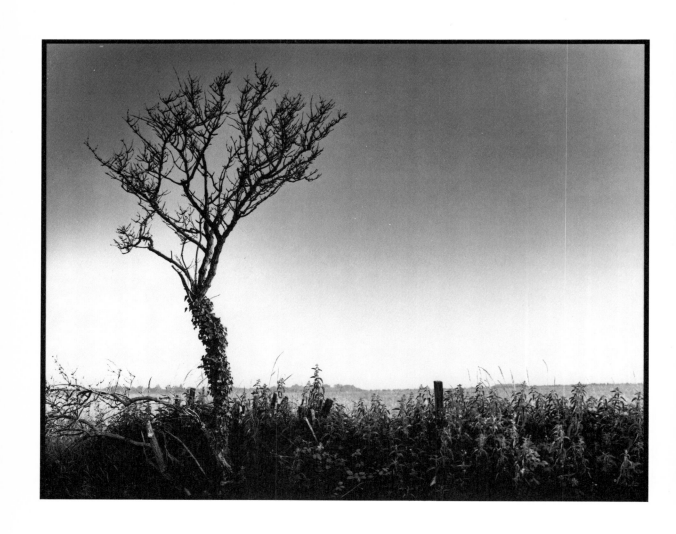

NO TITLE VII

Technical Details

Pentax 6 × 7 medium-format SLR camera
90mm − f 2.8 SMC Takumar lens
1/30 second at f 8
Ilford FP4 rated at 125 ASA/22 DIN
Developed in ID-11

Description

It is not necessary to try to capture on film an entire vista of rolling hills to obtain a pleasing landscape and, quite often, a smaller, more selective area taken from a large scene can prove much more effective. Simplification is frequently the key to success with many types of picture, and this is no less true when tackling landscape photography. What you can't see is quite often more fascinating in photography than what you can.

The picture reproduced here really contains very little information, and yet still remains interesting and indeed attractive. The small tree projects boldly into the almost plain area of sky, serving to grab the viewer's attention. Unusually, perhaps, the viewer's eye is then led down to the base of the picture to look more closely at the detail contained in the dark tones of the overgrown fence. This fence forms a barrier over which just enough information is provided to arouse the viewer's interest, leaving him with the feeling that he wants to see more.

Techniques

Very little special technique was required to produce this photograph, other than the ability to hold the rather heavy camera steady for a fairly long and awkward hand-held exposure. The only possible viewpoint for this picture was already occupied by a clump of trees and nettles, making it impossible to erect a tripod and only just possible to perform a rather complex balancing act among the botanical growth while I made the exposure.

Some burning-in was carried out to the sky in the darkroom, to produce a pleasing gradation of tone. Burning-in was also done to the base of the picture, darkening this to assist the role of the fence as a barrier. All of this was simple shading, carried out using my hands positioned in the light-beam from the enlarger's lens.

Technical Details

Pentax 6 × 7 medium-format SLR camera
165mm – f 2.8 SMC Pentax lens
1/2 second at f 11
Ilford Pan F rated at 32 ASA/16 DIN
Developed in Perceptol diluted 1 to 1

Description

Small pieces of landscape such as this can often contain a vast amount of detail: in fact, sometimes too much, so that the scene becomes rather confusing. The problem with such a picture is how to make the prime subject matter prominent. It would be a simple matter to move in close, using differential focus to separate the fern from an out-of-focus background, but this would provide little information about the surrounding environment. For this reason I chose to separate the fern by tone rather than by apparent distance. At the same time, I wanted to include the silver birch trees in the background, and these have been rendered very slightly out-of-focus to provide some sense of depth to the picture.

Techniques

In order to produce the required shortening of perspective, a medium telephoto lens was used, permitting a viewpoint to be taken up some 10 feet (3 metres) away from the fern. The camera was mounted on a tripod, as a slow shutter speed would be dictated by the aperture necessary to provide the correct amount of depth-of-field. The depth-of-field preview device was used to ascertain the correct aperture to record the background trees very slightly out-of-focus, and this determined the shutter speed. Fortunately, it was not a windy day, which made it possible to use such a slow speed.

Spot meter readings were taken from various parts of the scene, to determine how the tones would record and I eventually set the tones of the fern to reproduce as approximately zone 7 to 8 on the Zone Scale. However, in printing, it was still necessary to carry out some controls to obtain the result I required.

The background trees, having been in quite deep shade, would have printed too dark so this area of the print was shaded for about two thirds of the printing exposure, and to make the fern stand out clearly from its surroundings, considerable extra exposure was given to the lower half of the print while shading the fern with a piece of card attached to a thin length of wire.

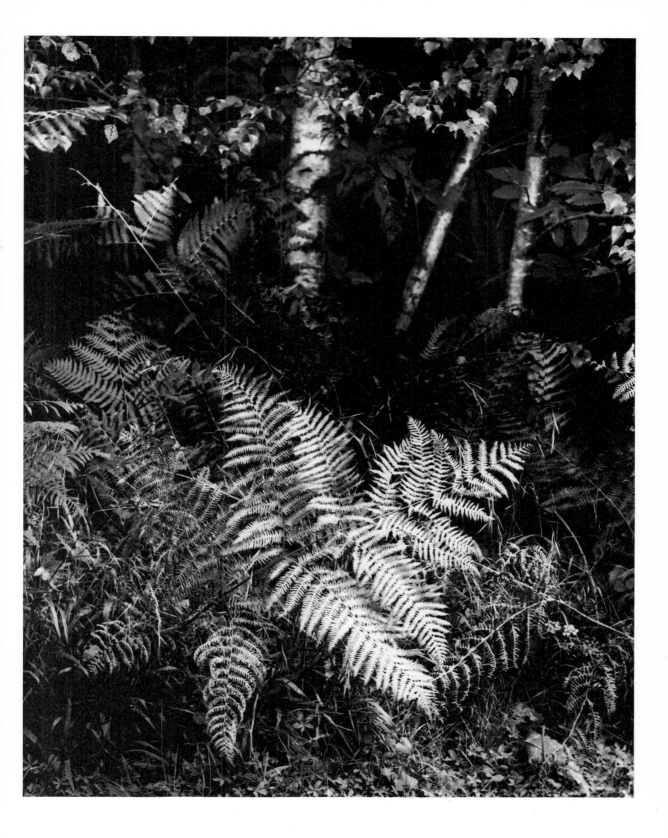

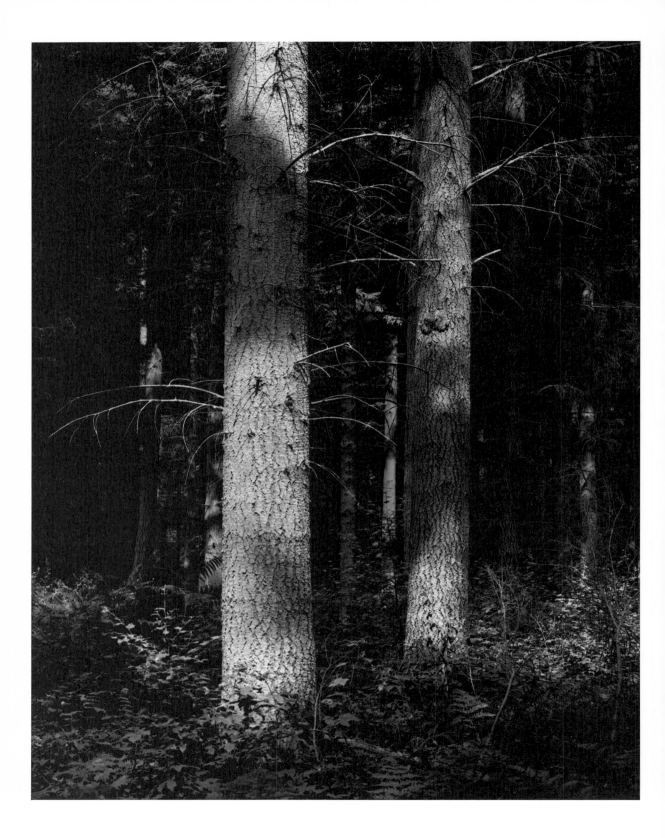

TWO PINES

Technical Details

Pentax 6 × 7 medium-format SLR camera
165mm – f 2.8 SMC Pentax lens
1/4 second at f 22
Ilford Pan F rated at 32 ASA/16 DIN
Developed in Perceptol

Description

Low afternoon sunlight has provided interesting contrasts of highlight and shadow in the woodland scene, picking out the two trunks of the pine trees in the immediate foreground. An interesting composition has been produced with the two centrally positioned and vertical light-coloured tones of the trees. The predominantly dark background permits these trees to stand out very clearly, yet retains enough detail to show more of the environment and maintain some interest within itself.

Techniques

In an effort to isolate the main subjects of this photograph, a viewpoint was selected some way from the two main trees, and a medium telephoto lens was used to 'pull' the subject closer, thereby eliminating any unnecessary detail and creating a much tighter composition.

A very slow speed film was used, and this was developed to produce the extremely fine grain which is essential to this type of subject. As a small lens aperture was required, in order to provide adequate depth-of-field, a fairly long exposure was necessary. For this reason, the camera was mounted on a sturdy tripod.

The principles of the Zone System were used to ascertain correct exposure, and the important highlight areas on the nearest tree were set to print to zone 7 on this scale.

During printing, several small highlight areas in the background were burnt-in with extra exposure, as these would otherwise have proved very distracting in the final composition.

NO TITLE VIII

Technical Details

Pentax 6 × 7 medium-format SLR camera
165mm – f 2.8 SMC Pentax lens
1/2 second at f 22
Ilford FP4 rated at 64 ASA/19 DIN
Developed in Perceptol

Description

A very old tree with twisted and knotted trunk provided this pattern and texture picture. Quite a pleasing photographic composition has been produced from quite a random subject, by a little thought and careful use of camera position. I find the downward flow of the bark, combined with the diagonals which are loosely formed by the sawn off branches and the generally light tone of the bark, very attractive indeed.

Techniques

The most interesting part of this tree happened to be situated fairly high up – perhaps about ten feet (3 metres) from the ground – and this made it necessary to adopt a looking up attitude. However, the use of a medium telephoto lens has flattened the perspective a little, and the use of a very small aperture has just about maintained sharpness at the top of the picture which, of course, was further away than the bottom of the frame due to the fairly steep angle at which it was necessary to take the picture.

Using a hand-held spot meter, a reading was taken from the lightest of tones, and this was adjusted to reproduce as a tone representing zone 8 in the Zone System by overexposing from this reading by three full f-stops.

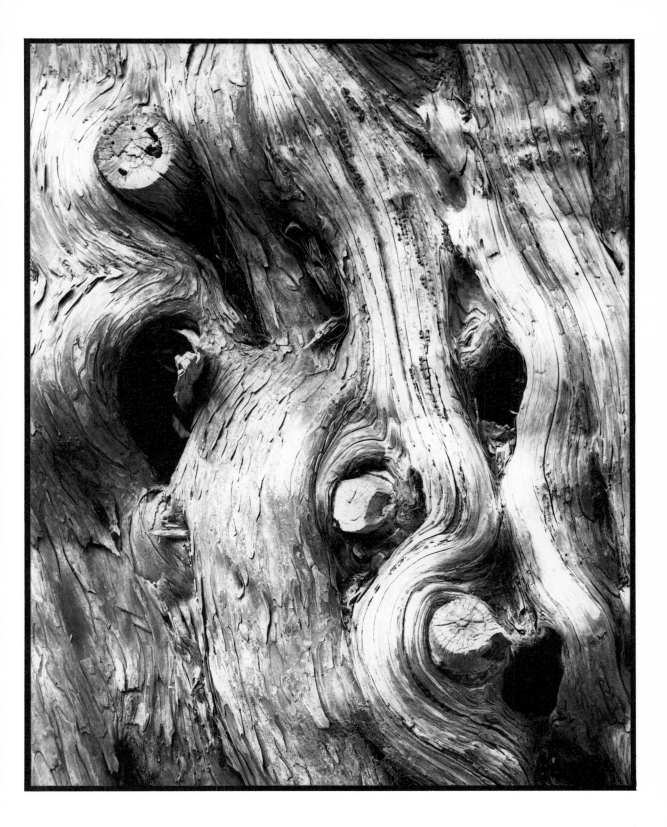

NO TITLE IX

Technical Details

Contax RTS 35mm SLR camera
135mm – f2.8 Zeiss Sonnar lens
1/2 second at f 11 with red filter
Ilford FP4 rated at 64 ASA/19 DIN
Developed in Perceptol

Description

A rather unusual landscape picture has been provided by very oblique lighting and a high contrast treatment.

This has produced a very strange, and almost sinister atmosphere to the photograph. The rather unusual composition in the positioning of the brightly lit silver birch tree further enhances this impression.

Although the greatest part of this photograph is very dark, there is still plenty of interesting detail within this area and, of course, it is this dark background which enables the single brightly lit tree to stand out so prominently.

Techniques

Late afternoon sunlight falling obliquely along the front edge of this wooded area had picked out small details and highlights in the main area of woodland. The single brightly lit tree, however, stood perhaps three paces forward of the main woods, and consequently received far more direct light.

A viewpoint someway distant from the scene was selected, and a telephoto lens was used to compress the perspective a little. The use of a deep red filter has greatly increased the already high contrast of the scene, helping to ensure that the single silver birch tree stands out starkly from the dark sombre background.

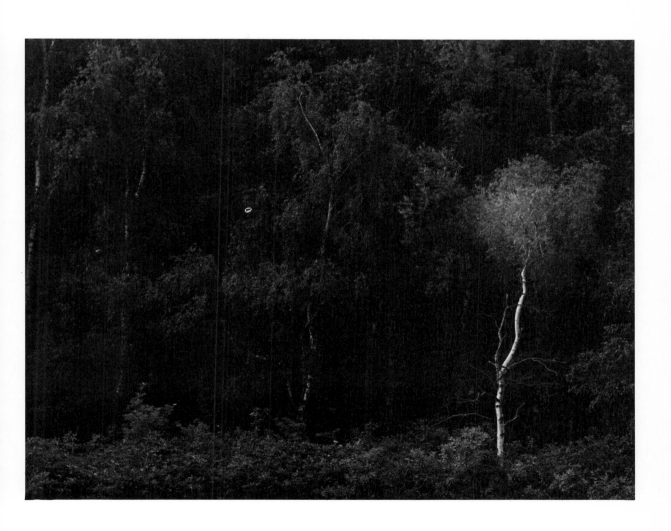

PEELING BARK

Technical Details

Pentax 6 × 7 medium-format SLR camera
165mm – f 2.8 SMC Pentax lens
No. 2 auto extension tube
1/2 second at f 22
Ilford Pan F rated at 25 ASA/15 DIN
Developed in Perceptol

Description

Although our eyes and brains are well equipped to perceive and recognise three dimensional objects, it is extremely difficult to put over an impression of this depth on a strictly two dimensional piece of printing paper. I have, however, made an effort to portray this lifting and peeling feeling in this picture of silver birch bark.

Very strong and directional sunlight has provided a deep hard-edged shadow behind the small area of peeling bark, which immediately helps to lift this 'curl' away from the flat surface, and the unusual trimming of the print further assists this lifting away. The horizontal lines formed by the dark areas of the bark also help this impression – as they tend to lead the eye across the picture from left to right – then discontinue suddenly where the curl of bark lifts up.

Techniques

The area of tree recorded in this photograph is really quite small, and it was therefore necessary to use an extension tube between the camera's lens and body to produce a close-up image.

The biggest problem was that, due to the small diameter of the tree trunk, very strong curvature was encountered. This made it very difficult to obtain adequate depth-of-field, even at a minimum aperture of f 22 and using a telephoto lens to provide reasonable camera-to-subject distance. Because of this, it was necessary to select a smaller extension tube than that first chosen, producing a smaller image on the negative, but from a greater camera-to-subject distance. This has produced a further flattening of perspective, making it easier to record the entire subject more sharply. The negative does, of course, then need to be enlarged further to produce the required print size.

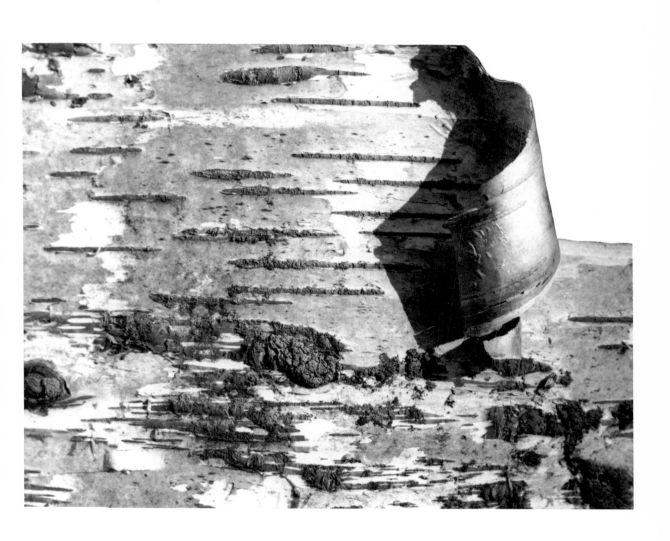

9
CONCLUSION

The massive growth in the popularity of photography as an interest, and the subsequent availability of relatively inexpensive yet highly sophisticated cameras and associated accessories has brought a great deal of enjoyment and satisfaction to many people. The advances which have been made in the production of automated cameras have now made it possible for almost anyone to achieve satisfactory results. This, in turn, has made people free to 'think' more about the pictures they are taking, since many of the technical problems have now been removed.

However, this very freedom through simplification has, quite predictably, brought about a situation where, although it may now be quite a simple matter to produce acceptable and adequately exposed photographs, almost anybody is capable of achieving this standard; and there are now a growing number of photographers who seek to improve their work, and somehow lift it above the level of merely competent picture taking. Creativity and imagination can be the route to achieving this goal.

There are many pitfalls, however, with perhaps the biggest of these being ourselves. The human is a creature controlled by emotions, and these very emotions of pride, jealousy, prejudice, love, hate and envy all affect, to some extent, our attitudes towards photography. It is all too easy to become hooked on one single aspect of a hobby, travelling down a narrow corridor with a blinkered view of everything else around; believing that only the area which we are interested in is 'right'. This sort of attitude will only lead to disappointment and perhaps, ultimately, to a totally disillusioned feeling

about your work when you discover that not everyone thinks your ideas or pictures are the greatest thing since sliced bread! Criticism is often very easy to give but much harder to take and make no mistake about it, if you produce work which is in any way different from the accepted norm, you will invite criticism.

It is foolish to be offended by such criticism as this will only have a destructive effect on your photography. The secret is to try to analyse the comments which you receive about your work and, above all, be really honest with yourself. If there *is* an element of truth in the criticism (and deep inside you really agree with the comments), then admit it and, if necessary, adjust your future picture taking to accord with your true feelings. Self criticism is perhaps the most difficult criticism to give or take but, if carried out honestly, is probably the most valuable. The only person who can really decide whether a picture is a success or a failure is yourself. If a picture is everything you intended, and given the opportunity, you would not wish to change it in any way, then it is obviously a success.

Strangely, the harshest criticism often comes from those least qualified to criticise. Some people choose to limit their own photography to just one particular type – such as portraiture or landscape – which is their right, but they are often then the first to criticise other types of work when they may not be experienced at all in other types of photography. It does seem sad to specialise to such an extent that all of the other fascinating areas of photography are excluded.

It has also been said often that a picture should

tell a story or communicate, and that 'art' photography has little value. When one considers this statement in more depth, it seems absurd. While few would argue that photo journalism, documentary or reportage photography are often extremely powerful, many people are also quite capable of appreciating a picture for no other reason than that it may be pleasing to look at, or simply interesting. All types and styles of photography have some sort of value, different maybe, but value nonetheless and a constructive, imaginative and creative approach, can 'give' something extra to all of the various types of photography. That is the real value of creativity!

Fortunately, photography is such a vast hobby, with all its different aspects and possibilities, that there really is no excuse for becoming bored or disillusioned. When you consider that anything which can be seen by the human eye is a potential subject, and that almost every other hobby can be recorded by the camera, it is easier to understand just how big the world of photography really is. It is difficult to think of another interest that is so limitless or which can encompass so many other interests. There really are so many aspects of photography to explore, that the question *what can I photograph?* should never arise, and yet it does. Why? It can only be that the photographer is not looking or, perhaps, although looking is simply not 'seeing'. It may also be that although the photographer knows what he or she wants, and may even be able to pre-visualise the desired end result, the technical ability to produce that result is lacking.

Pre-visualisation is the key to success in any form of creativity, and it is essential to know what you wish to achieve before you actually take a photograph. A sculptor would merely end up with a pile of broken stone chippings on the studio floor if he or she had not pre-visualised the finished work, and simply chipped and chiselled away at the slab of stone in the hope that something might take shape.

Good technique is also vital in achieving the pre-visualised result. It is useless to cut corners in an effort to save time or work. The success of the final image will depend on carrying out a series of processes and procedures in the correct order and manner if total satisfaction is to be achieved.

Care is essential at all times, as it is very easy to become lazy in one's approach to photography. Even the initial viewing of a potential subject through the camera's viewfinder requires some concentrated effort, and many people become so engrossed by their prime subject matter that they neglect to take note of such things as background, direct foreground or distracting detail near the edges of the frame.

Treat your camera's viewfinder as if it is the finished picture, one day to be hanging on your living-room wall or in an exhibition. Look at the background and the foreground – use your depth-of-field preview button if your camera has one – and ask yourself if there are any distracting details which come into focus only at the aperture at which the picture is to be taken. The more care that is taken at this stage the easier will become the printing, resulting in a greater chance of achieving the desired effect in your finished photograph.

One very real value of creativity is not in producing different or original images but in acquiring the ability to 'see' pictures in the world around you. While there is certainly nothing wrong with straight record photography, it should be appreciated that a certain amount of creative ability on the behalf of a photographer can improve almost any type of photograph, even within the strictest confines of accurately recording an object by the photographic process.

It is very easy to see the work of professional photographers and envy their position and their freedom to travel the world and use exotic locations for their photographs. In reality, it is unnecessary to travel far to find exciting and interesting pictures and, without doubt, potentially good pictures are all around us. Your own home or garden, street or park can provide enough subject material to last a lifetime, as all that is necessary is to look and observe!

With 'found' subjects, try to analyse precisely what it was that attracted your attention. Then consider how you might emphasise this point in

your final print. As you gradually develop your creative ability, this first analysis of your subject matter will, more often than not, determine the final print and, indeed, even its presentation. Subject matter is limitless, and even subjects which you have previously photographed can provide fresh material. Look again, perhaps through a different lens, under different lighting conditions or at a different time of the year, and it is quite possible to produce an entirely new picture from previously used material. With a little thought, and the application of sound technique, it can be surprisingly easy to produce interesting photographs from the most mundane subject matter.

Although creativity cannot truly be taught, I do believe that creativity and imagination are within all, and all that is necessary is to develop this ability, through techniques which can be applied to producing imaginative pictures and by developing a sound basic knowledge which will enable an imagined or pre-visualised result to be brought into reality as a finished photograph. Beyond this, encouragement and stimulation are required, and this can often be found by studying the work of other photographers, or indeed, artists. This is not to say that one should simply copy the work of others, as this will rarely give true satisfaction. The work of some of the more imaginative photographers can, however, be extremely valuable in providing a stimulus for your own imagination; often providing a basis for an idea which can be interpreted in your own way, and in your own particular style.

This book has been compiled to help, encourage and stimulate photographers who wish to lift their work above the level of normal camera club photography. This is not to suggest, in any way, that the standard of photography in camera clubs or photographic societies is low. On the contrary, during my frequent visits to such clubs where I lecture on photography or judge competitions, I have been impressed to find high standards of technique among the more advanced members. However, a club environment is somewhat restricted, even limited, in that the opportunity to see different work from a wide range of photographers is not generally available and, because of this, much of the work to be seen in camera clubs today lacks imagination or originality.

I think that one of the main problems here is that, for many club members, it can become over important to do well in the club competitions, which creates a tendency to produce work to please the judges rather than yourself. As most camera club judges are simply members of another camera club themselves, with possibly a similar outlook on photography, work done merely to please a judge will often be in a similar vein to that found throughout most other camera clubs. It is sometimes best to forget about winning certificates or trophies, as these will not improve your photography. Only you can do that, and it will be better achieved by producing work purely for your own pleasure, as this will enable you to develop your own style naturally.

All of the pictures in the folio part of this book are examples of my own 'personal' photography and, as such, it would be unrealistic to expect readers to like every one of the photographs. I would, however, hope that everybody finds at least some of the photographs either pleasing or interesting, and that this book, as a whole, provides you with an incentive to produce more creative monochrome images in the pursuit of your photography.

INDEX